LAKE COWICHAN CHIROPRACTIC

CANADA'S

Classic Fishing Lodges

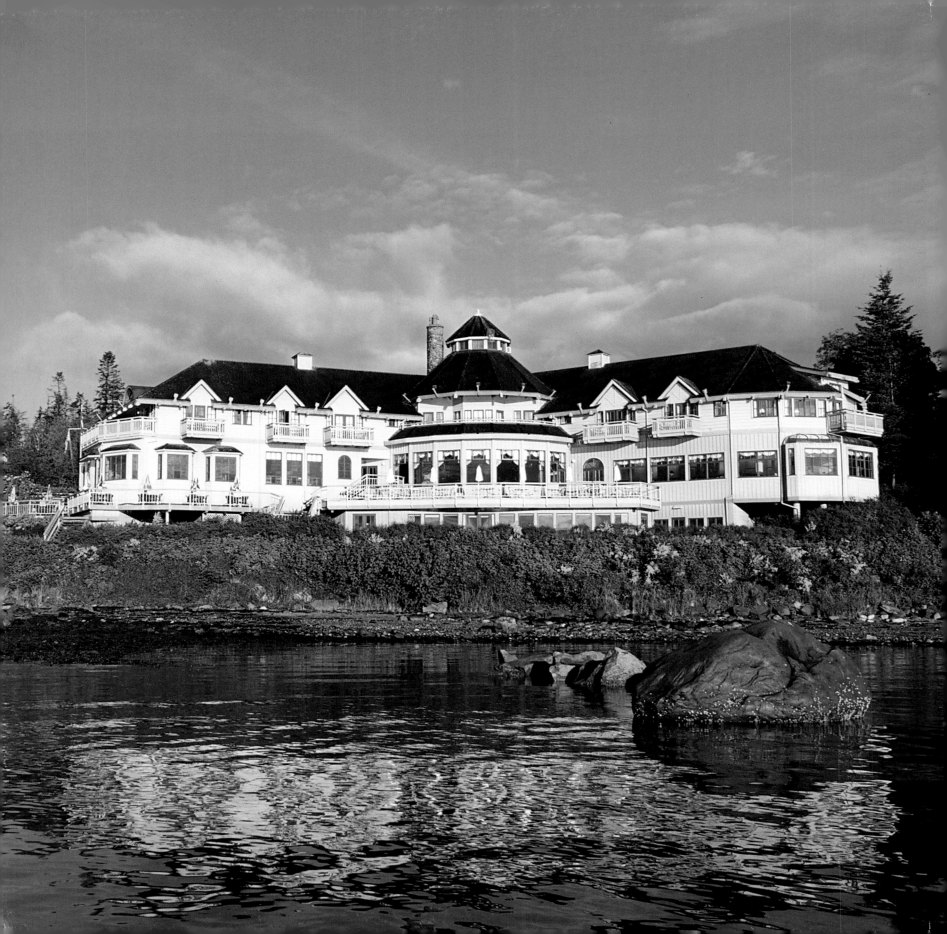

CANADA'S

classic Fishing Lodges

Text by John St. Louis & John Townley
Photography by Mark Krupa & Donald Standfield

The BOSTON
MILLS PRESS

A BOSTON MILLS PRESS BOOK

© John St. Louis, John Townley, Mark Krupa and Don Standfield, 2003

National Library of Canada Cataloguing in Publication

St. Louis, John, 1972–
Canada's classic fishing lodges / text by John St. Louis and
John Townley;
photography by Don Standfield and Mark Krupa.

ISBN 1-55046-396-9

1. Fishing lodges — Canada. 2. Fishing lodges — Canada —
Pictorial works.
I. Townley, John, 1974– II. Standfield, Donald, 1955– III.
Krupa, Mark IV. Title.

SH571.S24 2003 799.1'0971 C2003-901188-7

Publisher Cataloging-in-Publication Data (U.S.)

St. Louis, John, 1972-
Canada's classic fishing lodges / text by John St. Louis
and John Townley ; photography by Don Standfield
and Mark Krupa. — 1st ed.

[160] p. : col. photos. ; cm.
Includes bibliographical references and index.

Summary: Fishing lodges in Canada, portrayed in essays
and photographs, including sport fishing, recreation, lodgings,
fishing guides, and their great outdoor environment.

ISBN 1-55046-396-9

1. Fishing lodges — Canada.
2. Fishing lodges — Canada — Pictorial works.
I. Townley, John, 1974– II. Standfield, Donald, 1955–
III. Krupa, Mark IV. Title

799.1/ 0971 21 SH571.S24 2003

Published by BOSTON MILLS PRESS
132 Main Street,
Erin, Ontario N0B 1T0
Tel 519-833-2407
Fax 519-833-2195
books@bostonmillspress.com
www.bostonmillspress.com

IN CANADA:
Distributed by Firefly Books Ltd.
3680 Victoria Park Avenue
Willowdale, Ontario M2H 3K1

IN THE UNITED STATES:
Distributed by Firefly Books (U.S.) Inc.
P.O. Box 1338, Ellicott Station
Buffalo, New York 14205

Design: Gillian Stead and PageWave Graphics Inc.
Front Cover Design: Gillian Stead

Photo page 2: Painter's Lodge, Vancouver Island, British Columbia

Printed in Canada by Friesen Printers

The publisher acknowledges the financial support of the Government of Canada through
the Book Publishing Industry Development Program (BPIDP) for its publishing efforts.

Contents

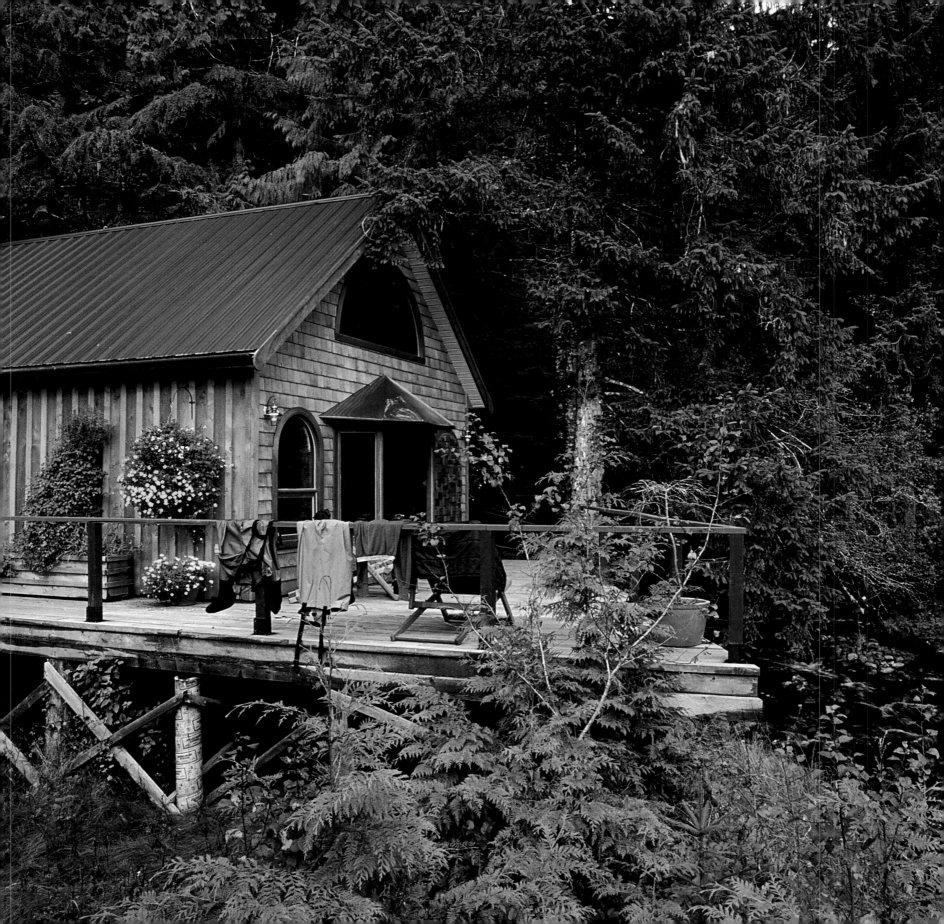

Preface

The pursuit of worthy adversaries takes many fishermen to the last frontiers of wilderness. This is one of our sport's many blessings, the opportunity to escape the ordinary, to venture to distant locales and unfamiliar waters. Canada abounds with such opportunities and remains an enticing playground for those drawn to dramatic natural beauty and abundant wildlife. North of its major cities, Canada's waters, rock, trees and ice conspire against civilization, from the Pacific to the Atlantic to the Arctic. Scattered amid this daunting labyrinth of forests, glacial lakes and wild rivers are many of the finest fishing lodges in the world, most dedicated to providing action and indulgence in equal measure.

Each of the lodges featured in this book is a tribute to Canada's bountiful sport-fishing heritage, as are the lodge owners themselves, most of whom have surmounted huge challenges to forge these angling shrines. Their reputations for excellence echo around the world. This book celebrates seventeen of Canada's finest fishing lodges, their pioneers, and those who carry the torch today. We hope that it will also convey a sense of the magnificent scenery, the freedom, the warm camaraderie, and the phenomenal fishing that can be experienced at these establishments.

The lodges are presented for the reader in no particular order. They are not arranged geographically, by lodge size or fish species. Can a feisty Chinook outrank a monster pike, a tenacious steelhead or an energetic brookie? Can the legendary Miramichi River give more pleasure than rustic, far-northern Great Slave Lake or the west coast's exotic Queen Charlotte Islands? They each call to us with their extraordinary singular allure.

Researching and writing this book was the stuff that dreams are made of — arguably one of the most enjoyable sporting assignments ever. For two men whose love of fishing began with catching rock bass off a dock in Ontario's Muskoka lake district, the five months spent visiting these seventeen fishing lodges, in seven provinces and two territories across Canada, was almost too idyllic. Several lifetimes worth of trophy fish, helicopter and floatplane trips, river-rafting, single-malt scotch and stellar shore lunches spoiled us rotten. So much hospitality, so many friendships and wonderful memories. It was an incredible privilege that we shall never forget.

OPPOSITE PAGE Built on stilts to protect it from the Pacific tides, a Nimmo Bay cabin awaits its guests under the shadow of old-growth forest at the base of British Columbia's Coastal Mountain Range.

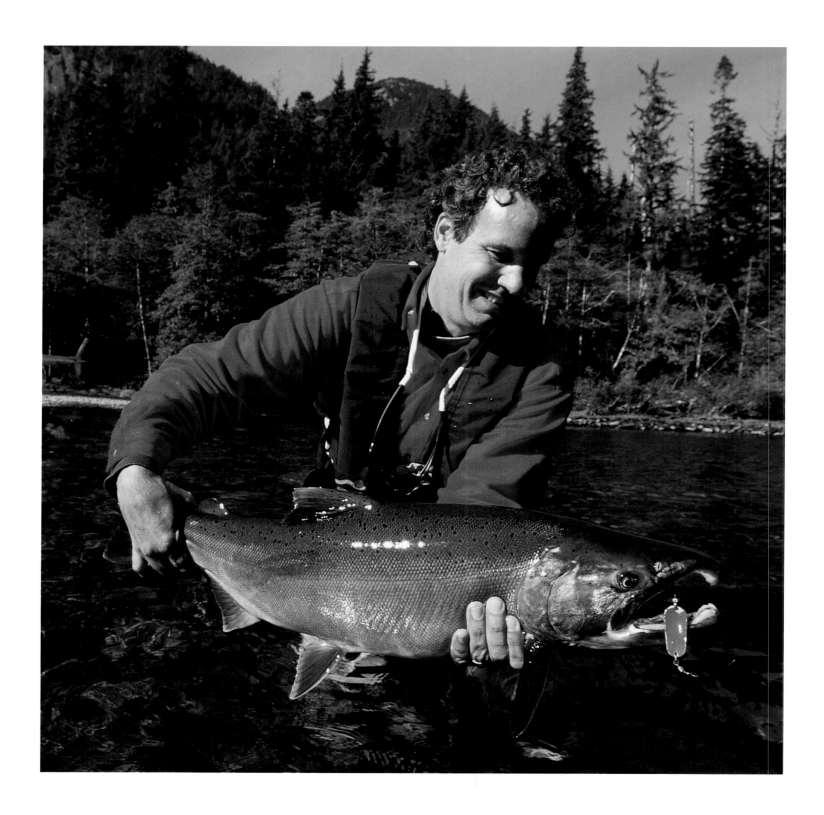

Acknowledgments

This book would not have been possible without the invaluable contribution, support and guidance of the following people and companies:

companies

- Howard Johnson Hotel, Winnipeg, Manitoba
- High Country Inn, Whitehorse, Yukon Territories
- Abercorn Best Western, Richmond, British Columbia
- Air Thelon Ltd.
- Delta Vancouver Airport Hotel, Vancouver, British Columbia
- Northwest Territories Arctic Tourism
- Abigail's Hotel, Victoria, British Columbia
- Chateau Victoria
- The Orvis Company, Inc.
- Delta Besborough Hotel, Saskatoon, Saskatchewan
- Tourism Saskatchewan
- Wilson's – Toronto's Fly Fishing Centre
- Country Inn Suites, Thompson, Manitoba
- Air Nova
- The Aurora Hotel, Happy Valley/Goose Bay, Labrador
- The Labrador Inn, Happy Valley/Goose Bay, Labrador
- PageWave Graphics, Toronto

Individuals

- Joy Inglis
- Hillary Stewart
- Gary Pearson
- Ilene Painter
- Michael Levine
- Don Saunders
- Professor James Wilson
- Helen Campbell
- Victor Moose
- "Jiggin" Jack Beeler
- Steve Woloshyn
- Leon Cook
- Lani Waller
- Eric Peterson
- Diane Kretz
- Alesha Lopez
- John Denison
- Noel Hudson
- Jane Gates
- Gillian Stead
- Dr. Leon Leppard
- Eva Gutsche
- Diane St. Louis
- John A. B. Townley

OPPOSITE PAGE *An October-run chinook salmon awaits release into renowned writer-angler Roderick Haig-Brown's home river. Campbell River has given its namesake community on British Columbia's Vancouver Island the reputation of being "the salmon capital of the world."*

9

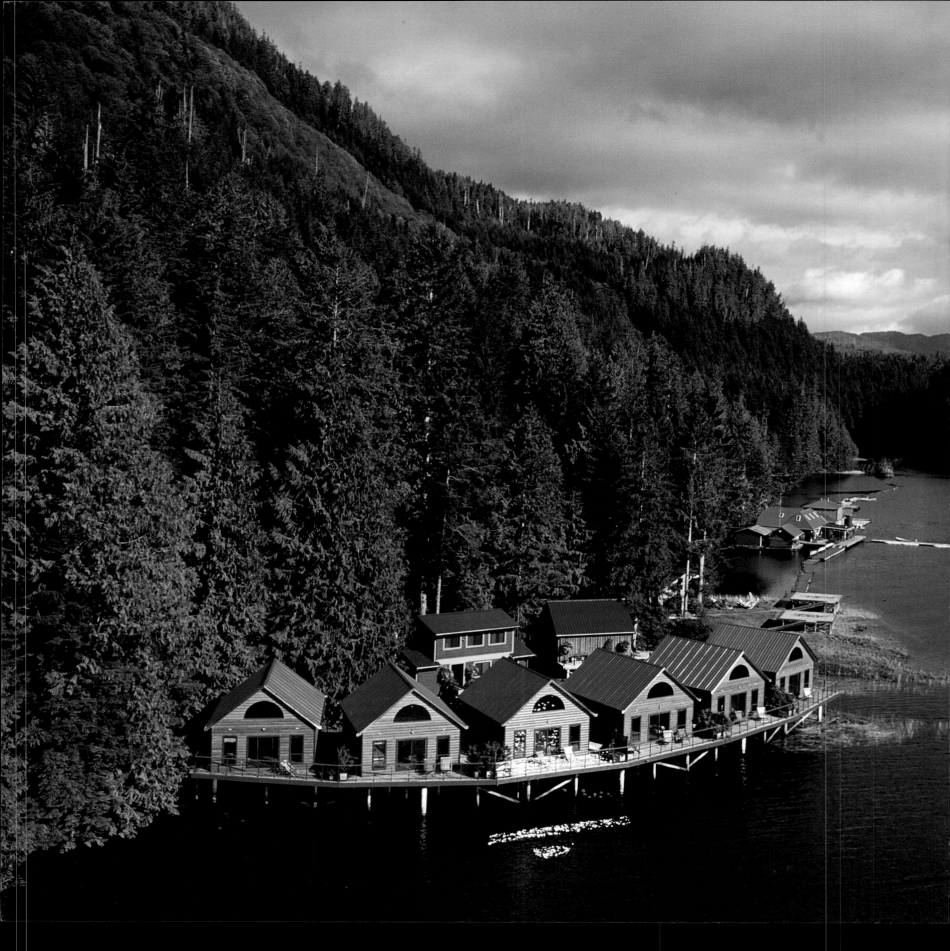

Nimmo Bay Heli-Ventures

Tucked away in one of British Columbia's secluded coastal inlets is Nimmo Bay Resort, a destination of necessity for those who seek the best in fishing adventure. The extraordinary capability of its helicopters to explore their wilderness playground, combined with the lodge's peerless service, has made Nimmo Bay an irresistible magnet for people with a desire for the exceptional.

Nimmo's tireless founder, Craig Murray, originally came to British Columbia in the '70s from his native Ontario with the simple intention of building himself a sailboat. He ended up building and selling two before briefly flirting with the logging and commercial fishing industries. It was during this time that he came upon the virtually untainted coast of central British Columbia and was inspired to establish a sport-fishing lodge there. His criteria for a suitable location were strict. It had to be beautiful, secluded, blessed with sunshine and have a reliable source of fresh water close at hand. Some canny detective work led to a local who suggested Nimmo Bay, and on visiting it for the first time, he was smitten.

Craig built an attractive floating lodge that initially catered to saltwater anglers intent on catching ocean-run salmon. But his whole outlook on the industry changed dramatically at the end of 1983, when he had his first taste of a heli-fishing trip. The thrill of the ride, the ability of helicopters to reach previously inaccessible

Guest cabins stand above the salt chuck in a remote inlet off the west coast of British Columbia. The cabins were constructed on-site from local woods such as red and yellow cedar, hemlock, fir, yew and alder. Behind the cabins, heli-pads await the return of lucky anglers. INSET Nimmo's soothing hot tubs look out upon the glacier-fed waterfall that provides 90 percent of the resort's electricity needs.

water, and the experience of catching two steelhead in the first twenty minutes were enough to convince him that this was where the future of his business lay. The very next year, helicopters became Nimmo's primary mode of transport, and by 1991 the only one. Today, Nimmo Bay takes fishermen to over thirty river systems within a 30,000-square-mile zone around the lodge, from sea level to 7,000 feet.

Anglers were not the only ones to benefit from the lodge's application of helicopters. Craig soon realized that a whole realm of other activities could easily be made available, and it is quite possibly this side of the business that now attracts the lion's share of his clients. Heli-hiking on alpine pastures, exploring the limestone caves and white sand beaches of Vancouver Island, and whitewater rafting on a nearby river are some of the more strenuous challenges that guests now relish. If these sound too daring, then watching killer whales on Johnson Strait is an option, as is a gentle solo kayak trip in the sheltered enclave of Nimmo Bay.

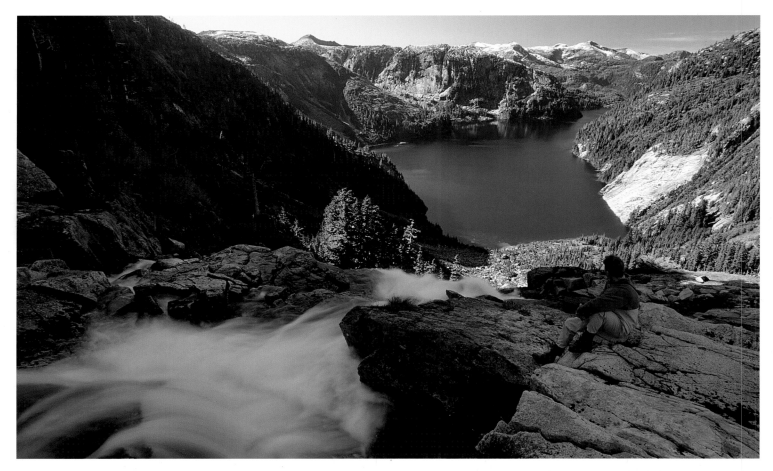

There is more to fishing than fish. This spectacular waterfall feeds Twin Lake, British Columbia. "Rivers and inhabitants of the watery element were made for wise men to contemplate, and fools to pass by without consideration," an ingenious Spaniard is quoted as saying in Sir Issac Walton's The Compleat Angler.

Some people still consider that to be hard work and settle for a series of exotic lunches on mile-high glaciers or wherever takes their fancy. The permutations are endless, especially when you add in the incredible fishing opportunities.

The A-Star helicopters that Nimmo Bay uses seat up to six guests and are supplied by Vancouver Island Helicopters, a business with an impeccable safety record. This, however, does not preclude pilots from entertaining guests. In fact, of all the activities, the helicopter rides probably leave the most indelible impression. The sheer bliss of following a meandering river downstream at 140 knots while listening to the soundtrack from the film *The Piano* was overwhelming. I won't mention what flying over a 2,000-foot precipice while listening to Kenny Loggins's "Danger Zone" did to me. The varied beauty of the terrain constantly delights the senses. A higher force truly touches this part of Canada, and to witness its coastal fjords, snow-capped mountain tops and sparkling blue glacier-fed lakes from your own magic carpet is a phenomenal experience.

The other beauty of helicopters is that they do the hard work. Anyone can be taken virtually anywhere. Guests do not have to bushwhack or wade across swollen rivers if they choose not to. If it's raining or the fish are not biting, then it's simply a case of hopping in and traveling to a location where the sun is shining or the fish are more co-operative. No one need be retired from

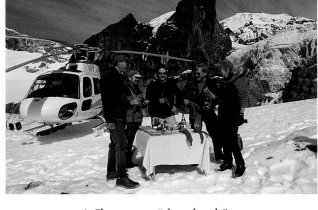
A Champagne "shore lunch" on a glacier 6,000 feet above sea level.

fishing or adventure with one of these modern-day chariots of the gods at their disposal.

While the activity profile offered by the lodge developed, Craig made sure that the level of service and accommodation also evolved. The 1993 introduction of the first savory chef was followed two years later by the addition of a pastry chef. Heather Davis holds both these positions today. She is master of her craft, with creations that constantly challenge the diner to take one more bite. Much of the food, such as the Dungeness crab, sockeye salmon and prawns, is supplied locally — in some cases straight off the boat. Heather's talents as a haute cuisine and sushi chef were no more evident than on the final night, when she treated us to a banquet of assorted sushi, soba salad, duck medallion and hamachi tuna. She also made sure that we had an innovative yet healthy breakfast each morning before sending us off with a hamper of delicacies for lunch. Her truffles, which inevitably fell into short supply, launched more than one argument.

In 1996 guest accommodation was transferred to six waterfront cabins perched on stilts above the tidewater. A further three riverside chalets were added in 1999 to complete the sanctum, which sits in harmony with the densely forested shoreline. Inside these quarters is virtually every modern convenience one could hope for, right down to the CD player, stocked fridge and back-scratcher. Outside, hanging baskets overflowing

Nimmo Bay is a family business, something that Craig and Deborah Murray would like to see continue for many years to come. To this end, they are preparing the next generation to take over the reins. Their eldest son, Fraser, and his brother, Clifton, spent most of their formative summers working at the lodge. Both are natural, articulate men who can entertain and perform nitty-gritty, behind-the-scenes tasks in equal measure. Fraser joined the business full-time in 2001 as operations manager, while Clifton performs the task of maitre d' with flair and puts his considerable music skills to good use by constantly entertaining the lodge's guests. Clifton is still at university, but he has signaled his intention to join his older sibling as soon as possible as marketing director, while Georgia, the youngest, is pursuing a singing career.

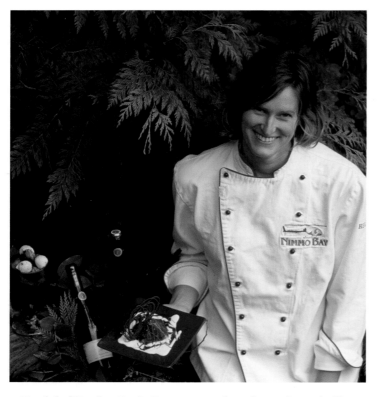

Head chef Heather Davis. Dungeness crab, sockeye salmon, halibut and prawns come from the rich local waters surrounding Nimmo Bay and are prepared for guests within hours of being caught.

One of the key ingredients in the lodge's recipe for success is attention to detail. As Craig says: "The key is not to do things well one hundred times, or a thousand times, but ten thousand times." One immediately senses that all members of the staff love their jobs and believe that they are contributing towards something very special. "Tread softly, leave only footprints and take only memories" is central to the ecologically friendly philosophy of Nimmo. Water is the lifeblood and soul of the operation. Half of the lodge floats, and the centrally located glacier-fed waterfall supplies all the drinking water and 90 percent of the power needs of the lodge via a Pelton Wheel generator. To protect this precious resource, the soaps and cleaning products used are environmentally sound, and in 2000, a state-of-the-art Advanced Hydroxyl Wastewater System was installed. The lodge's impact is further minimized by composting all organic garbage and by flying out all non-biodegradable waste.

with flowers make the brief stroll over the floating walkway to the main lodge a pretty and fragrant affair. This structure, which also rises and falls with the tide, houses the dining room, with its commanding view of Nimmo Bay, and a comfortable lounge that is adorned with the watercolor paintings and local art of Gordon Henschel and Tim Motchman. There is also a collection of eye-catching reels, creations of flamboyant Dutch designer, artist and fly-fisherman Ari Hart. In addition to being a good friend of Craig's, Ari has the distinction of fashioning the Remco reel, the only piece of fishing equipment ever to be displayed by the Museum of Modern Art.

14

Recognition of Nimmo Bay's conservation efforts came in 1999, when it earned British Columbia's Environmental Industry Award, a first for the tourism business.

In addition to looking after the immediate vicinity of the lodge, Craig keeps his finger on the pulse of the entire area that his helicopters range over. The pilots regard themselves as stewards of the central coast of British Columbia, and if they notice anything that concerns them, they will photograph it. Thus, any environmentally unfriendly activity that occurs on Nimmo Bay's patch reaches a large and vocal audience very rapidly.

The season at Nimmo Bay stretches from late April to October. Non-fishing-related activities are best enjoyed

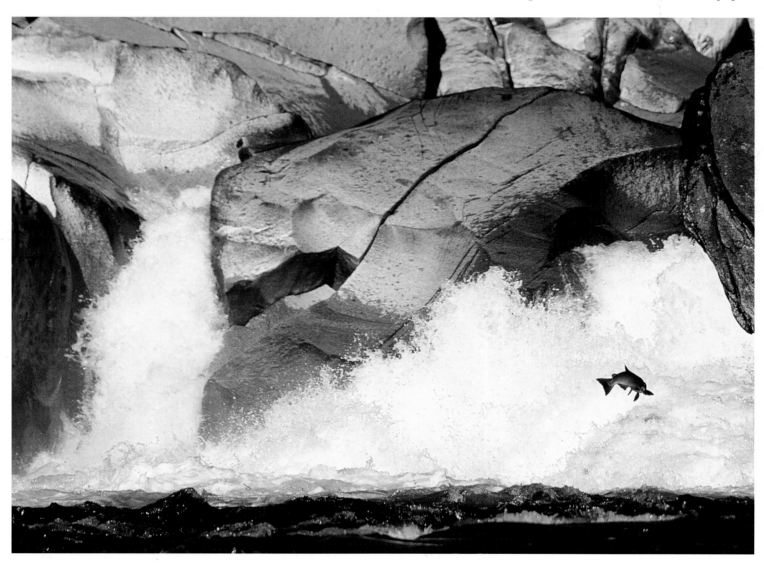

One of thousands of coho salmon that each year struggle in vain to negotiate thundering Seymour Falls.

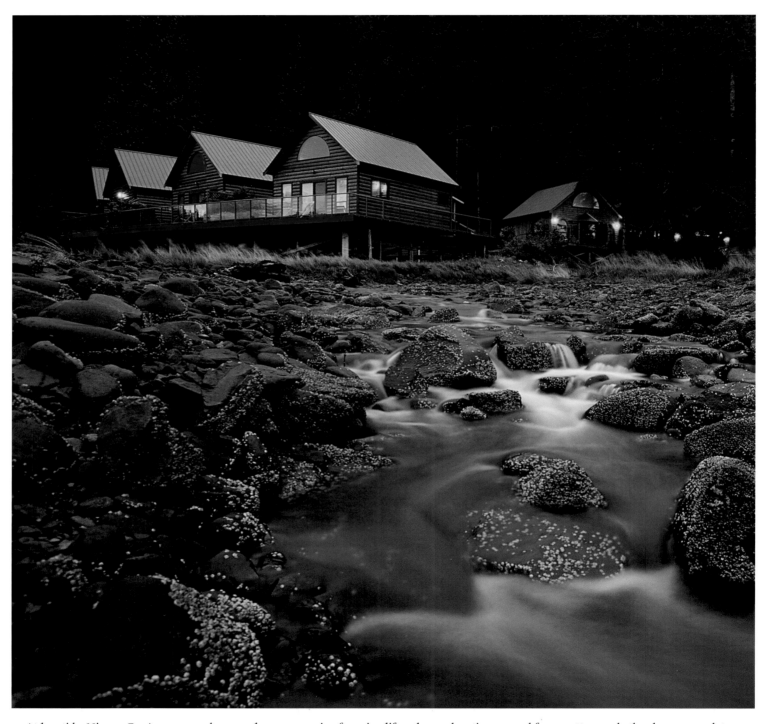

At low tide, Nimmo Bay's ocean garden reveals a cornucopia of marine life, a happy hunting ground for sea otters and other hungry predators.

when the weather is at its most clement, generally June to October. Catch-and-release fishing opportunities vary according to the time of year. Steelhead fishing is available at the beginning of the season, after which trout are the target species until the first run of salmon appears in late July. During August, all five species of Pacific salmon start to run upstream, so that by September most of the rivers are teeming with fish. The lodge record to date is a 77-pound chinook salmon, which was taken from the "meat hole" on a secret river. A replica of this pot-bellied mammoth hangs in the dining room. Steelhead weighing 30 pounds have been landed, as have 7-pound cutthroat and Dolly Varden trout. When the pink salmon are still fresh it's not unusual for each guest to hook in excess of one hundred during the course of a single day.

Nimmo Bay's three B2 A-Star helicopters, capable of transporting seven people each, roam over a 30,000-square-mile playground of coastal mountains, lakes and rivers.

The lodge provides all the necessary angling equipment, so its visitors only have to show up with sunglasses and sunscreen. Both spin- and fly-fishing are permitted, but only with single barbless hooks. Every fish that is played must be returned safely to the river after a quick cuddle and a photograph. One conservation measure that we had not seen before was the use of steel and bismuth gear.

We visited Nimmo in late September. Giant chinook had been in the rivers for weeks and pink salmon for months. But mint-fresh silver coho salmon were just beginning to move in from the sea. Unfortunately, on our first day we awoke to a fairly severe Pacific storm, and although the helicopter could handle the torrential rain, the rivers could not. The first and only river

we visited that day yielded a couple of modest-sized fish early on, but after it rose 2 feet in an hour and turned the color of milk chocolate, it was game over. Our pilot, Rob, valiantly searched for fishable water, but it was not to be, as every river resembled the Yangtze from the air.

An early return to the lodge meant that we could get some kayaking in, and Fraser suggested that we take our rods, as there were still coho waiting to move up a small creek at the far end of Nimmo Bay. Our rods were not really required, as the massive old-growth cedar and spruce trees and the towering Mount Stephens were distraction enough, especially in the delicious silence that followed the storm. True to Fraser's word, there were indeed coho to be caught, but casting

a fly rod from a kayak proved to be an incredibly frustrating and unsuccessful ordeal. One of the other guests, Dan, must have caught five beautiful fish using a Pink Spoon. Watching him fight a 12-pound coho in the prime of its life from the confines of a wobbly kayak was extremely entertaining, and a first for all of us. At least he had someone to retrieve his paddle once the battles were through!

After the lengthy downpour on our first morning, the weather changed and was magnificent for the remainder of our sojourn. Coastal rivers recover remarkably quickly from these batterings, and the very next morning, after

Helicopter pilot and fishing guide Rob Fletcher prepares to gently release a fine male coho just prior to spawning season.

we had made short work of Heather's scrambled eggs in filo pastry and beef-and-onion sausages, Rob took us to a pretty waterfall pool.

This small river, the identity of which cannot be revealed, receives a run of roughly 5,000 coho salmon per year. Most of them seemed to be crammed into this idyllic body of water not too much bigger than a skating rink, and at any one time at least three fish would be making a frantic effort to leap the falls, a seemingly impossible task given the high water. Over the following two hours, six of us landed two dozen fish, all fresh and willing to prove it to us. The largest was an 18-pound male that led a seasoned fly-fisherman downstream and submitted only after an epic twenty-minute battle. Two first-time anglers were responsible for ten salmon between them — quite the baptism.

Everyone was high on the moment and very reluctant to stop for lunch. After repeatedly requesting that we return to the helicopter, Rob whistled loudly and yelled, "Ladies and gentlemen…Lunch!" We clambered back into the helicopter like naughty children, wondering in silence what spot could possibly top the riverside shade of a thousand-year-old spruce tree.

Rob's mystery spot turned out to be Twin Lakes, a favorite of Nimmo Bay regulars. At the top of a valley, just below the snow line, lies a small, pastel-blue lake that flows over a 1,000-foot drop-off into a brilliant aquamarine lake. Rob set the helicopter down a few yards from the edge of the cliff and waited for our reaction. Silence reigned; we were simply mesmerized by the panoramic

The Intertidal Chalets blend into the lush coastal canopy that engulfs Nimmo Bay. Some of the chalets' interior lights are handmade stained glass depicting First Nations masks. They are made locally in Courtenay on Vancouver island.

vista provided by this vantage point. A large glass of Chardonnay returned our power of speech, but only just, as "Wow" seemed to be the limit of most people's vocabulary. After that backdrop and Heather's culinary delights, picnics will never be the same again.

The fishing improved as the river cleared and the coho could get a proper look at our pink flies. We were able to visit several systems a day. On some occasions we would stop simply to observe the natural spectacle of thousands of spent salmon holding in inches of water. This phenomenon was not lost on the local bald eagles, or bears for that matter. One pool had no fewer than eight grizzlies lined up along its length. It was any nature-lover's fantasy. But then that is what Nimmo Bay specializes in — providing magical memories for people to cherish forever.

Home of the theory of Hospitality $E^2=MC$™
(Expectations Exceeded=Memories Created)

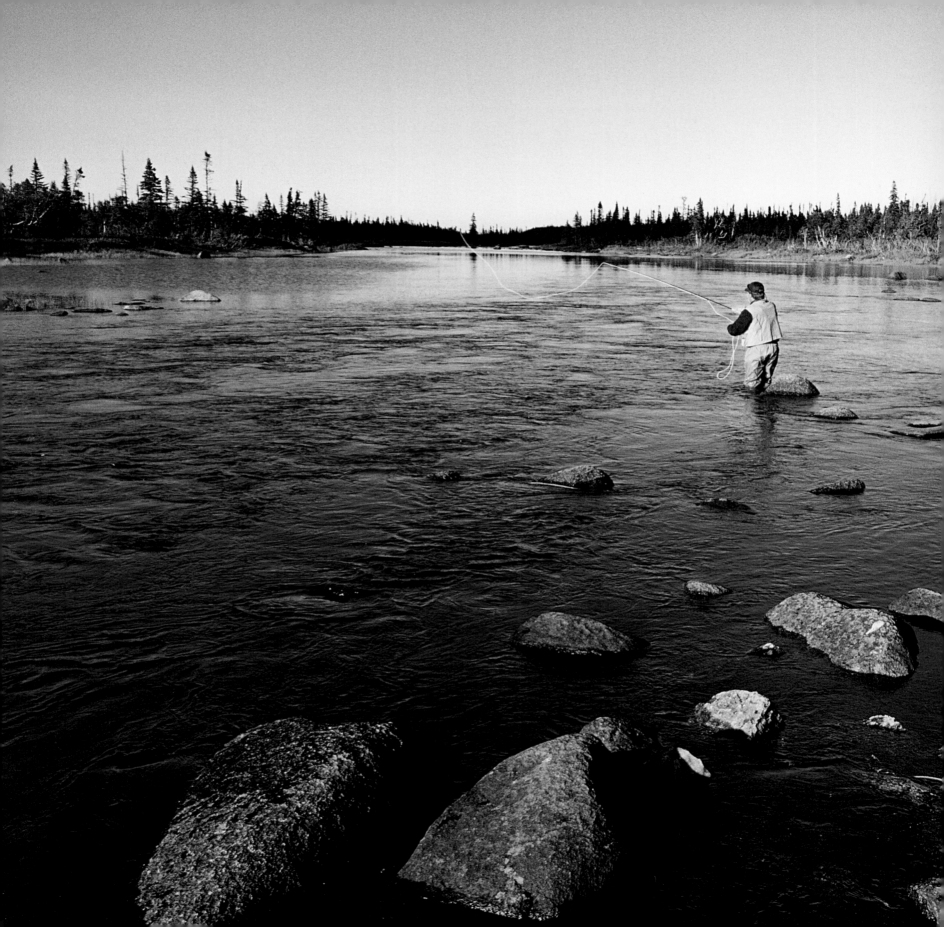

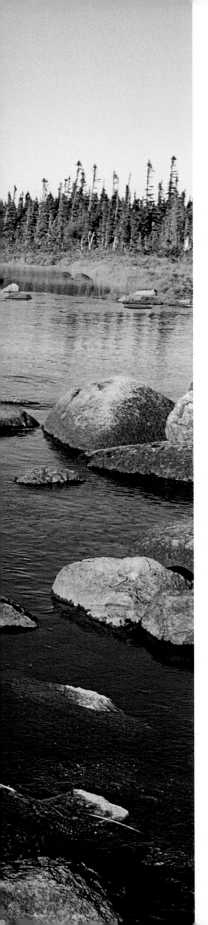

Tuckamore Lodge

Newfoundland's Northern Peninsula is a rugged region teeming with moose and bears and home to a network of rivers that holds vast armies of Atlantic salmon. It is here, on the edge of the wilderness, that Barb Genge has built Tuckamore Lodge and Outfitters, a modern fishing, hunting and wilderness adventure service. In fact, there are so many activities offered that visitors seldom spend their entire stay pursuing any single one. In addition to fishing, hiking, hunting and whalewatching, there are several day trips to various sites of historic interest and natural beauty. Among these is Gros Morne National Park, a landscape of mountains, fjords and scenic coastline which, because of its geological significance, has been designated a UNESCO World Heritage Site. That puts it on par with the Grand Canyon. The same honor has been bestowed upon L'Anse aux Meadows, the only authentic Viking settlement in North America. There is much more to this beautiful part of the world than one would expect.

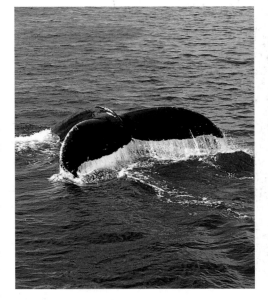

The population of Newfoundland is distributed primarily along the coastline, leaving large areas of the interior uninhabited. This reflects the province's strong ties to the sea and its former dependence on a maritime economy. Following the voyages of John Cabot to this area at the end of the fifteenth century, fishermen from several European nations spent the summers harvesting vast quantities of cod, herring and whales for their home markets. The Treaty of Utrecht, in 1713, established British title to this

A lone angler fly-fishes for salmon on the Salmon River, which flows through Newfoundland's Northern Peninsula into the Atlantic Ocean. INSET Humpback whale-watching — the varied side trips are an integral part of the Tuckamore experience.

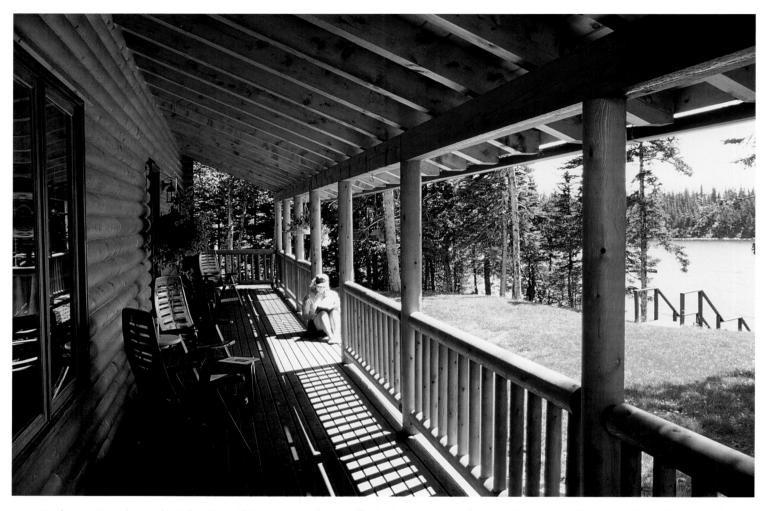

Tuckamore's main porch catches the midday sun and always affords the anxious angler a scenic view of well-populated Southwest Pond.

island, so that by 1800 most foreign settlements had been abandoned. Newfoundland joined Canada in 1948, but most Newfoundlanders remain fiercely proud of their Irish and English ancestry. They have endured hardship time and again, but are a proud and resilient people. They are also the friendliest souls you will meet anywhere in the world, and their hospitality is nothing short of legendary. First-time visitors are not strangers for long.

Barb Genge is a remarkable woman who may be physically slight but is large in stature and utterly fearless. The name of her lodge, "Tuckamore," is actually a Newfoundland term for the stunted balsam, fir and spruce trees that grow in alpine areas and along the coast. The stark, weathered profiles of the trees reflect a degree of tenacity that Barb no doubt identifies with. She has spent her entire life championing Newfoundland's great Northern Peninsula. After being

22

appointed the local economic development officer for the communities around Main Brook in the early '80s, she packed in her job as a fish broker. This new work presented several challenges that she relished and introduced her to the formidable battlefield of provincial politics. Through her work she quickly realized that the commercial cod fishery that had sustained previous generations was dying, and that the people would have to adapt or sink.

Barb's husband at that time was a bush pilot who flew foreign hunters into various outfitting camps. Barb was not only able to eavesdrop on their conversations, but to actually visit the establishments they were talking about. If the enthusiasm of the sports made a strong impression, so too did the poor quality of the existing camps. "Most of them weren't fit for humans," she thought, confident that she could provide superior accommodation and service. The outfitting business also appealed to her on another level, as it was sustainable, employed local people and brought tourist dollars to Newfoundland.

Members of the provincial government were horrified. Not only were they quite content with the status quo, but the prospect of a woman with virtually no experience meddling in the male-dominated world of hunting was simply outrageous to them. Accommodating the fishermen was a less contentious issue, however, as the government had never valued this resource. (Most Newfoundlanders will tell you it still does not.)

Barb stuck to her guns, building the lodge in 1986 and welcoming the first guests the following year. When

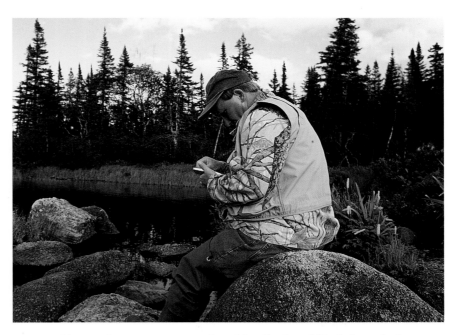

Guide Brendan Murray contemplates his collection of flies before selecting a Salmon River favorite, the tried-and-tested Thunder & Lightning.

she parted company with her husband during that first year, her detractors rubbed their hands and eagerly awaited Tuckamore Lodge's demise. It never happened. The hospitality, food and accommodation were very popular with hunters, and soon fishermen were also discovering the delights of the lodge and the appropriately named Salmon River, which meets the sea just over a mile from the lodge. When Barb signaled her intent to diversify further and offer whalewatching to her clients, the government protested once more, claiming that it was insanity to have hunters, fishermen and "non-consumptive" guests under the same roof. Once again they were forced to eat humble pie. Today, Barb has expanded the lodge's repertoire even more to pastimes such as birdwatching and snowmobiling. Only fourteen years after its inception, Tuckamore now enjoys an international reputation.

Because of the various activities available, we limited ourselves to four half-day fishing expeditions and spent the rest of our time in the able hands of Shanna, Barb's right-hand woman, top tour guide and canny entrepreneur in her own right. The cultural eye-opener was a visit to the L'Anse aux Meadows Viking site. Discovered by Helge and Anne Stine Ingstad in 1960, its sod buildings are the earliest known European structures on the continent, and its smithy the site of the first-known ironworks in the New World. Shanna marched straight to the information desk and promptly had a flushed Parks Canada interpreter treating us to a riveting tour. The layout of the village was explained, as were the shocking eating and sleeping arrangements.

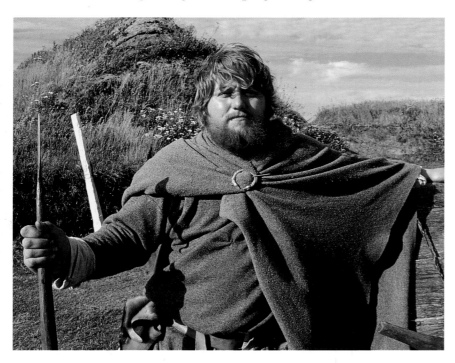

Tuckamore guests can visit L'Anse aux Meadows, North America's earliest known European settlement and a UNESCO world heritage site. At Norstead, a replica Viking settlement a stone's throw away, a colorful ensemble of actors reenacts life as it was a thousand years ago. OPPOSITE PAGE *Looking out at Southwest Pond on Newfoundland's Northern Peninsula.*

The stereotype of warriors continually feasting and pillaging is a far cry from what went on here; however, these intrepid Norsemen did have the distinction of being the first Europeans to catch Atlantic salmon in the New World. According to the Norse sagas, *Salmo salar* were taken from Black Duck Brook, the tiny waterway meandering through the settlement. Unfortunately, there is no mention of this ancient strain falling to flies.

Another entertaining distraction related to the island's Viking heritage is Norstead, a replica Viking settlement hosted by actors in traditional Nordic garb. As president of the Viking Trail (which stretches from Deer Lake, at the base of the Northern Peninsula, to Battle Harbour, in Southern Labrador, and features various tourist attractions), Barb was instrumental in its realization. Created in 2000 to mark the thousandth anniversary of Leif Ericson's epic journey across the North Atlantic, Norstead provided an interactive experience with attitude. Shaggy brutes cursed as we struggled to master the tricky art of axe throwing, while Don, our trusty photographer, managed to attract hoards of Viking maidens with his beard (and charms). I was so engrossed in thought after having my runes read that I left my camera behind in the soothsayer's tent. Fortunately, Scandinavians are an honest bunch and it was still there an hour later.

During our stay we were fortunate enough to enjoy a couple of scenic coastal boat tours. The first was a productive whale-watching excursion out of St. Anthony, near the tip of the Northern Peninsula. But the

hands-down winner was the one out of Conche, a picturesque fishing hamlet an hour south of the lodge. Barb had repeatedly told us, "Just wait 'till you see Conche," and sure enough, when the van reached the top of the fjord the vista that greeted us was postcard perfect. Shanna dropped us off on the quay and introduced us to Paul Bromley, a commercial fisherman who has run boat trips on his 36-foot-long liner, *Bromley's Venture*, since the collapse of the cod fishery. Despite his gruff exterior and vice-like handshake, he

was, like every Newfoundlander we met, incredibly friendly and very talkative. His intention had been to take us directly to Puffin Island, a seabird colony, but having already been on one whalewatching expedition, we were soon hollering, "Thar she blows!" Paul obligingly spent an hour following numerous finback and humpback whales.

After this enthralling detour we proceeded to Puffin Island, where we saw hundreds of these comically somber-looking birds, as well as cormorants, kittiwakes,

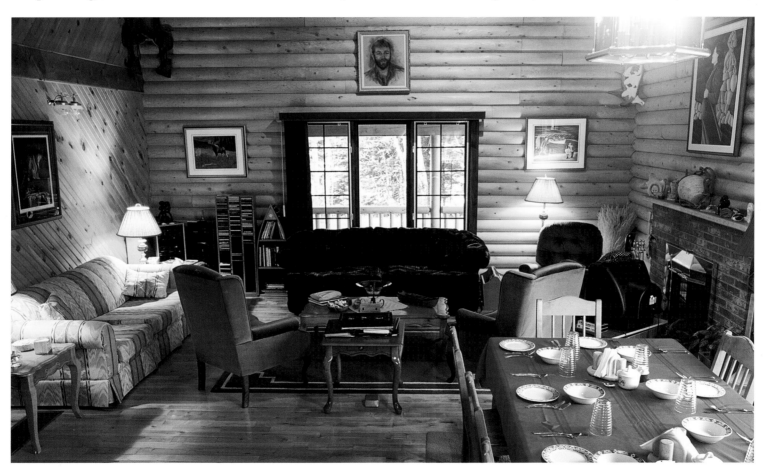

Tuckamore's cozy living room is tranquil during the day, but after dark often plays host to the raucous "Screech In,"
a ceremony that grants visitors unofficial Newfoundland citizenship after, among other things, kissing a frozen cod,
reciting Newfoundland jargon, and downing a shot of Screech, a powerful Newfoundland rum.

geese and gray seals. Paul then motored over to the cliffs of the coast and stopped a couple of times to jig up a cod while we soaked in the scenery. Had we been on his boat in June or July, we could have sidled up to an iceberg, cracked off a bit and sampled the purest water on earth.

There are two lodges at Tuckamore. The original lodge is a pine A-frame, while its new neighbor is an attractive Scandinavian-style chalet constructed from Nova Scotia white cedar. Both blend into the spruce-lined shore of Southwest Pond (a lake in any other part of Canada). Inside these buildings is a sizeable collection of artwork, including a giant 8-by-5-foot Viking scene,

Dappled sunlight caresses the white cedar walls of the guest chalet.

outdoor landscapes and hand-carved sculptures. The chalet-like atmosphere is so relaxing and inviting that Barb has even added a honeymoon suite for adventurous newlyweds.

In the evenings, new friends chat and pass wine around the communal dining table before trooping out onto the porch to observe the heavens. The group expeditions foster a sense of camaraderie, as does the weekly in-house concert that Barb arranges to introduce her guests to Newfoundland music. I am sure the "Boys from Conche," as Barb affectionately calls them, have converted many people. Flutes, guitars, banjos, accordions, fiddles and haunting voices captivated everyone. Laughter one moment and tears the next — it was powerful stuff. After the applause and an encore, their ringleader, Austin Dower, leapt up and presided over the "Screech In," a ceremony that would let us join the Royal Order of Screechers and enter into the brotherhood of Newfoundlanders.

Incidentally, Screech is the liquid fire that passes for rum in Newfoundland. There are certain tasks to be completed for qualification. The first involves pledging allegiance to Newfoundland, next is kissing a frozen cod on the lips, and the third is knocking back a generous amount of Screech, which sets people up for the final hurdle. This is especially tricky, as you have to repeat a Newfie phrase after the master of ceremonies, who tries to make it as unintelligible as possible. Everyone howled with delight as friends mumbled gibberish and were forced to have yet another of the good stuff!

Tuckamore Lodge overlooks Southwest Pond, which is a small link in the Salmon River's watershed. The Salmon River itself is so idyllic that simply gazing at its waters was sufficient to convince us of our impending success. Each year, 10,000–12,000 salmon return, an enormous number for a modest-sized river. Such is the lack of fishing pressure that only 1,000 salmon were

27

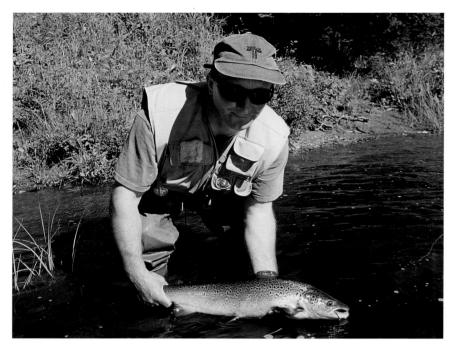

*Twelve thousand salmon a year return to the modest
yet appropriately named Salmon River.*

landed in the year 2000. Eighty-five percent of these
were grilse, but thanks to the moratorium on commer-
cial salmon fishing in 1993, every year sees more
trophy fish on the ends of lines. The river owes part of
its health to Barb, who initiated a major habitat
restoration project along its length. A group of volun-
teers, ably led by Michael Van Zyldejong, a biologist
working on his fisheries doctorate, restored nesting
sites, removed thousands of cords of pulpwood and
over 1,500 bags worth of garbage from the riverbanks.
To look at it today one would never know that it had
been desecrated on such a large scale. With Barb as its
unofficial guardian angel, you can be sure that every-
one now treats this precious resource with respect.

Hot, dry conditions had slowed fishing in the weeks
leading up to our arrival, but on this occasion the gods
were smiling and let loose a modest storm
just prior to our arrival. This raised the river
and stirred up the fish, though it did necessi-
tate a little detective work on the part of
Brendan, our guide, as the fish had shifted
from their previous holding spots. He was
more than equal to the task and took us to a
gentle set of rapids on our first evening. So
many fish were rising that it was impossible
to target a specific one, and in the excitement
I neglected to cover the water in a methodical
fashion. That, or I selected completely the
wrong fly. Thankfully, my trusty partner was
on better form and hooked a grilse just before
dusk, after I relinquished the hot spot.

The next morning, Brendan drove us to
a classic pool farther up the Salmon River,
but still just a fifteen-minute drive from
the lodge. On our brief trek in we bumped
into a cheerful couple who claimed that they were
through for the day, as not only had they not caught
a fish, but they had not seen one either. Once they
were out of earshot, Brendan confidently told us that
they were either liars or terrible fishermen or both.
This beautiful run of about 150 yards has a series of
rapids and small pools stretching several hundred
yards above it. The fish had been holding at the tail of
the pool, but with the changing water conditions,
Brendan informed us that the fish could be anywhere
and were probably everywhere. I marched up to the
base of the rapids, tied on number ten Thunder &
Lightning and let rip.

The air was sweet after a light shower, and the
water in front of me too perfect not to provide sport.
My confidence was justified, and a 5-pound grilse

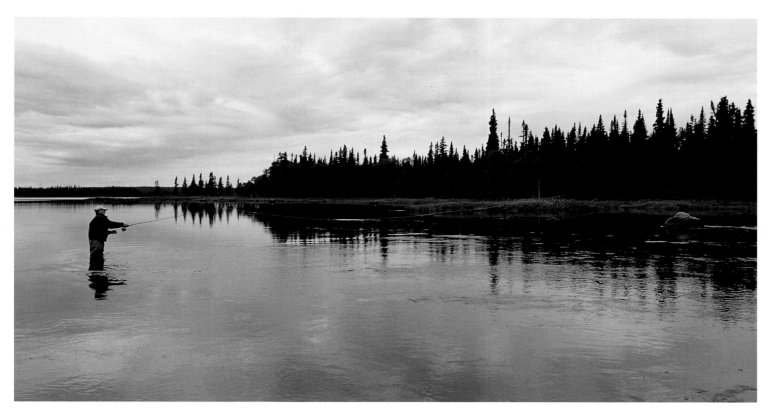

The Salmon River owes part of its health to Barb Genge, owner of Tuckamore Lodge, who initiated a major restoration project along its length. Thousands of cords of pulpwood were removed from its bed and banks, restoring the river as prime salmon habit.

soon pounced on my fly. The strong current added gusto to the fight, but eventually the fish tired and was ready to be photographed. Unfortunately it did not know of our benign intentions, because it made a desperate but ultimately and successful lunge for freedom just as Don, our photographer, was setting up. As luck would have it, a 7-pound salmon holding on the exact same spot obliged moments later. This was a more powerful fish that charged into the rapids before somersaulting out of them, and my reel sang joyously several times before the salmon submitted. This one did not escape the close attention of Brendan until Don stopped snapping.

The salmon season stretches from June 15 to September 7, after which hunting moose and bear becomes the main focus. We had a fair amount of success in late August, but all the guides informed us that July is really the prime month. Tom and Brendan, our guides, were fonts of knowledge and patience. Their words of encouragement, combined with a few gentle ribbings, added flavor and fish to our trip. We cannot think of better people or a better place for the inexperienced or uninitiated to get their first taste of the power of Atlantic salmon. But that's not to say that seasoned anglers won't enjoy themselves too, as ten hook-ups a day is not uncommon during peak times.

29

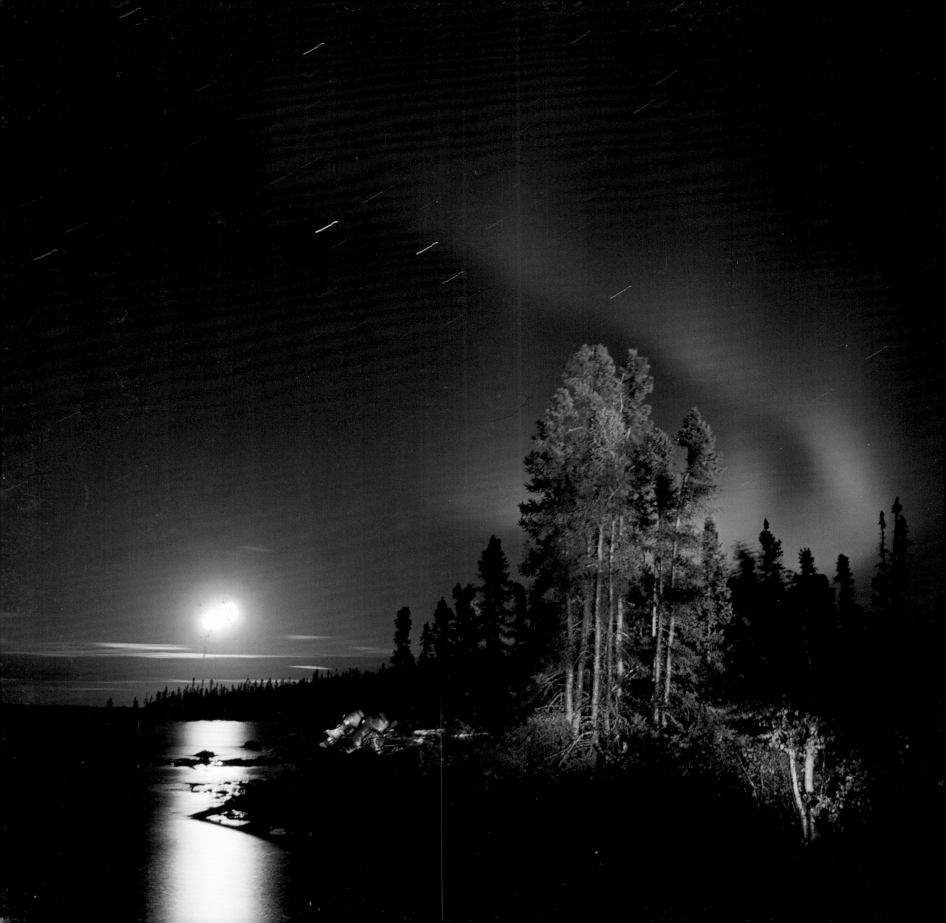

Selwyn Lake Lodge

Saskatchewan is known as the breadbasket of Canada. Of its 140 million acres, 65 million are given over to agricultural use, more than in any other province. As one travels north, seas of wheat give way to ranches and finally to the beautiful, yet unforgiving, forests and lakes of the Canadian Shield. At the top of the province, even trees struggle to survive in an environment where the average winter temperature is -20 degrees F. This harsh climate is its saving grace, protecting it from large-scale development and leaving it in an almost pristine state. It's here that Selwyn Lake Lodge welcomes a select number of anglers every summer to sample some of the finest trophy pike, lake trout and grayling fishing in Canada.

Most of the staff at Selwyn Lake Lodge hail from Black Lake, a Dene (formally known as Chipewyan) community about 90 miles away. The Dene have lived in the area for the last 700 years, though a number of distinct cultural traditions have occupied Black Lake discontinuously since 6000 B.C. *Chipewyan* is a Cree word, and literally translates as "caribou eaters," a reference to the Dene's almost total dependence on this plentiful animal. As the Beverly or Kamunuriak herds spent their summers on the tundra of the North and the forests around Selwyn in the

Midnight magic — the otherworldly northern lights spiral around the moon as it rises over Selwyn Lake, Northern Saskatchewan. INSET *Morning greetings at Selwyn Lake Lodge on Snowshoe Island.*

31

winter, so too did the Dene. This stable source of food, clothing, shelter and tools made the Dene self-sufficient and independent relative to the Cree, who came to rely on the fur trade after European contact. Some of the Dene did become trappers, but most continued to "live like the caribou" well into the twentieth century, keeping the culture and identity intact.

There are several historic sites of Dene occupation around the shores of Selwyn Lake that can be identified today. These were rest camps, fishing or berry-picking spots and strategic locations for intercepting the migrating caribou. There are also numerous graves that can be found dug into sand eskers, evidenced by wooden picket fences, small houses or crosses. These are powerful reminders of a proud people who continue to thrive in this tough environment, and make for interesting side trips for inquisitive guests.

In Selwyn's Lake Lodge's lounge, guests sip cocktails and share stories under the watchful eyes of big-game trophies, which include an extremely rare silver pike.

Gord Wallace and his wife, Mary Daigneult-Wallace, built Selwyn Lake Lodge in 1993. Gord was born in Ontario and started his working life with the Thomson Newspaper Group in Toronto. After fourteen years in the city, his yearning for a change in lifestyle became irresistible and persuaded him to pack his bags and buy a fishing and hunting lodge near La Ronge, Saskatchewan. A brave decision for some, but a natural one for Gord, who discovered that not only did he enjoy the outfitting business, but he was also good at it. Over the next twenty years he set up and eventually sold several camps that still flourish to this day, all in northern Saskatchewan.

Selwyn Lake Lodge was the realization of his greatest goal — the creation of a high-end fishing lodge in an unspoiled part of Saskatchewan. His appetite for the business was as strong as ever, but he wanted to nurture something in which his entire family could participate and one day take over. During previous reconnaissance missions over the rugged landscape of the Canadian Shield, he had become acquainted with Selwyn Lake, a vast and untouched body. He was convinced that it could provide the setting and quality of fishing that committed fishermen had come to expect. Having obtained a commercial license, he immediately sought out the handful of people who would know the area intimately, namely local Dene trappers. Gord is quick to emphasize that a crucial factor in his success as an outfitter has been his partnership with Native communities wherever he has conducted business.

Through the Black Lake Band office he met Leon Cook, who has spent most of his

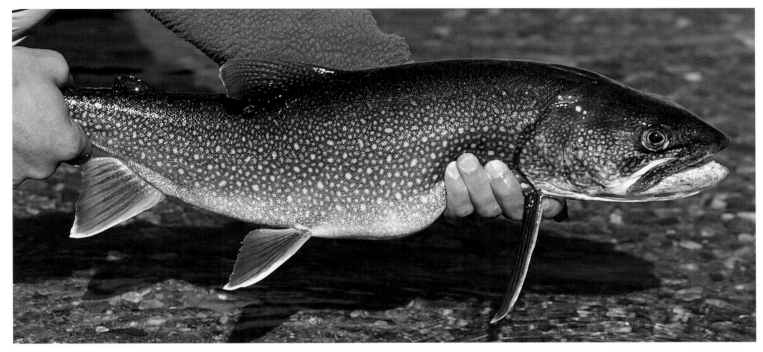

A young lake trout poses graciously for a photo before being released. During the summer months, lake trout move to deep water, rising again in the fall in the tributaries and along the shoals of the their home lakes. Lures such as Williams Wablers, Lucky Strikes and the legendary Daredevle Five of Diamonds often prove irresistible to Selwyn's lake trout.

life working in the vicinity of Selwyn Lake. It was Leon who suggested the present site on Snowshoe Island (so called because a trapper's dog team ate his snowshoes while he was camped there) as the most suitable location for the lodge. On a rocky island, guests experience far fewer mosquitoes than they would on the mainland. The lodge is also shielded from the prevailing northerly winds by a hill, which not only creates a slightly warmer microclimate, but also protects the wooden docks from ice floes in the spring and provides a safe harbor for Gord's floatplane.

Construction of the lodge was completed in 1993. As Gord envisaged, his son Nigel and daughter Becky rose to the challenge and took on positions of responsibility around the camp, as well as learning the ropes

of management. Despite developing a healthy client list, Gord was very conscious of the need to remain ahead of the competition, and it was with this in mind that he sold half of his interest in the lodge to Jim Yule, chair and CEO of PIC Investments Inc., in 1996. Jim and son Greg's involvement has brought sharp business acumen and a fresh perspective to this family affair. At his suggestion, separate gourmet and pastry chefs were introduced in 1998. The following year, the main lounge area underwent an ambitious expansion to accommodate corporate groups.

Our guide at the lodge was none other than Leon Cook. At fifty-nine years old, Leon is an outspoken firecracker of a man. A trapper for most of his life, he had also been the chief of his community for several

33

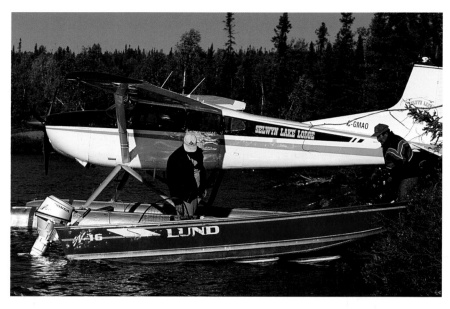

Floatplane fly-outs to neighboring lakes give guests the opportunity to fish waters that see only a handful of anglers a year.

laugh was put on hold and he would solemnly leave an offering, usually a leafy birch branch, as a sign of respect.

On the water, Leon was interested in two things: educating us in the ways of his people and catching fish. Large lake trout are the ultimate quarry as far as he is concerned, and chasing after lesser fish, while fun, is really a waste of time. The record lake trout caught (and released, as all trophies are) on Selwyn Lake is 56 pounds, and every year guests catch a few specimens in the high 40s and hundreds over 20 pounds, the minimum size for a trophy.

Selwyn Lake covers 135,000 acres and straddles the 60th Parallel so that two thirds of it is actually in the Northwest Territories. This far north there is stark beauty all around, whether in the stunted spruce trees that stretch to the horizon, or the tired hills still stubbornly resisting the elements. The most curious features to be found in this landscape are the boulder gardens dotted around the lakeshore. These are created by ice floes pushing 1,000-pound rocks off the lake bed and are a constant reminder of the brutal winters that are experienced up here. But despite the high latitude, the summer sun is still powerful enough to warm up the lake's unbelievably clear water, necessitating the use of weights or downriggers to present lures at depths where the water is cooler and the big lakers feel comfortable. During the spring and autumn these tactics are not required, as the fish hold around the shoals. At the beginning of September, casting over shoals did work, but trolling at depth was far more productive, as the bruisers were still foraging at about 30 feet.

years, a position that brought him face to face with the Pope, Queen Elizabeth and Pierre Trudeau. He has never received a formal education, owned a map or a compass, but he knows every plant and animal and every shoal, bay and fishing hole on Selwyn Lake.

His knowledge is complemented by his gift for storytelling, which he made full use of by regaling us with Dene legends and tales from the recent past. During our numerous expeditions he took great pains to point out countless Native landmarks and patiently explained the reasoning behind their names and what beliefs were associated with them. Included were the site of the winter festival; an island where vast numbers of Dog-Rib Indians were massacred by a bereaved Dene warrior; and the final resting place of Chief Piche, who signed the last treaty in these parts. On those occasions when he took us to one of the many gravesites scattered around the lake, his infectious

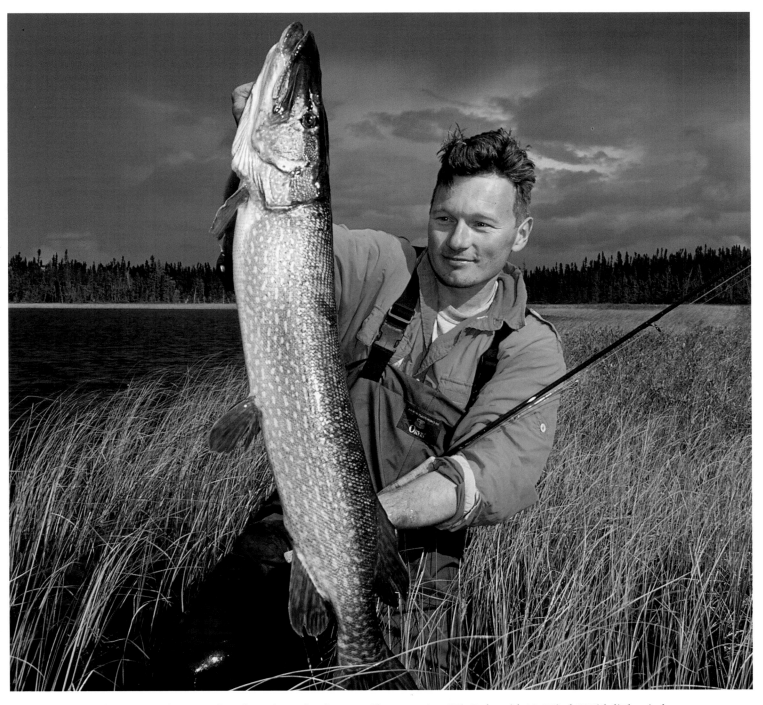

The Dene Native name for Selwyn is Hochaghe Tue Cho, *meaning "Big Lake with No Wind." With little wind,*
clear water and countless reedy bays, the lake provides excellent sight-fishing opportunities for trophy pike.

We caught dozens of beautiful fish every day, but only a handful in the trophy range throughout our stay. One day, Gord flew us about twenty minutes south to Bompass Lake, one of the many fly-out lakes accessed by the lodge. Its topography varies between cliffs and sandy beaches.

Shore lunches were fascinating and delicious. In addition to always having the perfect spot in mind, Leon was a master woodsman. Despite his wiry frame he could fell trees and split logs like Paul Bunyan. In addition, we had never witnessed a guide with such a deft hand when producing a boneless fillet from any species. He could easily have been a surgeon. The fish was always cooked to perfection, whether in a frying pan or roasted over an open fire in the traditional Dene fashion. While he was cooking, he would predict the weather for the afternoon, point out plants used for traditional medicines or poultices and talk excitedly about the big fish we were sure to catch.

Although lake-trout fishing took up the bulk of our time, other guests were enjoying outstanding success on the pike-fishing front. Ed and Lindy, a thrill-seeking couple from New Mexico, had come to Selwyn to test their homemade flies on these toothsome predators. Their guide for the week was Dave, a wizard with a fly rod and an all-star member of Gord's staff. He estimates that when it comes to pike fishing in September, flies outfish gear by a ratio of five to one. The Dene name for Selwyn is *Hochaghe Tue Cho,* or "Big Lake with No Wind." This is a fairly accurate description and is no doubt due to the numerous islands that carve the lake up into a bewildering maze of

Pike feed voraciously in the fall in preparation for the long winter ahead.
This may lead to some of the heaviest specimens being taken at the end of the season.

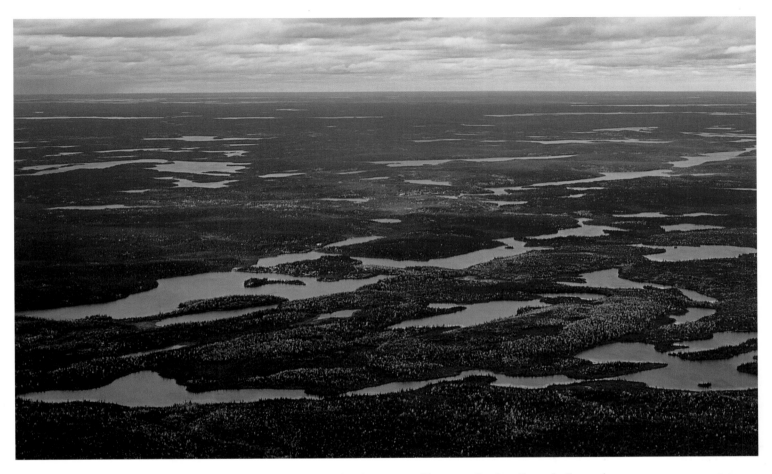

The endless wetlands of Northern Saskatchewan provide a paradise for pike and pike anglers.

deep bays and inlets. This provides not only sanctuary from the wind for fly-fishing, but also an incredible amount of structure for fish to forage around.

Ed and Lindy went home with twenty Polaroids bearing testimony to fish over 40 inches, but not before they "loaned" us a few of their creations. We put these to good use, catching dozens of pike in one day, including a couple of trophies. One of our party hooked a 42-incher, in peak condition, right next to the boat. The sight of its massive gills flaring as it inhaled the fly is something we will never forget. After

the take, it shook its head like an angry lion before practically setting the reel on fire as it shot into a weed bed 20 yards away.

Early September is a busy time in the North. The leaves of birch trees become more brilliant by the day, protective lake trout preparing to spawn chase lures right to the boat, and geese, instinctively knowing that the time has come, head south in giant raucous formations. Amid this hive of intrigue and activity, Selwyn Lake Lodge is an oasis of comfort and calm —a diamond-in-the-rough beauty of northern Saskatchewan.

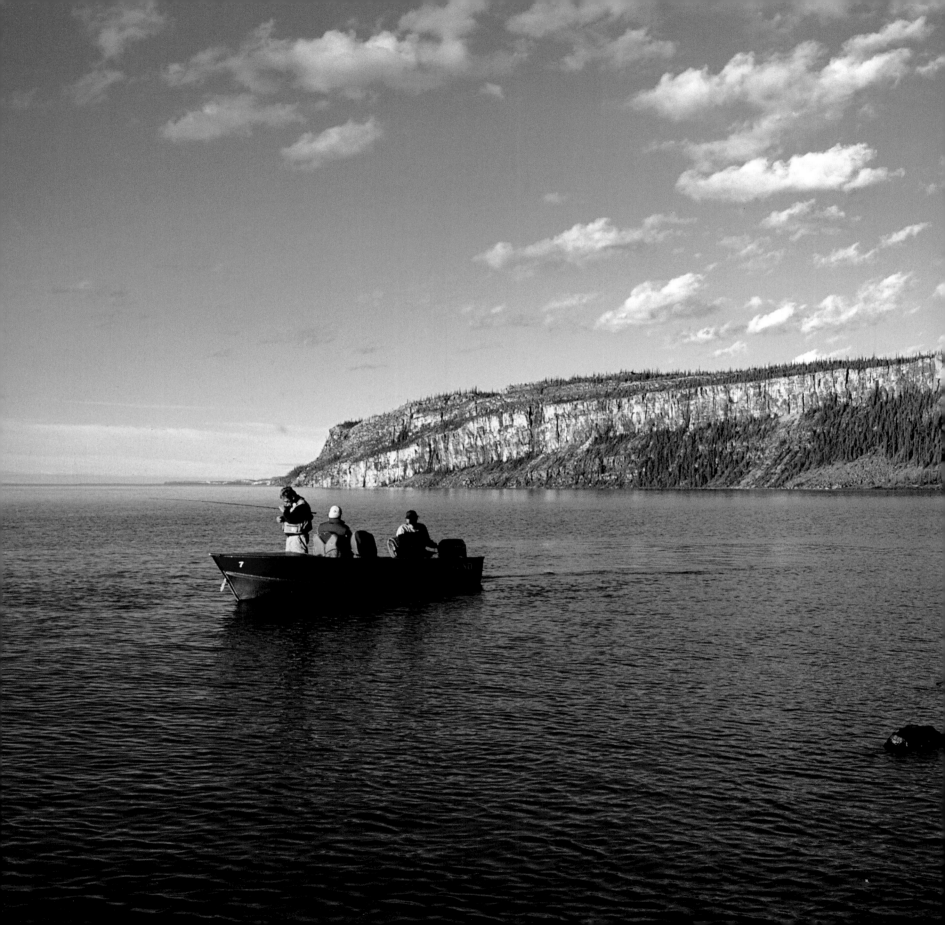

Plummer's Great Slave Lake Lodge

The most sought-after game fish in Canada's Far North is the lake trout, a creature that fights hard, makes a delicious shore lunch and can achieve epic dimensions. Specimens over 100 pounds have been reported in the nets of commercial fishermen, and in 2001 Kerrilyn Laing from Winnipeg landed a world record 74-pound leviathan by more sporting means. Many consider these fish to be "big game." For over fifty years Plummer's Great Slave Lake Lodge has been catering to adventurous souls who venture to the Northwest Territories. It's a beautiful part of Canada that still offers fantasy fishing throughout the summer.

The natural distribution of lake trout closely follows the limits of Pleistocene glaciation, which includes to most of Canada, but surprisingly few locations provide the necessary conditions for monsters to thrive. Great Slave Lake is one such place. Covering 10,000 square miles, it is the second-largest lake entirely in Canada and the deepest in North America. There is no heavy industry to sully its pure water, a layer of ice shields it for eight months of the year and fishing pressure is minimal. This is just as well, because this far north the ecosystems are relatively poor, resulting in very slow fish growth. Fisheries biologists estimate that it takes ten years for lake trout to reach 2 pounds, after which they put on approximately half a pound per annum. Thus a 50-pound fish is probably over a century old.

Taltheilei Narrows, Great Slave Lake, Northwest Territories. The sheer 500-foot cliffs of the Pethei Peninsula provide a spectacular backdrop to complement one of the world's best lake trout fisheries. INSET A lone wolf emerges from the brush to investigate fishermen as they troll by his territory.

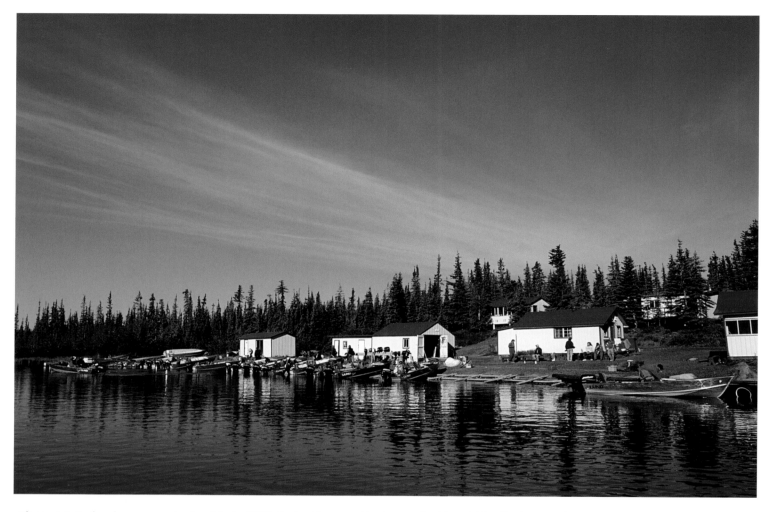

Plummer's Lodges began as a single cabin in 1953. Today, they provide the standard by which all other Northwest Territories lodges are measured.

The entire Northwest Territories lies above the 60th Parallel, and for most of the year is a very harsh land. At the time of European contact, the Inuit, Dene and Dog-Rib cultures inhabited it thinly. Early European exploration of this daunting terrain was part of the futile search for a Northwest Passage to the Orient. A trailblazer in this respect was Samuel Hearne, an extraordinarily resilient employee of the Hudson's Bay Trading Company. During his most notable expedition (1770–1772), he reached the Arctic Ocean at the mouth of the Copper-mine River. On the return journey to his Hudson's Bay post, he crossed a frozen Great Slave Lake in the dead of winter. He is given credit for its unusual name, in fact a simple reference to the Slavey Native people who inhabited the area. *Arctic Dawn — The Journeys of S. Hearne* is an account of this trek and other adventures.

Trapping continued to dominate the local economy and politics until the 1930s, when gold was discovered

near the north arm of the lake, and the bustling town of Yellowknife sprang up to support the rush. Trapping still exists, but the recently discovered diamond deposits have subdued talk of gold. C. C. Plummer, an avid outdoorsman and businessman from Flin Flon, Manitoba, was first drawn to Yellowknife in 1938. A champion shot who would later enter the Shooting Hall of Fame in Minnesota and Manitoba, he was definitely not the sort to pass up a sporting opportunity. During this stay his imagination was aroused by tales of fabulous fishing at a place called Taltheilei Narrows, in the east arm of Great Slave Lake. So glowing were the reports that he dropped everything and promptly organized a sortie. A local Dog-Rib chief, Joseph

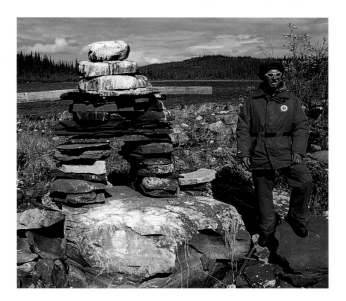

One of the Plummer's guides poses next to an inukshuk, a signpost of the North.

Abell, was his guide, and together they covered 150 miles by canoe with the help of a four-horsepower outboard engine. Fortunately, his intuition was rewarded, and the legends proved to be true: Taltheilei was alive with enormous lake trout.

The success of this initial trip so inspired Plummer that he returned several times over the next decade, bringing along various friends to share the experience. On a couple of these subsequent trips, a collective diary was kept, and one excerpt from 1946 captures the mood perfectly: "Went on a picnic down to Mckinley River. Caught thirty-five grayling. Forgot my landing net with five fish in it. Got home at 7:00 P.M.

and went out and caught fourteen trout. It was a grand day in any man's country."

Plummer's son, Warren, was a trained bush pilot, whose skill they put to good use during the '40s. Together they explored vast tracts of Canada's Far North, constantly searching for hunting and fishing opportunities. In addition to revisiting Great Slave Lake on several occasions, they also discovered a fishery that could rival it — Great Bear Lake.

By the early '50s Warren had set up a floatplane business in Sioux Narrows, in northwestern Ontario. The majority of his clients were fishermen and hunters who used his services primarily in the spring and autumn. During the summer, as the fishing action slowed, so too did his business, but Warren managed to persuade a few loyal customers that he knew of a gorgeous location where the fishing was fabulous throughout the summer — Great Slave Lake. For the first few years, he flew groups of four the incredible distance from Sioux Narrows to Taltheilei Narrows (over 1,200 miles) in a Beaver. Starting very modestly with one permanent staff member and a single cabin in 1953, the camp mushroomed over the next couple of years, demand rising as news of the fishing possibilities spread. Warren's son, Chummy, had his first taste of the business as a thirteen-year-old, helping to float cabins across the bay when the entire camp was transplanted

to its current location on a rocky peninsula. He slid effortlessly into the ranks once finished his schooling, and was running the original lodge at twenty-four.

Today, Chummy heads up the Plummer empire, which moves from strength to strength and now includes six lodges in the Northwest Territories and Nunavut. His father continued to fly into his eighties, but these days is taking things a little easier. According to Chummy, there is no secret to their success: "This is a people business and we treat people real well." He could have added three more secrets: location, location, location.

In addition to being one of the best fishing spots on the lake, the environs of the lodge make up some of the most picturesque shoreline. Opposite the lodge is the Pethei Peninsula, which separates MacLeod and Christie

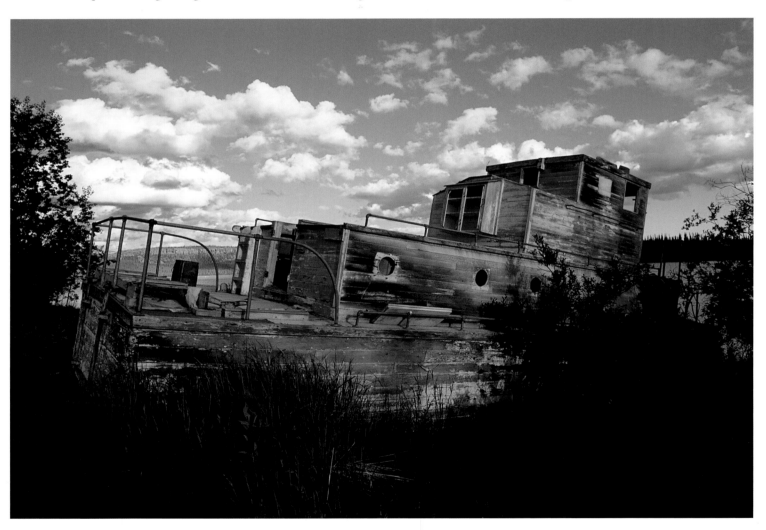

This decaying ship is a remnant of a by-gone era when commercial fishing was permitted on the East Arm of Great Slave Lake. Surrounding it are long-retired wooden guide boats from Plummer's fleet.

Despite an abundance of baitfish, the frigid waters of Great Slave Lake limit the speed at which the fish can grow, approximately half a pound a year. This beautiful lake trout is over 20 years old. Each year, a number of fish judged to be over a century old are caught at Plummer's Lodges.

Bays, the two principal bodies of water in the east arm of Great Slave Lake. This peninsula is part of the McDonald Fault and boasts sheer cliffs up to 500 feet high that run east to west as far as the eye can see. It is simply a stunning backdrop, especially in the evenings when the crimson sunsets cause the cliffs to glow.

Comfortable but modest white plyboard cabins overlook Taltheilei Narrows and the Pethei Peninsula. The main lodge faces east so that the morning sun lights up the lounge area and illuminates the trophy list. This is strategically located next to the bar and features every lake trout over 20 pounds and every pike over 40 inches. The number of trophies brought to the boat every day is quite staggering.

Though the fishing is very good, not every fish is a trophy. In fact, the average size is roughly 8 pounds, but even a novice angler can expect to hook at least fifteen fish per day. Every moment in the boat is spent either playing fish or on the edge of your seat anticipating the next strike. Because the water is so cold and well-oxygenated, the fish are comfortable at all depths. This

has tremendous implications on the sporting manner in which these fish may be played, as weights are not necessary, leaving the fish to fight unencumbered. But the lake is huge, and the most effective method to cover the most water is by trolling, either with large spoons or baited jigs. For some reason the baited jigs are more popular here, but spoons are reportedly more effective up on Great Bear Lake. Stationary jigging over structures is also possible, and this was how we picked up our largest fish.

Just as with C. C. Plummer back in 1938, our most memorable piscatorial encounters occurred right in front of the camp, in Taltheilei Narrows. With twilight stretching to 1:00 A.M. there is plenty of time to fish after dinner, and nearly all the guests headed off to distant hot spots they had discovered during the day.

The previous evening we had noticed some frenetic seagull activity nearby and had decided that it must have been a feeding frenzy. (Why we didn't venture out then is still a mystery to me.) After an hour of mosquito bites and frustratingly few fish, we were ready to

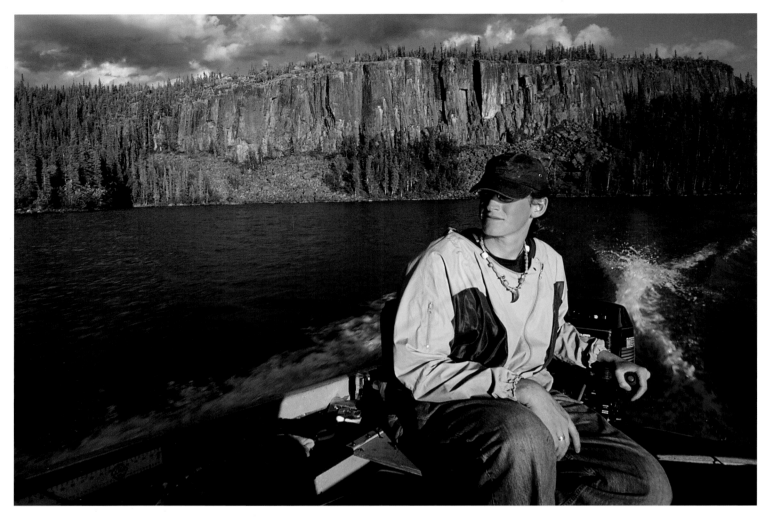

A guide motors away from sheer cliffs that are part of the geologic feature known as McDonald Fault. Great Slave Lake
is the second largest lake located entirely in Canada, covering 10,000 square miles, and the deepest in North America.

call it an evening. But all of a sudden the seagulls took to the fiery sky and started to dive-bomb the water. We raced over to make a closer inspection, only to catch glimpses of some very large dorsal fins breaking the water and baitfish scattering in every direction. Barely able to contain our excitement, we cast our jigs into the thick of the action. Over the next hour we discretely followed the seagulls back and forth through

the almost-tidal current of the narrows. Seven fish, all topping 15 pounds, were landed to whoops of glee, though we lost several more. These were noble warriors, battling to the last, and with the scenery, dappled lighting and company, it was as close to fishing perfection as we came all summer.

We were relieved to find that the quality of guides has dramatically improved since Samuel Hearne's era.

Thankfully, war parties and shooting all the wildlife in sight have gone out of fashion. Our guides were professional and flexible, and even had the intuition to suggest some scintillating side trips. One non-fishing highlight was climbing an 80-foot cliff to peer inside a bald eagle's nest. Two huge chicks panted in the sun while we excitedly burned several rolls of film. Though we were an appropriate distance from her children, we grudgingly beat a hasty retreat when mum arrived on the scene. A spine-tingling encounter!

Another first for us was the shore lunch to end all shore lunches. Unfortunately, these don't happen every week, but our trip coincided with Bob Engle's birthday bash at the appropriately named Bob's Bay. Originally from the U.S., he pioneered commercial aviation in the Far North, then sold his operation to First Air, the main carrier in northern Canada. He swears by Plummer's and regards this part of the world as his spiritual home. After years of practice, organizing food for fifty people did not phase the staff at all, and in no time we were munching on fresh corn, steaks, walleye fillets and an assortment of salads. Beer, wine and Champagne washed down these delicacies. Despite some boisterous suggestions from Grant, the amiable camp manager, a birthday dunking in the lake was unfortunately not in the cards.

An option that we foolishly passed over was a fly-out. These are for people who want to catch vast numbers of pike and walleye. One father-and-son team who, by their own admission, were

modest fly-fishermen, caught dozens of pike, including four topping 40 inches. The star of the show during our visit was a Texan who landed a 68-pound fish on 8-pound test. A regular at the camp for many years, he casually remarked that it was almost as big as one he had caught three years previously. We were far more excited about the catch than he was. Apart from shore lunch, all the fishing is catch-and-release only, so that one should still be around next year.

For the moment, Great Bear Lake hogs the limelight with its recent world record. But Great Slave Lake also holds a few aces. The scenery is spectacular (and below the tree line), the weather is better and wildlife sightings are common. The lodge is also close to prime fishing grounds, and with the warm hospitality thrown in for free, guests are definitely onto a winner.

Safe in their cliffside nest, a pair of bald eagle chicks awaits their next meal.

The Silver Hilton

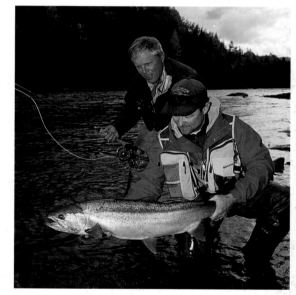

The debate over what, exactly, steelhead are rages on. Most scientists and anglers believe them to be sea-run rainbow trout, but a knowledgeable and vocal minority insists that they are more akin to salmon and should be classified as such. What everyone does agree on is that they are the finest game fish found in the rivers of Canada's west coast. The tributaries of the mighty Skeena River, which drains a sizeable portion of central British Columbia, are home to wild steelhead of a caliber that is found nowhere else in the world. It is on one of these magical tributaries, the Babine River, that the Silver Hilton offers fishermen the opportunity to sample the best of the best.

The Silver Hilton was originally constructed in 1983 by Bob Wickwire. "Babine Bob," as he is affectionately known, was lured to this part of British Columbia from Oregon in 1961. For someone who loved to fish and hunt and whose only post-secondary education was in fly-tying and rod-building, the "fisherman's paradise" described in an article featured in *Field and Stream* had to be investigated further. It was love at first sight for Bob, and that same year he and a friend from his high-school days bought the "Last Resort," on the northwestern arm of Babine Lake. Clients were scarce that first year, but after his marriage to Jerrie Lou back in Oregon during the off-season, things changed for the better. Two years later he bought a lodge at the head of the Babine River, and following the

The Babine is one of only four rivers in British Columbia to have its entire length designated as a class one trophy river, which in this case is defined as providing "trophy steelhead fishing in an unspoiled wilderness environment."
INSET *Owner and conservationist Stephen Myers admires his first fish of the morning.*

47

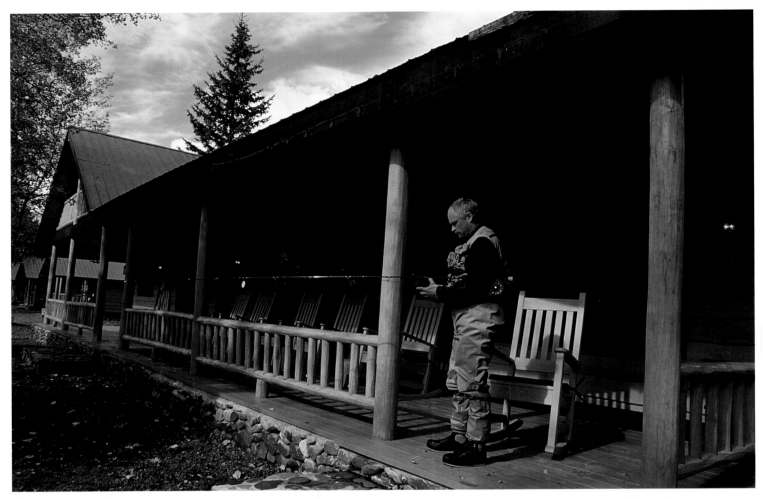

Guide Jud Wickwire checks gear on the front porch in preparation for running the river. Jud's parents, "Babine Bob"
and Jerrie Lou Wickwire, founded the Silver Hilton. He has the distinction of catching a 25-pound steelhead
at the age of four, guiding at age six and driving jet boats at age twelve.

advent of the jet boat in 1966, he built the river's first lodge — the Babine River Steelhead Lodge.

It was as much the excellent service provided by the entire Wickwire family as the high-quality fishing that started the Silver Hilton's reputation as one of the finest lodges in North America. Jerrie Lou served meals that guaranteed guests' unwavering allegiance, while Jud, their son, pulled his weight from an impossibly

early age. He caught a 25-pound steelhead at the age of four, was guiding at six and driving the jet boats at twelve. The Wickwires decided to retire in 1997 and began looking for a buyer.

They found the perfect new owner in 1998 when Stephen Myers, an American businessman from Palm Beach, Florida, purchased the lodge. Stephen had spent most of his working life in self-imposed exile from

riverbanks until a friend rekindled his love of fishing in the early '90s. The Atlantic salmon fishing that he experienced gave him a taste of their majesty and fighting qualities, but in his opinion these occurrences were too few and far between on the rivers he visited. After voicing his misgivings, someone suggested that he should think about steelhead fishing in British Columbia, as they were just as big as salmon, more plentiful and, most importantly, eagerly took flies — even dry flies. Being a man of action but precious little spare time, he arranged for a friend to investigate the matter further. A short list of properties and lodges was drawn up for him to visit. And, just as Bob Wickwire had been some thirty-seven years previously, Stephen was overwhelmed by the setting and the fishing. His generous offer to buy the lodge was immediately accepted by Bob.

Stephen has indeed turned out to be the perfect owner for the lodge. He kept all of the staff, maintaining the family atmosphere and professional work ethic, while spending money to elevate the service and accommodation to a level usually seen only in the Atlantic salmon camps of eastern Canada and Europe. All of the guest cabins were refurbished, as was the main lodge, which was also expanded and now resembles a museum with its antique reels, taxidermy and Ogden Pleissner paintings. Stephen also added a few creature comforts, such as the sauna, and amusing personal touches, including several silver plates bearing humorous inscriptions.

But his most important and invaluable contribution has been the personal time, energy and resources he has committed to several conservation issues. Everyone benefits from his actions, not the least Stephen,

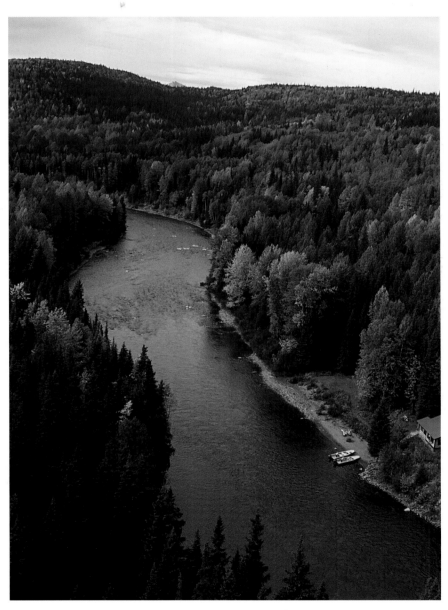

This intimate outpost sleeps four guests and is located ten miles upstream from main camp on one of the Babine's most prolific pools.

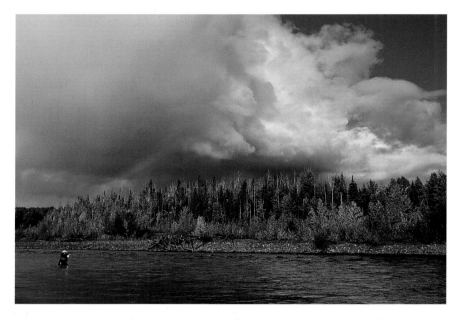

A rainbow arches over the "skating rink" pool, a favorite with dry-fly enthusiasts. Dry flies produce when the water is in the high 30s Fahrenheit or warmer, usually September to mid-October.

who cherishes the two weeks a year he spends at his "Augusta National of fly-fishing." An engraved plaque, which is mounted above the hand-hewn timber-and-river-stone fireplace, sums up Stephen's feeling for the lodge: "Silver Hilton Lodge —Bob and Jerrie Lou Wickwire 1961–1998, Stephen Myers — 1998–eternity.

The Silver Hilton can boast its own in-house fishing guru in the form of Lani Waller, one of the most renowned steelhead fishermen in the world. Trey Combs, in his excellent book *Steelhead Fly Fishing*, says of Lani: "He could find a steelhead in a rain barrel and raise it to a fly." Before he arrived on the scene, the prevailing opinion was that Babine steelhead were not good candidates for the fly. The dramatic shift from gear to fly-fishing was, in part, Lani's doing, and he also had a major hand in the evolution of tackle and

techniques on the river. It was actually Lani who suggested naming the lodge after the Silver Hilton, a famous Klamath River steelhead fly. Lani's real passion is dry-fly fishing, and his most famous dry-fly creation, the Waller Waker, a favorite at the lodge, was designed to show up on film as well as to catch fish. Both of these properties can be observed on Silver Hilton water in his seminal *Trophy Steelhead* 3M video. Lani has been the sole booking agent for the lodge since 1983 and is very proud of the impartial, open-door policy that he employs. Anyone can fish here, provided they use a fly.

Whether bright silver or displaying their magnificent crimson spawning colors, steelhead are gorgeous fish. Their beauty, combined with their size and strength (the product of two to four years of feeding in the North Pacific Ocean), rapidly turns the pursuit of them from a sport into an obsession. Trips are organized a year in advance in an attempt to satiate an unquenchable thirst for this spectacular experience, regardless of how many fish are caught. The Babine is arguably the finest wilderness river in the world for trophy steelhead, but as relative novices we called upon the ever-approachable sage, Lani Waller, to articulate just what it is that makes it so special. This was his reply:

British Columbia has the finest steelhead fishing in the world. Of its rivers, the Sustat, the Dean and the Babine are the best because of their secluded wilderness locations. Theirs is a legacy which is found only in British Columbia as it has been destroyed virtually everywhere else.

One in fifteen fish caught on the Babine will be twenty pounds (trophy size) or more. Other rivers, most notably the Kispiox, may have a higher percentage of trophies, but the high escapement (returning numbers) of Babine fish means that it holds more trophy fish than any other river in the world. In addition to this, the Babine is one of only four rivers in British Columbia to have its entire length designated as a class one trophy river, which is defined as providing "trophy steelhead fishing in an unspoiled wilderness environment." It is the only river on the Skeena system so designated.

The season for steelhead fishing on the Babine is relatively short, stretching for nine weeks from the beginning of September. Water clarity is the single most important variable, and any given week may produce the best fishing or the worst. Thankfully, among Skeena River tributaries, the Babine is one of the first to clear and the last to wash out.

Fear not, for all is not lost if the river happens to be unfishable. The 2000 season saw the inaugural "Silver Hilton Olympics" on a day when the river was "blown out." A signal from Stephen Myers kicked off the proceedings in style before guests and staff, representing several countries, vied for glory in six events:

> Long-distance casting
> Accuracy casting
> Trap shooting
> Horseshoes
> Bocce
> Chipping competition (golf)

Legendary golfer Jack Nicklaus took a surprise silver in the long-distance casting (Argentina won gold), but allegedly struggled in the chipping competition before snatching gold in the final round. All the events were held on the airstrip behind the lodge.

Babine Steelhead are known for their aggressive nature, and guests of the Silver Hilton are the first anglers they encounter. Twenty-five miles of water

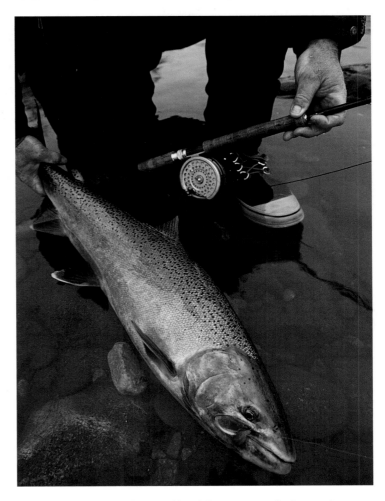

This colorful Babine steelhead demonstrates the impressive physical traits typical of the powerful Skeena strain. The Babine River is said to hold more trophy steelhead (weighing 20 or more pounds) than any other river in the world.

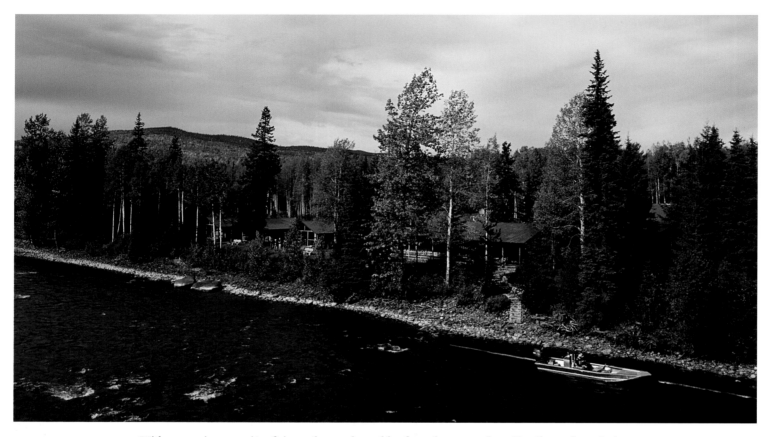

*With a carrying capacity of six anglers and capable of speeds greater than 40 miles an hour in just
a few inches of water, jet boats allow guests to enjoy Silver Hilton's full 30-mile stretch of river.*

are nominally divided into three beats that hold four rods and are rotated throughout the week. No other lodge has access to this water, and as it's a vast stretch, the fish are always well rested. Dry flies produce when the water is in the high 30s (Fahrenheit) or warmer, usually September to mid-October. Wet flies on floating (greased) lines or deeply sunken will catch fish all season. All fishing is catch-and-release using barbless single hooks. First-time steelheaders can expect one or two hook-ups a day, while hard-core Babine veterans usually land three or four fish a day. The record for one rod is 101 fish landed in six days of fishing.

The contrast between exhilarating jet-boat rides and the contemplative solo pursuit of a trophy fish on some of the prettiest water to be found is something few ever forget. Back at the lodge, the five-star treatment carries on. Breakfasts are cooked to the guest's preference, as are the hearty lunches that everyone is handed before they set off on a new adventure. The sensational dinners, which are served around a magnificent oak table, are preceded by a glass of punch or something stronger from the bar. After dinner the cigars come out, as do the day's heroics and follies. Once a week guests are treated to a bluegrass concert in front of the roaring fireplace by

the Silver Hilton's resident musician and aspiring star, Jenny Lester. She, like all the staff, has a deep love for the lodge and the river.

Fishing had been slow prior to our arrival, but the guides talked a good game about the impending tsunami of fish that was expected at any moment. Given the patchy and unpredictable distribution of fish, Jud Wickwire suggested that we try a rarely fished stretch of river that had held a number of small pockets of water. The two of us were dropped off at the top of approximately a mile and a half of discontinuous rapids with a walkie-talkie and a can of pepper spray, both essentials in the heart of grizzly country. A cursory examination of the river left us in agreement — we would leapfrog downriver, fishing suitable stretches thoroughly but quickly with wet flies on greased line. After only two minutes John hooked into a solid fish that threatened to take him down a nasty set of rapids, but his drag and iron will eventually prevailed. After a gallant, if dogged, fifteen-minute fight I tailed a beautiful 17-pound buck, his biggest ever. Not a bad start. Composing himself, he then hooked a 10-pound silver bullet of a hen, which he played with aplomb and released himself. Fortunately, I did not have to wait much longer, as a slightly smaller but equally bright and acrobatic hen took my leech pattern unbelievably close to the bank. Three fish in a little over half an hour from barely 100 yards of river!

We religiously covered the rest of the water for most of the day, hooking a further three fish and landing two of them. Back at the lodge the guides were astonished. Our six hook-ups had been more than the other ten rods combined, not to mention that the fish were taken from water that was not even named. However, our glory was short-lived, as the next day all of the guests enjoyed success while we were well and truly skunked.

The Babine is just as Mother Nature intended it to be. Monumental cottonwoods and aspens cover the surrounding hills right down to the water, cocooning the river and providing sanctuary for wildlife. During our stay we saw osprey and bald eagles every day, and even the odd grizzly from the safety of our jet boat.

On our last day we set off early with Stephen Myers and Peter Corbin, an excellent Atlantic salmon fisherman and professional artist. Our destination was the

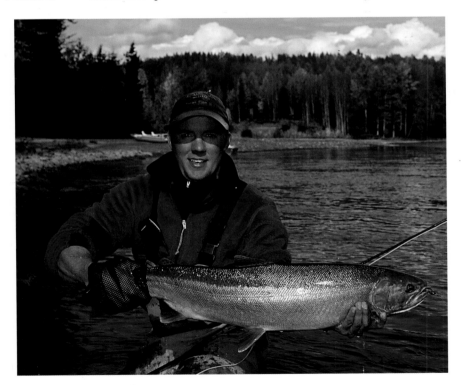

Guide Billy Labonte displays a chrome-bright hen that fell to a dry fly on a 6-weight rod.

upper beat, the first stretch of the river, which requires serious concentration as the awkward-sized rocks are difficult to negotiate while fishing. As the most junior member of the party, I was swiftly ejected and told to get on with it. The river was split in two by a rock bar, and I was soon covering the gentler, shallow water to the left.

Clearly I had not consumed enough coffee, as I was soon distracted by a flailing sockeye that seemed quite enamored with my boot. Unfortunately, I did not witness the take (which is half the fun), but I did hear an almighty splash and quickly realized from the protests of my reel that this was no ordinary fish that I had managed to deceive. It immediately left the shallows for the sanctuary of deeper and swifter water before making an eerily plodding and methodical run upstream. Tightening my drag only made my rod bend more ferociously, and for a good ten minutes the

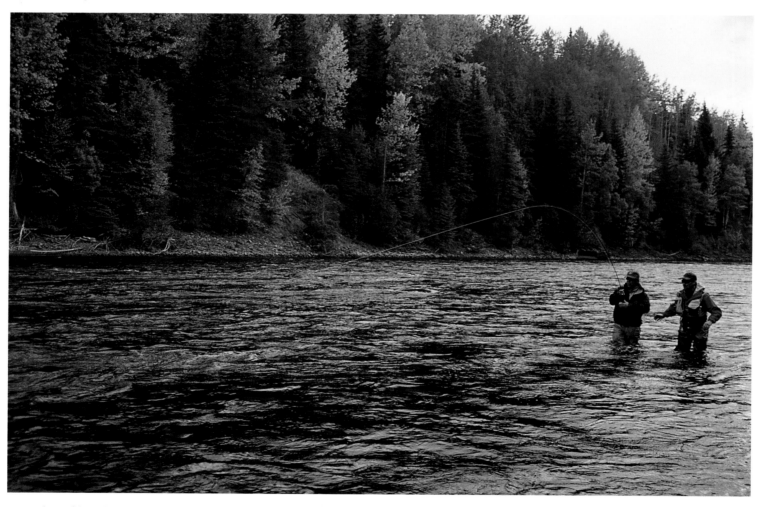

The Babine River's combination of big fish and big water provides a stiff test for even the most seasoned fly-fishermen. Guides recommend guests use 9-weight rods and 15-pound leaders. Sometimes even that combination proves insufficient to handle the river's larger fish.

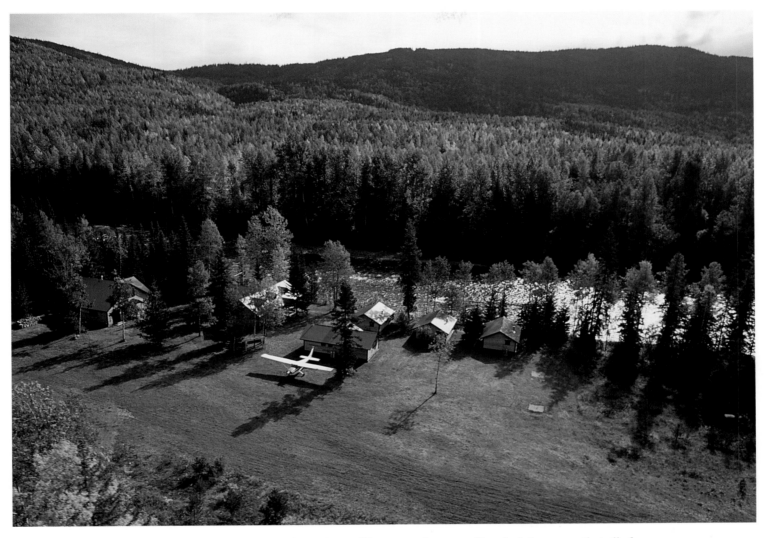

*The roadless expanse of the Babine River Wilderness Park surrounding the lodge means that all of
the Silver Hilton's supplies must be brought in by light plane. Guests are flown in from Smithers by helicopter.*

fish sat tight, resisting all efforts to coax it in. It eventually tired of this stalemate and rolled on the surface, in full view of the guide and myself, revealing its identity before setting off downstream on an electrifying run — a huge, colorful cock fish that was at least 40 inches and was now well into my backing and holding in very heavy water downstream. We scrambled over to the jet boat and fired it up, but just as we set off my line went slack. The fly was still there, but my shot at a trophy was over. Stephen, who had witnessed the entire proceedings, was left in no doubt as to where the honors lay: "That fish kicked your ass!" he chuckled. It certainly did, but it also turned me into a fervent steelhead fan.

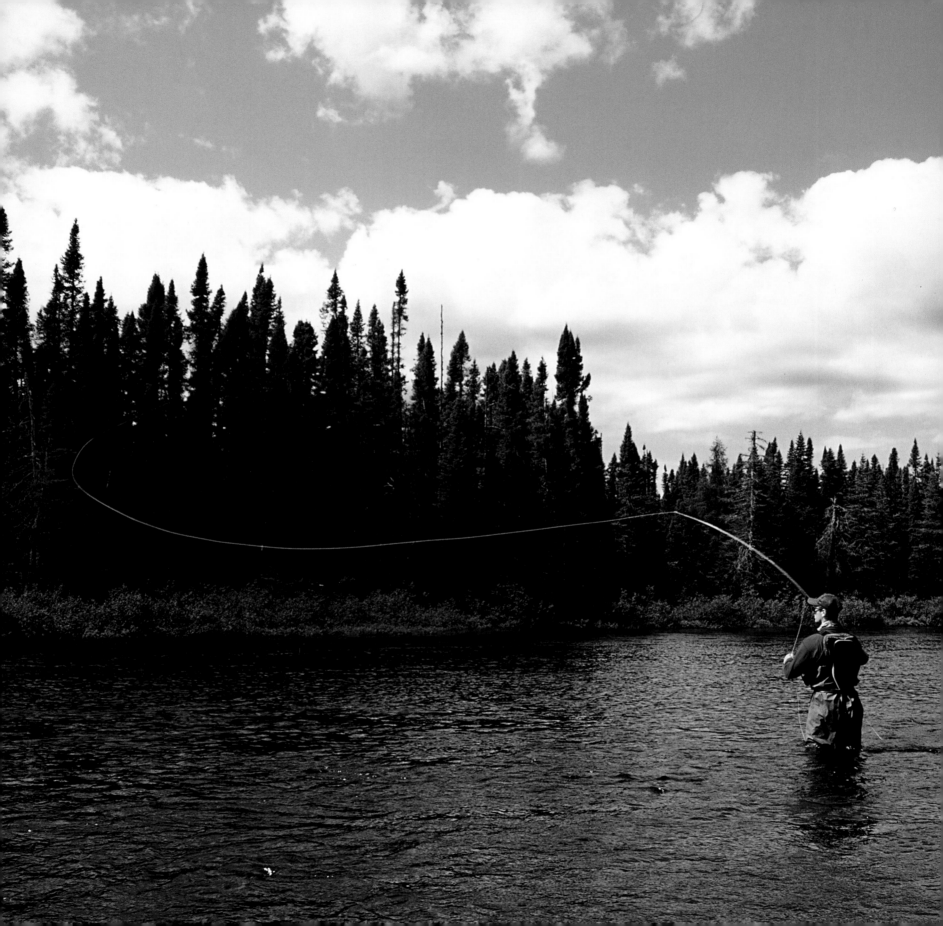

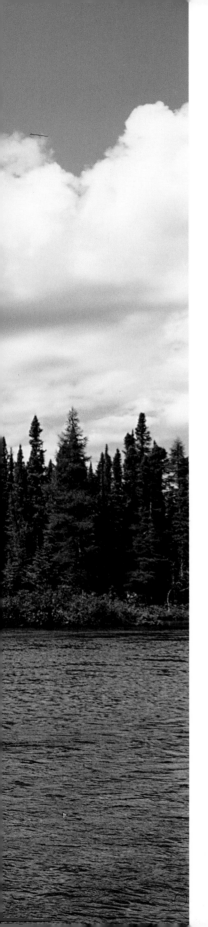

Cooper's Minipi Camps

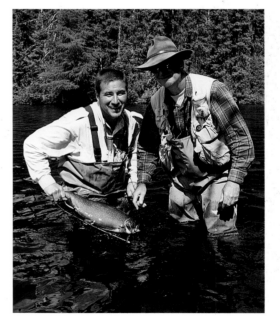

T he angling history of the Minipi River system, whose head-
waters collect at the base of the Mealy Mountains of Labrador,
roughly 60 miles to the south of Goose Bay, is an unusual one.
Its origins include a clandestine tale involving the United States Air Force
and a legendary fishing personality, scout and author. As curious a tale
as this would be for a lodge in most other provinces, Labrador
has a rich history of secretive fishing camps operated by the
Canadian and U.S. militaries.

The existence of large trout in this area was well known
to the Naskaupi and Montagnais Natives and to the white
trappers who have used the isolated, boggy, barren land as
their hunting grounds for generations. However, recognition
for the area's discovery as a fisherman's paradise should go to
sportsman, explorer and author Lee Wulff. Flying to Minipi
Lake, looking down at the spongy land, soaked by countless
lakes and creeks, it is easy to understand why Wulff could
not help but have been tempted into an unscheduled landing
of his small floatplane for a little test fishing — which, inter-
estingly, was his job.

As a major refueling center for USAF and RCAF planes
during the Second World War, Goose Bay was at one point
the busiest airport in the world. Following the war, the American Air
Force maintained a large presence in Goose Bay, using the airport as a
Strategic Air Command base and training station. In the early 1950s the

Renowned angler Lee Wulff was hired by the U.S. Air Force in the 1950s to scout areas
of Labrador for prime fishing grounds where sport-fishing operations might be
established under the guise of official "wilderness survival training" camps.
INSET A happy guest poses with a typical Minipi brook trout.

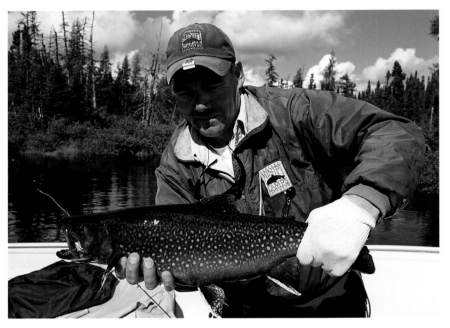

Handled with care, all brookies caught at Cooper's are respected as magnificent works of nature's art and all are released.

USAF hired Lee Wulff to scout out areas of Labrador to locate excellent fishing grounds where they could then establish sport-fishing operations under the guise of official "wilderness survival training" camps. Wulff was the ideal candidate for the job, as he had already worked in a similar capacity for the Newfoundland government, scouting out great fishing locations to assist the island's tourism industry. What he discovered in the Minipi system was spellbinding: football-sized brook trout in the thousands, averaging more than 5 pounds each. He developed a deep affinity for the area and the fish and returned often to film and fish on the waters, which are now home to the three lodges comprising Coopers' Minipi Camps.

Wulff believed that he had discovered the "last stronghold of giant brook trout" in the world, and in fact the area is now believed to be the epicenter of the brook trout's original habitat. Understanding the fragility of the ecosystems within the lakes and rivers that comprise the Minipi watershed, Wulff vowed to keep the place a secret until its treasure could be shared without destroying it. After filming a television show in 1966 on brook trout, during which he attempted to keep the Minipi location a secret, Wulff realized that man's lust for great fishing was too powerful and that a sport-fishing camp in the area was inevitable. He quickly hatched a plan to ensure that the outfitters who did operate on the watershed had a big heart for the fish and the environment.

Enter Bob Albee, a wealthy New York businessman who also happened to be a devoted conservationist and ardent angler. Albee was so entranced by Labrador and the Minipi fishery that he agreed to put up the money to build two lodges. Wulff introduced him to Raymund Cooper, a brilliant Englishman who worked for the Sandhill Salmon Club in Newfoundland, where Wulff was a member. A partnership was formed, and Cooper erected two separate camps in 1968 and 1969, one on Anne Marie Lake, named after his daughter, and another on nearby Minonipi Lake. In the rush to construct Anne Marie Lodge, building took place in the early spring while the ground was still frozen. When it thawed, the building shifted, leaving the floor with a distinctive slant. Adorned with caribou racks, both lodges are built in classic, trapper-cabin style and constructed primarily from spruce milled on-site. They are a natural fit, complementing their remote, rugged Labrador setting.

From the outset, these lodges were run with restrictions on the number of fish that anglers could keep, ensuring continuance of the unique strain of giant brookies. Cooper was one of the first outfitters in the province to introduce catch-and-release fishing, despite lack of support from the provincial government. Testament to this prudence is that today almost 1,000 brook trout and landlocked char over 5 pounds are caught and released by guests at Coopers' Minipi Camps each summer. The lodge's current owners, Jack and Lorraine Cooper (both unrelated to Ray), have continued the sustainable practice of catch-and-release. In recognition of their efforts to protect the area's brook trout and wilderness habitat, they were awarded the first-ever Environmental Sustainable Tourism Award by the Canadian government.

The Minipi's sport-fishing history involves another Cooper, totally unrelated to Ray. His name was Eugene Cooper, an adventurous master sergeant with the USAF who was assigned to Goose Bay Air Base, where he took charge of the Air Force's "survival" operations. In keeping with the Air Force's belief that the wilderness survival training curriculum in Labrador should be composed of fishing, Eugene Cooper was put in charge of several lodges for the military. These lodges were operated under a veil of secrecy, hidden from the public behind code names — No Name, Adlatok and Mackenzie — with no hint of their geographic location.

Eugene Cooper loved the land and his involvement with it and passed on his passion for the bush and outfitting to his son Jack. And although Jack swore he wouldn't follow in his father's footsteps, the call of the Labrador wild was eventually too overpowering. Outfitting was in his blood.

In 1979, at the same time that Ray Cooper was looking for a buyer for Anne Marie and Minonipi Lodges, a newly married Jack Cooper took his city bride, Lorraine, along the beach of North West River and beguiled her with his dream of running a fishing operation in Labrador. Opportunities for employment were not abundant in the area, and running a lodge promised an idyllic way to enjoy the type of life that both had always wanted. In June 1979 the new Coopers took over Anne Marie and Minonipi. But behind every dream is the harsh reality

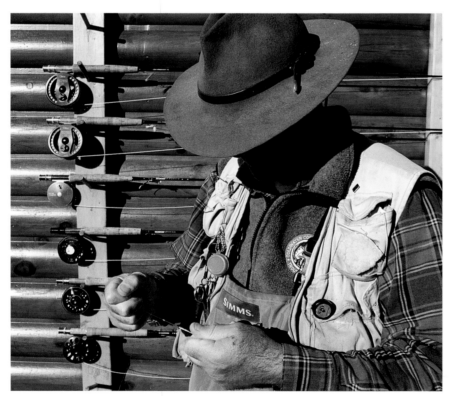

All fly gear must be thoroughly inspected before any fishing sortie.
There is no margin for error when a giant Labrador brook trout seizes a fly.

of trials and tribulations, and this is exactly what awaited the young couple, as related by Lorraine Cooper:

There were eighteen anglers booked at Anne Marie the first summer of '79. We arrived with more enthusiasm and determination than realism, which is what pulled us through. The operation was in shambles. The plumbing was literally tied together with shoe laces. There was an old kerosene refrigerator that only worked when it wanted, but in no worse shape than the outboard motors and water pumps. The city girl floundered with the wood stove that also supplied the hot water, and when the water pump wouldn't work, dragged 5 gallon buckets from the lake. I cooked, Jack guided all day, and returned at night, exhausted and weary, to tackle the list of repairs that accumulated over the day.

Eventually, Jack and Lorraine approached the Government of Newfoundland and Labrador with an offer to build a state-of-the-art facility on Minipi Lake and to clean up the site where the old USAF camp was. In 1985 the land was turned over to them, and during the summer of 1986 the new Minipi Lodge was built. This is the largest of the three lodges, with ten rooms and accommodations for up to twenty guests. The lodge is a cedar, Lindal-style chalet, with a large arrow-shaped prow that contains a second-floor lounge and library built over a cozy dining room, kept warm by sunlight and a Vermont soapstone stove. The entire front of the prow is glass, providing a grand view of the lake and fireweed-spotted shoreline. The bright pink of the fireweed petals contrasts with the burnt gray forest, destroyed by fire, on one side of the lake, and the untouched spruce forest covering the rolling hills on the other. An open kitchen borders the dining room, filling the lodge with the smells of fresh baking and home-cooked meals. The walls of the lodge are decorated with paintings, photos and poems, all tributes to the beauty and gamesmanship of the famous fish that lures anglers from around the world. Several pairs of antiquated snowshoes, in addition to sealskin jackets and clothing found in a nearby abandoned trapper's cabin, pay homage to the area's trapping heritage.

Adjacent to the main lodge is the guides' residence, housed in the old military lodge. This building plays an important role in creating the social atmosphere for guests and guides in camp. After an evening's fishing, as is customary, guests often wander into the guides' quarters for a taste of the East Coast hospitality and humor that Newfoundlanders and Labradorians are famous for. Despite being the brunt of many jokes themselves (most of us know at least one Newfie joke), nobody has as broad a repertoire of witty stories as do easterners, which each guide is eager to share.

Entertaining is not the only skill possessed by Cooper's guides. Each is an accomplished fly caster and fisherman, and all are passionate about their work. They take immense pride in their professionalism and the quality of service they have provided their guests over the many years that each has worked for Jack.

Surrounding the lodge are the telltale remnants of the camp's military history and influence. Large sheets of heavy metal grate airstrip sections still form the walking platforms connecting buildings and the sandy beach in front of the lodge where the boats are moored. Two hundred yards behind the lodge rests

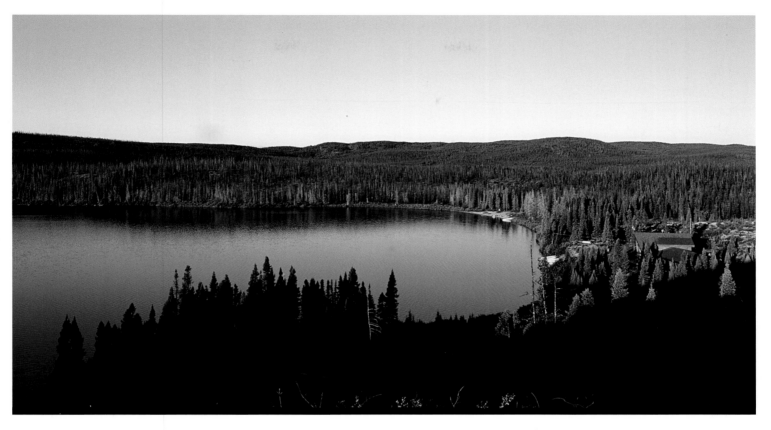

Viewed from a hill overlooking the main lodge, the forests of Labrador stretch as far as the eye can see.

a more ominous memory — the torn debris of an Air Force Otter floatplane that crashed shortly after takeoff decades ago. Miraculously, nobody was killed.

"Thar she blows, matey," exclaimed a guest as he humorously compared techniques used in catching Minipi brookies to the tactics of whale hunters. This is a surprisingly accurate portrayal. By far the most popular method of fly-fishing involves stalking, or more accurately, tracking the fish. Just as an animal leaves tracks in the snow, feeding brookies leave dimples and ripples on the water's surface as they suck in newly emerged mayfly duns. A fish's whereabouts can be tracked by following the ripples in the water as the fish

cruises beneath the surface, rising every 10 to 15 feet or so. The fish take the flies by inhaling them into their mouths, breaking the surface tension that supports the flies. There is a satisfying sound when this happens, like the cracking of jaws. Often, fishermen and guides are alerted to an unseen hunting fish by this sound.

The mayfly hatches on the Minipi are prolific, and insects comprise the vast majority of the diet of the fish. It's not unusual to find stone flies the size of a finger basking in the sun and clinging to the side of the main lodge. Out on the lake in the evenings, the sky above is abuzz with the dancing movements of clouds of mayflies. Throughout the day, the lake is littered with

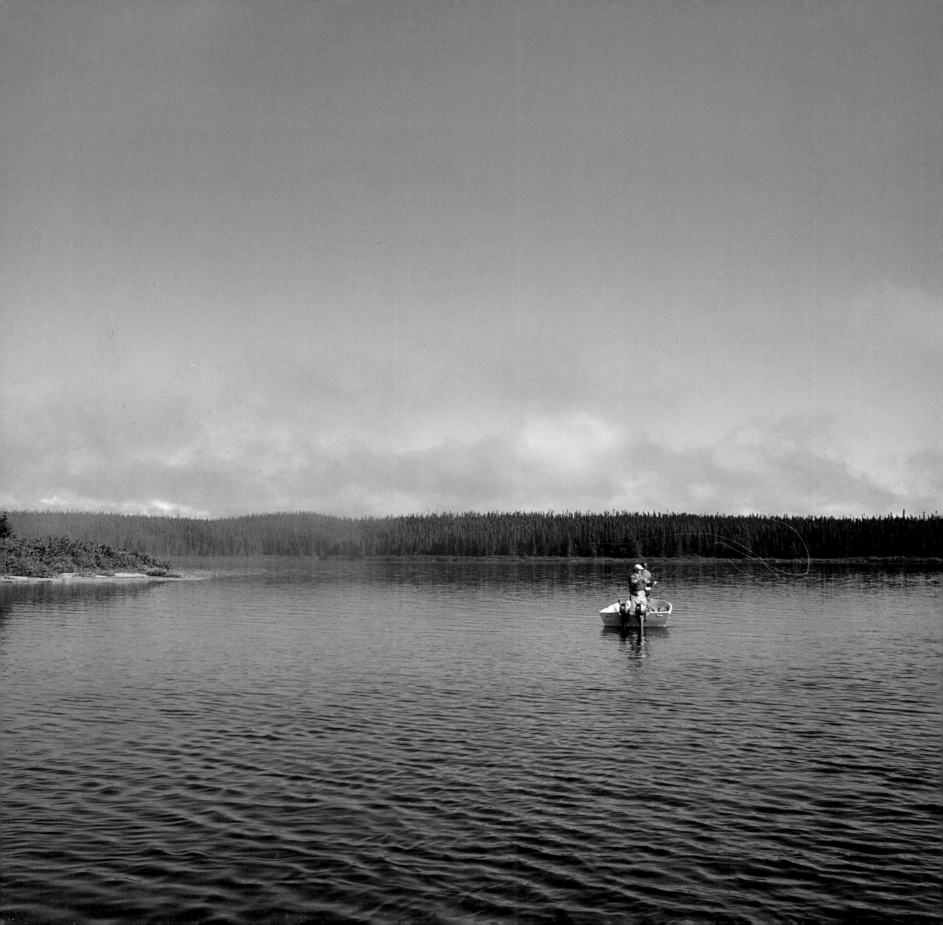

the exoskeletons of the day's newly winged inhabitants. From mid-July to mid-August the waters are host to hatches of *Hexagenia rigida*, an enormous mayfly that spurs the brookies into a frenzy. The surface motion makes for exciting dry-fly action, the most popular fishing technique at Cooper's. Large Humpies, Wulffs, Sofa Pillows, Irresistibles and Bombers are all popular fish candy. Fish in a surface-feeding pattern behave as if they are almost in a trance, and it's difficult to spook them and break their concentration. As a result,

it is often not a question of if you will catch a feeding brookie, but when. Patience and accuracy are almost always rewarded.

Man is not the only hunter of these beautiful fish. As they cruise stealthily below the surface in a hypnotic state, these fish are prime targets for osprey attacks. The brook trout's greatest defense is its large weight, which can force these birds of prey to abandon their quarry or face drowning. Many of the fish we encountered bore the telltale scars of more than one attack.

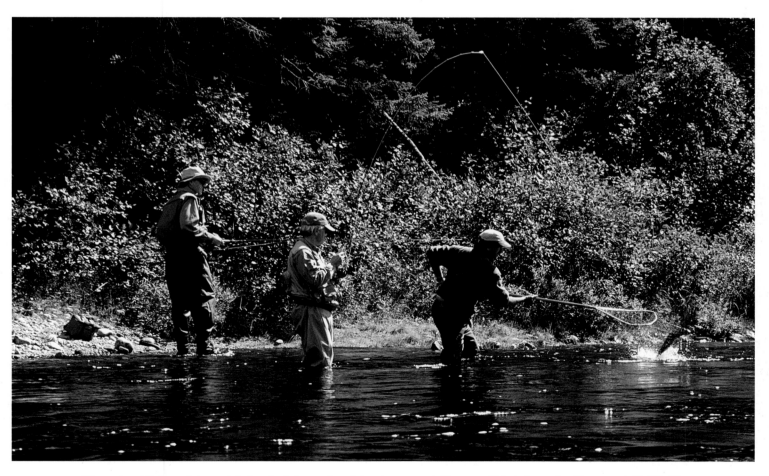

Throughout July and August, Labrador's larger brook trout are especially susceptible to huge dry flies, especially Wulffs, stimulators and mouse patterns. OPPOSITE PAGE *Anglers drift quietly across Minipi Lake looking for the tell-tale signs of brookies' dorsal fins cutting through the water as they hunt freshly hatched mayflies.*

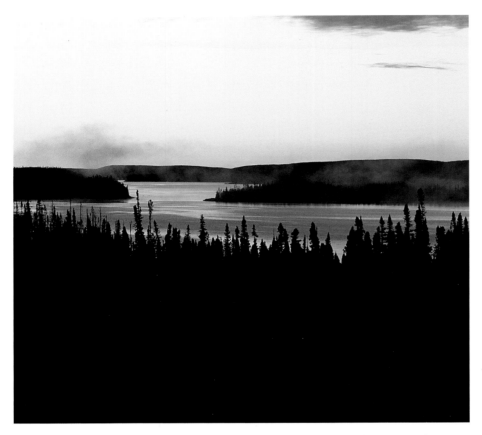

For generations, the existence of large trout in this isolated area was known only to Naskaupi and Montangnais Native people and a few trappers of European descent.

Places like Rick's Run, Ten Pound Brook and Rose's Brook are beautiful spots and make for interesting day trips into the backwaters of the Labrador wilderness. Anglers are followed on these sorties by curious gray jays as they walk on trails leading from the lake to the river boats moored on the banks of the brooks, through the spacious spruce forest over bouncy, mattress-like caribou moss, which is sometimes half a foot thick. The brooks are patiently flowing, intimate corridors of nature, winding through a forest of thick, tangled willows, birch stands, spruce, and tall, wispy tamaracks. Curiosity often pulls guests farther upriver than they had intended. On one such occasion, enticed by what mystery or new fishing hole might await us around each new bend, we went several miles up a brook, often dragging the river boat over small sets of rapids we encountered, to a point where our guide believed that no other guest or guide had been before. To celebrate our exploration, we took the liberty of naming after ourselves several of the ponds and lakes that we discovered. We also named one in honor of our guide, to ensure that the names' longevity would endure after our departure!

The brook trout display more carnivorous tendencies in these rivers, the fly of choice being a large mouse pattern. Deer-hair-tied mouse patterns bring up the biggest fish in a display of shocking aggression that is intensely fun to observe. Pity the real creature that falls haplessly off the side of a bank into the slow

Once a fish's conspicuous ripples have been spotted, the guide cruises slowly behind these "tracks" as anglers attempt to guess where the fish will take next by casting several feet in front of the most recent "fish print." Often, a fish will change its course and turn up behind the boat, creating a real challenge. But if the cast is delicate enough and on target, the fly is sucked down and a battle ensues. This is as close to actually hunting fish as you can get, and it is a captivating sport.

Lake fishing isn't the only option for guests; several brooks that feed the lake also hold large fish, especially those preparing to spawn towards the end of the season.

current, as they surely meet the same fate. In late summer, the fishing can be quite good in the brooks. During our visit, one guest caught six fish in four hours, weighing a total of 35 pounds, with two of them topping 7 pounds.

The Minipi watershed and its wilderness fishing experience ensnare the hearts and minds of those who visit. Most visitors feel compelled to return again and again because of the unique character of the land and the camps and the unsurpassed beauty of the brook trout. One corporate client has reserved a week in advance for the next ten years. As one guest blurted out emotionally to Lorraine Cooper upon walking through the front door of Anne Marie for the first time, "I've been dreaming about this place all my life. I just didn't know where it was."

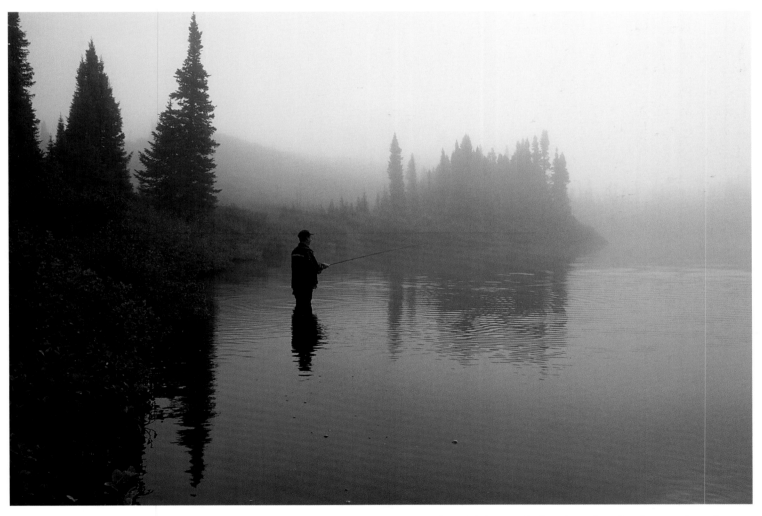

Early morning mist cocoons a guest in a world of his own. Most visitors return to the Minipi watershed again and again, drawn to its unique character and the unsurpassed beauty of its brook trout. One angler has gone so far as to reserve the same week in advance for the next ten years.

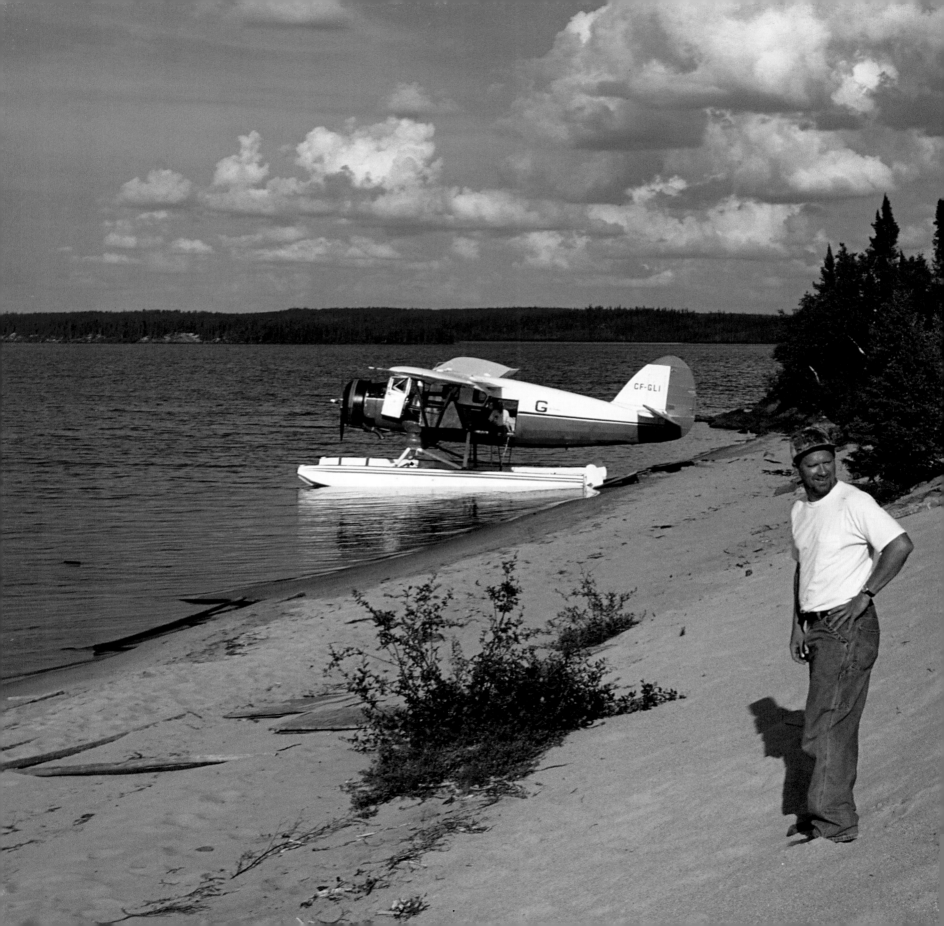

Big Sand Lake Lodge

ive hundred and twenty-five miles northwest of Winnipeg, Manitoba, lies Big Sand Lake Lodge, a sportsman's paradise. Built on the shores of one of the most productive sport fisheries in Canada, it is the creation of the people of the remote Cree community of South Indian Lake, 90 miles to the south. This unique lodge is more than a business accomplishment; it is a success story indicative of an entire community's willingness and determination to take a chance and beat the odds. The lodge is the realization of the community's dream to break free from the chronic unemployment that plagues many isolated northern areas. As the biggest employer for the community of 800 residents, it has provided hope and salvation, while opening up a piscatorial seventh heaven for those fortunate enough to visit.

The location at Big Sand Lake was chosen because it reminded the people of South Indian Lake of their own lake before it was flooded for hydro purposes in the 1970s. The elders of the community also selected it because of its outstanding fishing, well known to generations of hunters and trappers of the community.

All who work at the lodge are part owners and have a vested interest in its success, which is seen in their pride in their work. They have an intrinsic link to the lake's heritage and spirits through ancestors who fished the lake and hunted its shores before them. The Cree guides and staff rely on the fish they love for their livelihoods

Big Sand Lake's eskers — narrow, winding deposits of sand — are the remnants of Ice Age glacial activity. Guests at Big Sand Lake Lodge will discover Caribbean-like beaches that are perfect for shore lunches or just as a place to relax after a hard day of fishing. INSET A Big Sand Lake sandbar walleye.

and depend on them, as did their ancestors. Some say that a powerful sense of mutual respect exists between these old friends. Most of the bays of the lake and its feeder creeks are named after the guides, past and present, as tributes to those who have helped to build this monumental lodge.

Getting a job as a guide at Big Sand is a major accomplishment and career stepping stone for many of the young men who qualify; there is a waiting list within the community to work at the lodge, and competition is fierce. All applicants must first pass an extensive training course and exam through the Northwest Institute of Guide Training, the only course of its kind in Canada. This intensive program covers navigation, survival skills, fishing techniques, interpersonal skills and even how to photograph a guest's catch. The strong aptitude of the guides and their continuous on-the-job training contradict the belief that guiding is just an unskilled summer job. In fact, it is a serious profession that thousands of Canadians take great pride in.

Built atop an esker high above the water, the two-story pine-log main lodge commands a sweeping view of the lake and distant islands.

Upon breaking through the clouds, en route to the lodge, the golden sand for which it is famous is immediately apparent. Across the land, the distinct protrusions of eskers extend like veins on an aged hand, stretching into the horizon. These are the telltale signs of the land's glacial history and the source of the sand that creates Caribbean-like beaches along the lake's shore. In the late fall and winter, these upside-down river deposits act as signposts and thoroughfares for thousands of migrating caribou.

All of Big Sand's guides are graduates of the Northwest Institute of Guide Training and are part owners of the lodge.

The groomed sand airstrip explodes in a dust storm as the twin turboprop Hawker Siddely 748 touches down. Engines shut off, and eager guests disembark into the bright sun, where they are greeted by the Big Sand Lake Lodge manager and staff, decked out in sharp, bright red uniforms, standing with arms crossed behind their backs like a special task force of military-trained fishing guides. The discipline and attention to detail of the guides is impressive, and one of the reasons why part of Manitoba's professional guide training program was developed at Big Sand. A large sign at the end of the runway greets guests in Cree with the word *"Tansi,"* meaning "Welcome." A sense of wonder and disbelief is evident on the faces of all new arrivals, who marvel at this desert-like environment in Canada's North. The lodge manager, Rick Bohna, believes that there is more sand in the Big Sand Lake area than there is in the whole of the Sahara Desert!

Guests are transported from the airstrip to the main lodge on tractor-drawn covered wagons. A nourishing lunch of fried walleye fillets with lemon, baked beans, salad and fresh Red River bread awaits. The nineteen guides, who have changed clothes and are now outfitted in their mealtime uniforms of identical, collared khaki shirts, fill two of the large tables in the corner of the dining room. The main lodge is a grand, two-story affair constructed entirely out of pine logs, and stands proudly above the angled peak of the esker supporting it. On the lake side of the lodge, an enormous deck and walkway extend down to the calm bay below, which shelters the lodge's fishing fleet of 18-foot outboards. The boats are beached at the end of the day in front of the guides' camp, which consists of an old trappers' cabin, used by the fathers of some of the guides while hunting around the lake decades ago, and several elevated buildings where the guides bunk. In the center of guide camp is the shore-lunch hut, where the lunch kits are cleaned and prepared for the next day. At night, this building doubles as the guides' social center, where guests are occasionally invited in for high-stakes poker games. Enter at the peril of your pockets, but if they

*A sand esker, deposited by a retreating glacier
during the last ice age, leads to the main camp.*

relaxing, private environment in which to enjoy the tranquility of the forest's canopy after a day's fishing.

Big Sand Lake contains over 60,000 surface acres of water and is 70 miles long, providing a virtually unlimited selection of fishing opportunities for guests each day. In addition to the lake, there are a variety of fly-out options to one of the five outpost lakes, all of which are exclusively for guests of the lodge. The primary sport-fish species are pike, lake trout and walleye. One of the top spots is the "Snake Pit," a huge, weedy area bordered by a cool, flowing channel. This is a pike fisherman's dream, producing behemoths measuring 40 inches and larger every day, often on surface plugs and buzz baits. The ferocious strikes of these large pike send walls of water and weeds into the air. This, combined with their favorite battling tactic — launching themselves straight out of the water like rockets — makes the fishing at Big Sand an equally enthralling spectator sport. Despite having caught many large pike, I am still entranced by the photo of the biggest pike I've ever seen — a 50-pound leviathan caught on a nearby lake that hangs on a wall in the main lodge. The best method for catching pike at Big Sand is by tossing surface-action lures such as Suicks and Moss Bosses, which are guaranteed to stir up the weed beds until your arms are tired from catching fish.

Mistay Narrows, a ten-minute boat ride from the lodge, is heavily patrolled by hungry lakers, some of which get over 40 pounds and seem to hunt and feed all day. Our guide, "Fast Eddy," one of the most talented (or luckiest) fishermen ever, thrilled us by hooking

are deep enough then it is well worth it, as the room is full of laughter and great tales for much of the night.

The lodge has an ideal vantage point and commands a sweeping view of the lake and distant islands. Whether eating in the dining room, relaxing in the hot tub, enjoying a drink at the bar or in the games room, or perusing the tackle shop, the captivating horizon is just a turn of the head away. Along the winding reindeer-moss paths below the main lodge lie the guest cabins, Atihk (Caribou), Pisew (Lynx), Amisk (Beaver), Mooswaw (Moose) and Muskwa (Bear). These cabins have been built in the same style as the lodge and are all nestled in the shade of the birch and spruce forest. Verandas on each of the cabins extend outwards towards the lake, providing a

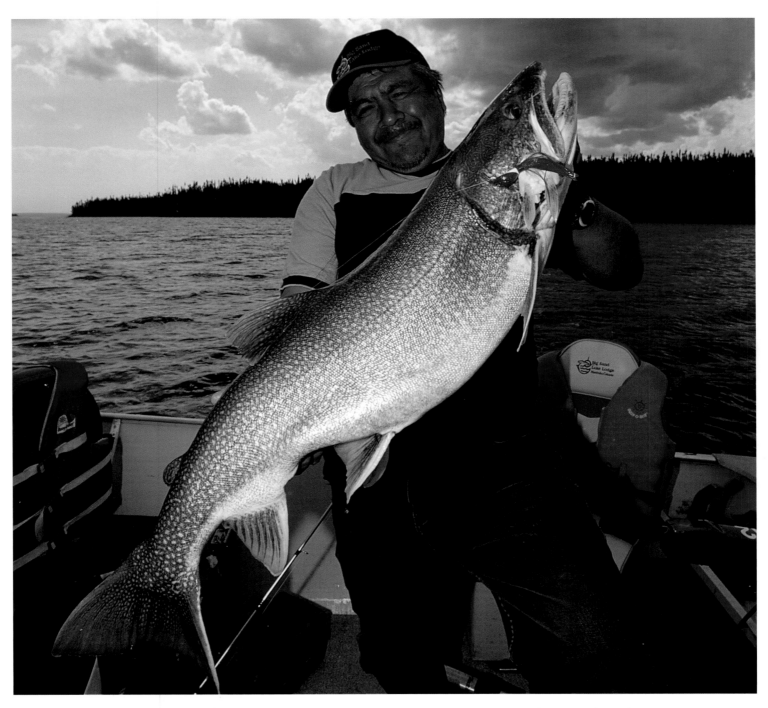

*One of the area's legends, "Fast Eddy," holds a prime Big Sand lake trout, one of the main draws for
the lodge's international guests. This beautiful brute was caught at a spot appropriately named "Eddy's Hole."*

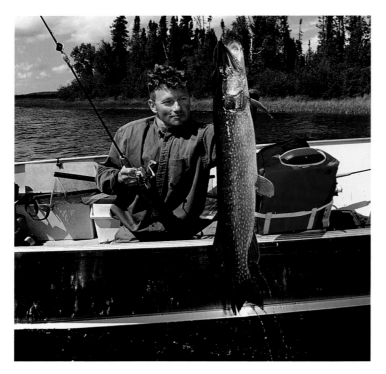 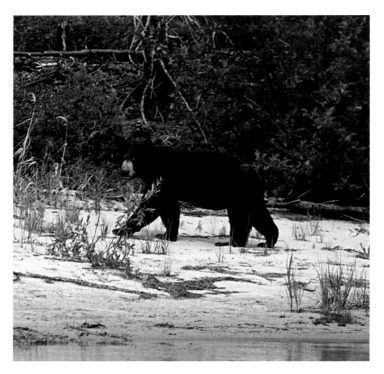

Cree legend states that "for as long as the sun shall shine, there will be fish in these waters." RIGHT *An inquisitive young black bear seeks an invitation to join a shore lunch. With the exception of shore lunch, all fish are catch-and-release.*

a 25-pound brute laker that fought for over twenty minutes. Tiring from the fierce fight, Fast Eddy demanded more than once to increase the drag on his reel. Worried that he'd lose the fish, we threatened him with grievous bodily harm if he did, until he relented. The fish was finally netted with a fish cradle and held aloft for a quick photo. Eddy smiled his big trademark smile, holding the end of his tongue between his worn teeth and hissing with glee at his biggest fish of the year. A certain spot in Mistay Narrows is now unofficially known as "Eddy's Hole." If you find it, trolling a Daredevle five of diamonds spoon or a cut plug herring will guarantee you a fish. Before the end of our stay, Fast Eddy would again delight us with his fishing prowess by catching the biggest pike of the trip.

On our first outing with him we invited him to fish with us as we cast for pike and walleye in the weed beds of Airport Bay. He dropped his lure into the water before his first cast, and almost immediately it was swallowed by a 3-foot pike! He then proceeded to catch three large walleye on successive casts. Such were Eddy's talents. With the exception of fish destined for the shore-lunch pan, fishing is strictly catch-and-release, using only a single barbless hook. These measures ensure that the Cree saying *Theekawi Sakahikan*, or "For as long as the sun shall shine, there will be fish in these waters," remains true.

The 18-foot aluminum boat grinds into the sand as we beach for shore lunch. One of the most sacrosanct activities at Big Sand is the daily deep-fried feed of fresh

fish accompanied by "bad-ass beans," a spicy and sweet concoction known to all the guides. The recipe calls for carefully measured amounts of French's mustard, ketchup, HP sauce, seasoning salt, Tabasco and fried onions mixed with cans of Libby's pork and beans. The best way to eat this mixture is poured over a plate, like a gravy, coating the crispy fish, french fries, corn and fried onions underneath.

During one memorable cook-up, Fast Eddy alerted us to a black bear bounding down the beach towards us at such a clip that often all four of its paws were in the air at the same time. Keenly aware that the enchanting scent of our bad-ass beans had given us away, we wasted no time in saving ourselves and our lunch. Corn, fish, french fries, fried onions and bean muddle were dumped into the biggest frying pan and hurled into the bottom of one of the boats before we all threw ourselves in and pushed off from shore, banging knees and shins on the metal gunnels in our excited rush. The 200-pound bear came to a skidding stop in the sand on the very spot we had stood not seconds before. The beans were not the lure, however, and the bear lay down on its chest and forepaws and buried its snout in the pile of walleye carcasses that Fast Eddy had thoughtfully left onshore by the water's edge. Calmed by the bear's apparent contentment, we untangled ourselves, passed around plates and helped ourselves to well-deserved, healthy servings of our bad-ass concoction. We ate silently, as all eyes were fixed on the

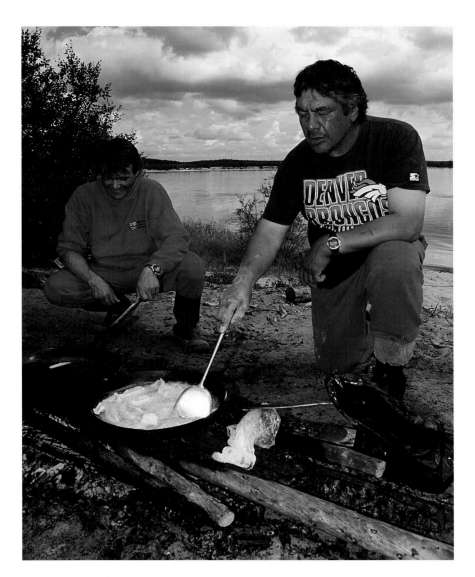

Guides prepare a camp favorite for guests: "bad-ass beans" with freshly caught, fried walleye, accompanied by creamed corn and home fries, all prepared over an open fire.

grunting, sighing bear not more than 10 feet from us. A most unexpected and yet fascinating lunch guest who made a great tale that we related to fellow guests later that evening as they plied us with drinks and pumped us for details.

73

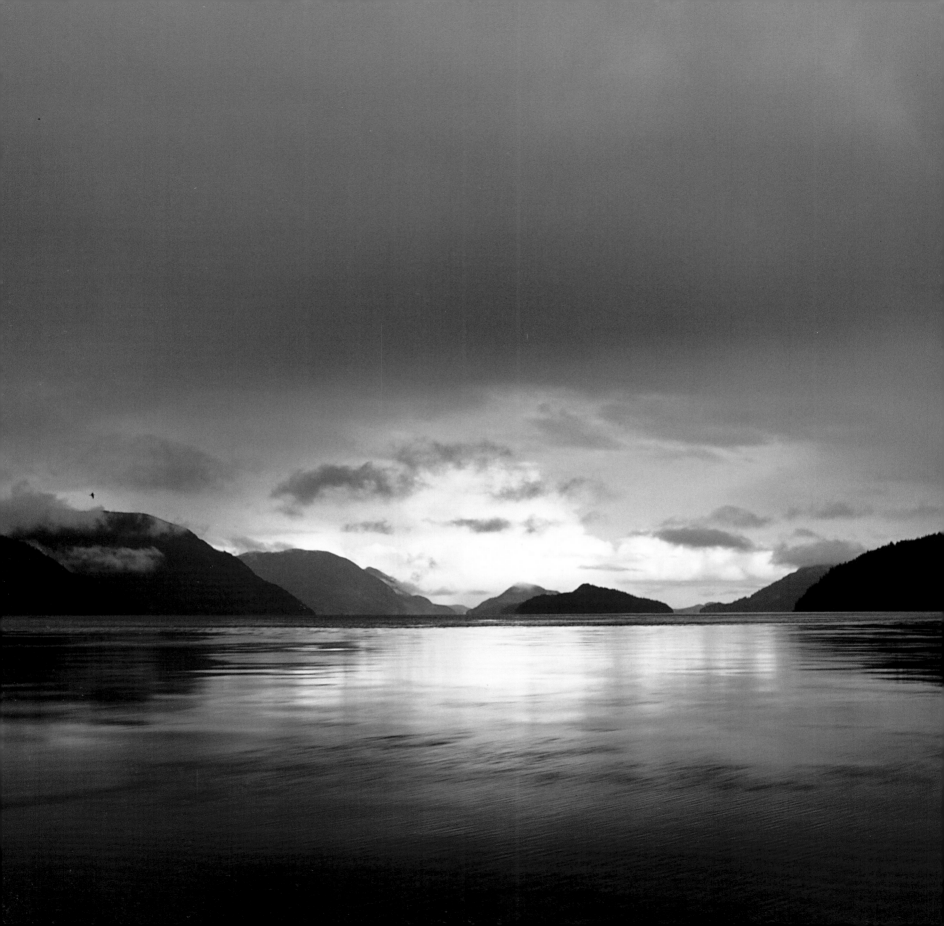

Painter's Lodge

Residents of Campbell River, on Vancouver Island, British Columbia, proudly declare their town to be the "Sports Fishing Capital of the World." And while some angling aficionados might question the validity of this lofty title, the locals do have a case. For over a century, sporting enthusiasts from around the globe have been flocking here to test their skills against the mighty tyee — chinook salmon greater than 30 pounds that are prevalent in the rich waters nearby. In addition to these large fish, there are also millions of migrating salmon of the other four Pacific species that pass through Discovery Passage, the body of water separating Vancouver and Quadra Islands. Painter's Lodge has been synonymous with first-rate fishing in style for over sixty years and remains the place to stay in this angler's mecca.

Despite industry and development, the coast of British Columbia remains a stunning environment. Mountains thick with towering cedars and firs rise from the sea to their snow-capped peaks in the distance, bald eagles are so common that you half expect to see one on every telephone pole, and the turbulent sea never fails to fascinate. The first Europeans to occupy the district of Campbell River were attracted not by its beauty, but by the vast stands of virgin forest. The loggers didn't settle permanently, of course, but Frederick Nunns, an Irish farmer, did. In 1891 he was the only white resident at Campbell River, but had already hosted a Californian fisherman the previous summer, charging him

The area surrounding Painter's Lodge is one of outstanding beauty. The lodge is within a short boat ride of many natural wonders, including Bute Inlet, a stunning fjord that carves deep into British Columbia's magnificent west coast. INSET Concerned over the exploitation of their beloved tyee (chinook salmon weighing greater that 30 pounds), a group of anglers established the prestigious Tyee Club in 1925.

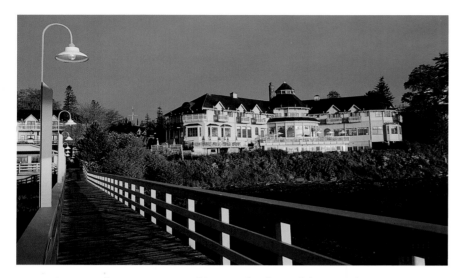

Painter's Lodge was constructed in 1938 but burned down under mysterious circumstances on Christmas Eve 1985. The Oak Bay Marine Group kept several prominent features of the original design when it rebuilt the historic lodge.

$2 a day for the service. Mr. Nunns's diary survived and gives a fascinating insight into life at that time, including the successes of his fishing and hunting excursions. On these trips he often was host to officers from the Royal Navy ships and steam launches that ventured through Discovery Passage. Much of Campbell River's early renown can be attributed to the enthusiastic reports of these world travelers.

International prominence came in 1896, when Sir Richard Musgrave, of the Royal Navy, landed a 70-pound tyee to complement a couple of other large fish he had already caught. He returned to England and wrote an account of his heroics in *The Field: The Country Gentleman's Journal*. In it, he describes his physical state after the hour-and-three-quarters battle: "My back and arms were thoroughly tired and my left hand was trembling so much that I could hardly put a cigarette in my mouth…." As proof of this fishy story he brought back and toured with a gelatin cast of the

fish. His feats inspired a generation of anglers, and many came, some staying weeks, some the entire season. No fewer than eight articles featuring Campbell River appeared in *The Field* over the next fifteen years.

Frederick Nunns aside, Native people acted as the first guides in the area and held most of the early fishing expertise. Their traditional method of catching tyee involved trolling abalone-shell spoons with whalebone hooks. A short length of treated kelp or cedar-bark rope attached these lures to a block of cedar, which was tossed overboard as soon as the fish struck. The resurfacing of the block signaled fatigue in the big fish. Normally their employers politely declined to use this method but did listen to suggestions that the line be kept taut and a strike delivered forcibly when a fish hit. Despite the best efforts of the guides, their guests often found their conventional gear no match for the tackle-smashing tyee.

Refinement of the fishing followed the establishment of Willows Hotel and increased competition among guests who returned each season. By 1908 regular patrons had set up an "official scales," with a presiding jury of experts for the authentication of weight and for the detection of foul play. Concerned about the exploitation of a worthy adversary, a group of anglers established the Tyee Club in 1925 to protect the mighty salmon and bestow upon it the prestige they thought it deserved. The rules were simple and have changed little over the years.

To qualify, an amateur fisherman must land on light tackle (less than 25-pound test) a chinook of not less than 30 pounds. Trolling under motor power

disqualifies, as does handling of rod or gear by anyone apart from the angler. Club buttons are awarded for fish of different sizes: bronze for 30 pounds, silver for 40, gold for 50, diamond for 60 and ruby for 70. There are more than 800 active members of this prestigious club, with nearly all the qualifying fish taken from Frenchman's and Tyee Pools, near the mouth of the Campbell River. Onlookers today can watch dozens of rowboats circling these pools in the twilight from mid-July to mid-September, just as they did eighty years ago.

In 1922 a young boat builder named Ned Painter saw a golden opportunity and moved his business from Port Alberni, on the west coast of Vancouver Island, to Campbell River. His first priority was to find a suitable location from which to rent boats to fishermen, and he promptly decided on the spit by the river mouth because it seemed the best place to catch tyee. He quickly established a thriving business based on a rowboat that he designed especially for fishing chinook salmon. These clinker boats, although only 14 feet long and 3 feet wide, were sturdy and quick, and are still in service today. Built from yellow cedar, they weighed 75 pounds at launching, marginally more than the fish his customers were after. He soon added guide services and tent accommodation on the spit for the many who were prepared to sacrifice creature comforts at the Willows for proximity to their preferred fishing grounds.

By 1930 Ned, eager to expand, purchased a strip of land across the river and constructed permanent cabins,

establishing Painter's Fishing Resort. A dining room was soon added, but to the exasperation of the cooks everything was focused on fishing. Even the meal schedule was dictated by the tides. Increasingly, prominent members of society began to patronize his business, most notably the King and Queen of Siam in 1931. It is said that the king suffered an exceptionally virulent bout of "tyee fever" during his stay.

Amazingly, such was the quality of fishing that the Depression had little or no effect on business, and more anglers arrived each year. In 1938 Painter's Lodge was opened, a wood-and-stone building on the waterfront that commanded a spectacular view over Discovery Passage and Quadra Island. From the outset, June Painter, a warm-hearted but fastidious woman, marshaled her staff and five children alike to maintain an atmosphere of rustic elegance, which pleased guests of all social levels, many of whom became friends and return guests over the years.

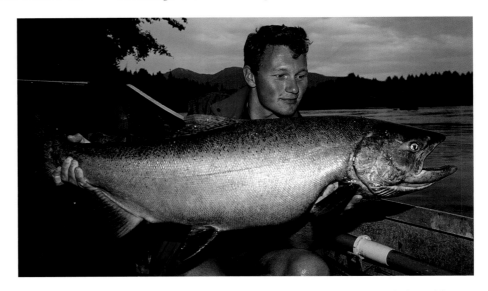

To obtain Tyee Club membership, an amateur fisherman must land on light tackle a chinook of no less than 30 pounds. Trolling under motor power disqualifies, as does handling of rod or gear by anyone apart from the angler.

Ned Painter sold the lodge in 1948, but by then the legend of Painter's Lodge was established. Over the next forty years the lodge saw four further changes in ownership, but no one dared to change the name. Stars such as John Wayne and Susan Hayward still adored the lodge and would continue to mix martinis between productive fishing excursions. Sadly, the original lodge burnt to the ground under mysterious circumstances on Christmas Eve 1985, but the Oak Bay Marine Group, spearheaded by the colorful Bob Wright, purchased the land and set about restoring the name Painter's to its former glory. In rebuilding the lodge they kept several prominent features from the original design, such as the grand fireplace, while tailoring it for the discerning modern traveler.

The sheer size and polished ambience of Painter's is striking. As you walk in there is a grand staircase on the left leading up to the Tyee Trophy room, whose walls are graced with a number of historic photographs featuring statesmen, stars and captains of industry.

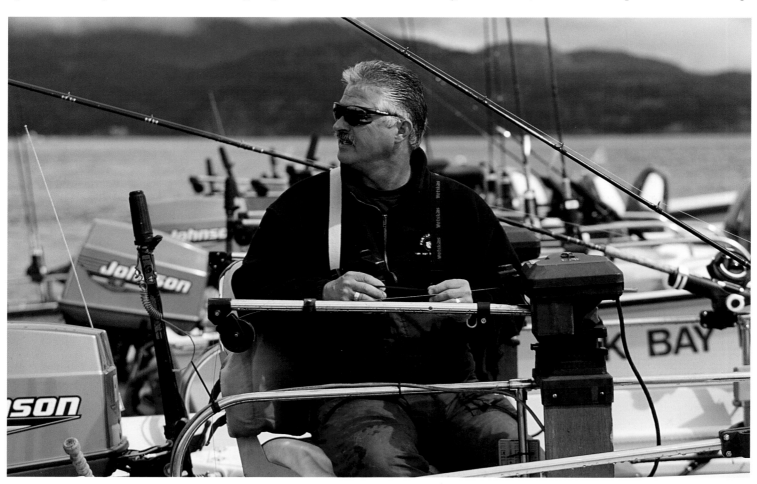

A guide prepares his gear on one of Painter's Lodge's 50 Boston Whaler fishing boats. In the foreground is a guide's best friend, an electric Scotty downrigger, built in nearby Victoria, British Columbia.

Ninety-six bedrooms, immaculate lawns, flowerbeds exploding with color and tiled swimming pools are not features that exactly spring to mind when conjuring up images of a fishing lodge. Creature comforts are not sacrificed here, a policy that has enabled Painter's to broaden its appeal to groups that would not normally consider fishing, or to people who enjoy fishing but know that there are other joys in life. Make no mistake, fishing is still the focus, as the lodge owns over fifty Boston Whalers, which go out several times a day. But for those who do not come here with rod in hand there are myriad other satisfying activities.

The highlight of our trip was definitely the combined wildlife adventure and rapids tour. About 20 miles north of Campbell River, Discovery Passage dissolves into a network of beautiful, tightly packed islands. To catch a glimpse of these alone is worth the trip. At the extremes of the tide, water flowing to and from Georgia Strait, a vast expanse of water to the south, must pass through the narrows between these islands. This large volume is essentially funneled through, generating currents up to 15 knots and standing waves sometimes 5 feet high, not to mention gigantic whirlpools. We shot these several times at speed so that the Zodiac cleared the water before coming down with a crash and a soaking for everyone. Everyone wanted our guide Jack Springer to continue, but he knew something far more interesting was about to happen. At the peak of the tide, the upswell from the ocean floor is so irresistible that juvenile hake are hurtled to the surface, where they struggle in vain to dive against their inflated swim bladders. Local bald eagles are well versed in this phenomenon and gather in the hundreds waiting for the helpless fish to start surfacing. Once this happens, they take to the air en

A rising Pacific salmon is the logo of the Oak Bay Marine Group, the largest sport-fishing operation in North America.

masse and proceed to rake the surface with their razor-sharp talons. It's incredible.

The icing on the cake was stumbling across a pod of twenty killer whales on the return journey. Jack managed to intercept their path so that when the engine was turned off these powerful, yet graceful, creatures passed directly under the boat and surfaced just feet away. We were the only boat for miles around and the experience left a powerful impression on all present. Back at the Tyee Pub in the lodge, we were able to watch the pod pass by Campbell River on their way south. They showed off with a series of spectacular breaches.

Oak Bay's acquisition of their main competitor, April Point Resort on Quadra Island, has proven an inspired move. This "sister lodge," with a worldwide reputation of its own, was founded in the 1940s by Phil and Phyllis Peterson. The rustic charm of April Point complements the more polished Painter's atmosphere perfectly. A shuttle connects the two lodges. This allowed us to indulge our passion for sushi at April

Point and visit Quadra Island's renowned resident author, Hilary Stewart, a delightfully quirky lady who lives nearby and kindly enlightened us on several Native fishing techniques.

According to Wayne Dregger (head guide and dead ringer for Ernest Hemingway), Campbell River can still boast that more salmon are caught per hour fished than any other area. The local waters are home to resident chinook that dine on herring and sand lances, and are directly in the path of millions of migrating salmon of all five species. This means that fishing is possible year round, but seriously good from mid-June to the end of October.

One unfortunate consequence of visiting at the beginning of the season was that the weather was not the only thing that had not warmed up yet. It was a breath of fresh air when our guide, Craig Robertson, informed us that he was determined to put us on to some chinook. After securing full-body weather suits for us, he took us to his favorite spot, just south of the lighthouse on Quadra Island.

Despite his efforts, when the moment of truth finally arrived I did my best to ruin everything. Somehow I had locked my rod onto the rod holder so that when the chinook struck, not only did I nearly tear the holder from the railing but I also caused the boat to tip violently to the other side, unseating my fishing partner and embarrassing myself. Fortunately, the fish was still on by the time I managed to free the rod, and I was able to experience several savage runs from the spunky 12-pounder before practicing my long-distance catch-and-release technique.

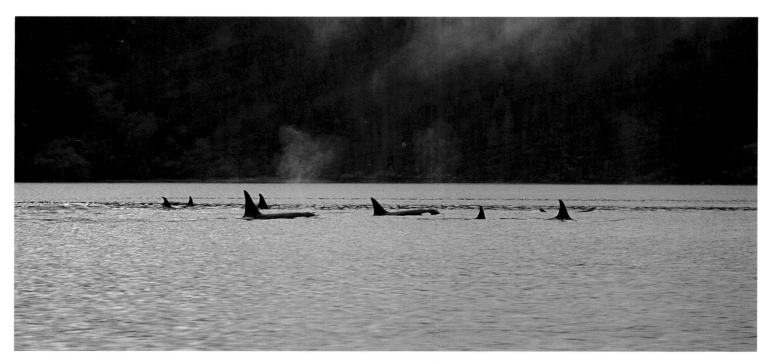

A pod of killer whales on their way south through Discovery Passage. This group feeds exclusively on salmon, unbiased testimony to the rich waters off Campbell River.

*Discovery Passage's waters attract an assortment of wildlife, including killer whales, minke whales, stellar sea lions,
Pacific white-sided dolphins, bald eagles, sea otters and black bears. Eager adventurers often hold their breath
as killer whales dive under one of Painter's 23-foot Zodiac eco-tour boats.*

In May we were using downriggers, but the preferred fishing method varies according to which guides you are with and what species are in. Trolling a cut-plug herring, a method first employed by the Native people, was standard practice, but most people have switched to downriggers to pursue trophy chinook, after noting the success of commercial fishermen. These provide controlled-depth fishing with spoons, plugs or herring, and once released from the clip leave you to fight the fish without a weight. Other methods include mooching, a form of jigging with live bait or lures, and power mooching, which involves skillful manipulation of the boat engine against the prevailing tide to keep the boat perfectly still. At times a guide's job can be very easy, as hoards of hungry fish are devouring everything in their path. Then occasionally they'll entertain you with bald-eagle impressions in an attempt to attract one near the boat with a spare herring. One thing is certain, don't leave your camera behind. On the mysterious waters of Discovery Passage, there is always something going on.

If it's glory you're after, forget the downriggers and motorboats. Find yourself an Olympic rower in a clinker boat and make for Frenchman's or Tyee Pool.

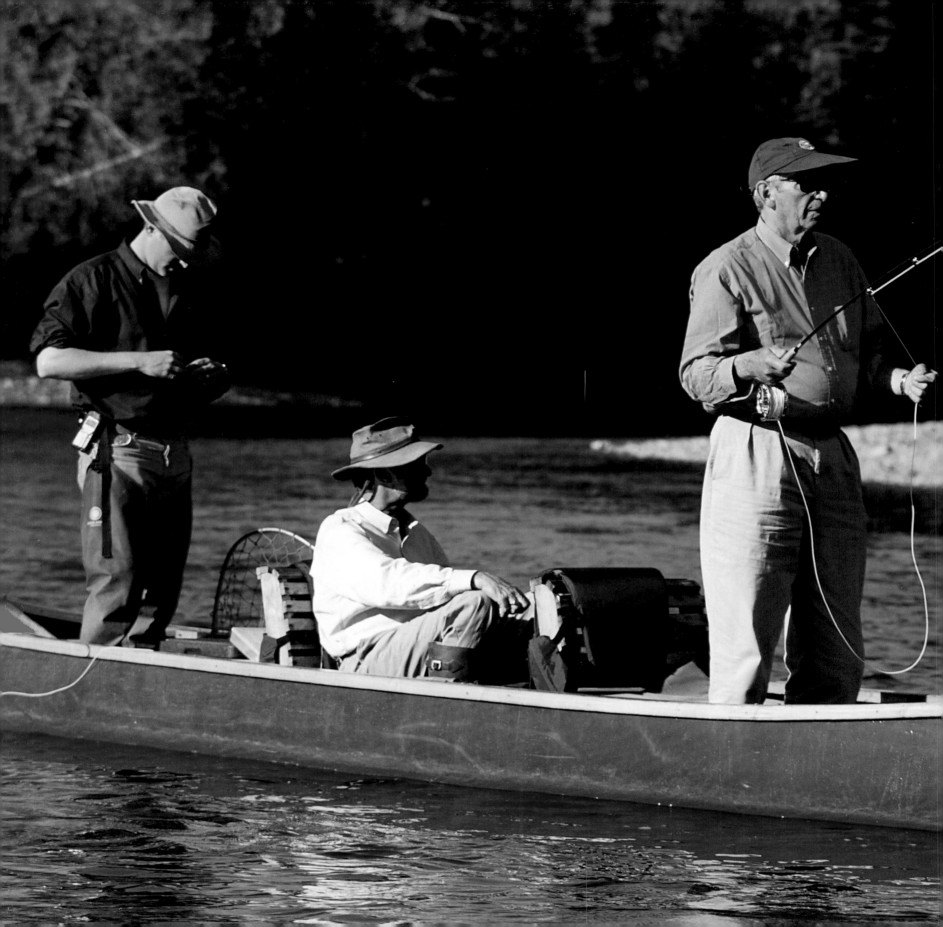

Camp Brulé

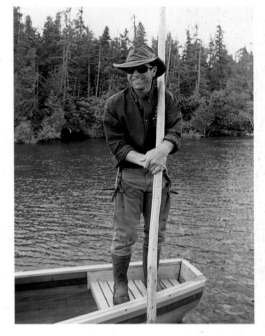

"They're monsters, gentlemen," proclaimed head guide Tom McWhirter. "There's some so big that they run straight downriver at full tilt. No amount of the fastest poling will stop them. There's just no sense to the screeches coming from the reel."

The idyllic Petite Cascapédia River tumbles down from the Chic Choc Mountains of Quebec's Gaspé Peninsula to empty its brilliant turquoise waters into the Baie des Chaleur at New Richmond. For nearly a century it has been overlooked and left to the few who have appreciated its real worth. With strong runs of salmon in recent years, it can be ignored no longer. Owned by Ron McWhirter, Camp Brulé controls some of the best and only private water on the river. Over a century old and managed by a family that has been present from the beginning, this timeless establishment cannot fail to stir the heart.

Mention the Gaspé Peninsula to any salmon angler and their eyes will instantly glaze over. The beginning of the Appalachians, with its lush ancient mountains and clear rivers, is the stuff dreams are made of. It is here that the roots of fly-fishing for salmon in North America grow deepest. The names of its illustrious rivers, such as the Bonaventure, Matapédia, Dartmouth and Grande Cascapédia, are music to the ears of salmon lovers. This latter river is undoubtedly the grande dame among the two dozen salmon rivers of this region, and one of the worst-kept

Guide and camp manager Kevin McWhirter works on a fly while a guest concentrates on covering Home Pool from a Sharpe canoe on the Petite Cascapédia River, Gaspé Peninsula, Quebec. INSET Guide Tommy McWhirter flashes one of his trademark smiles.

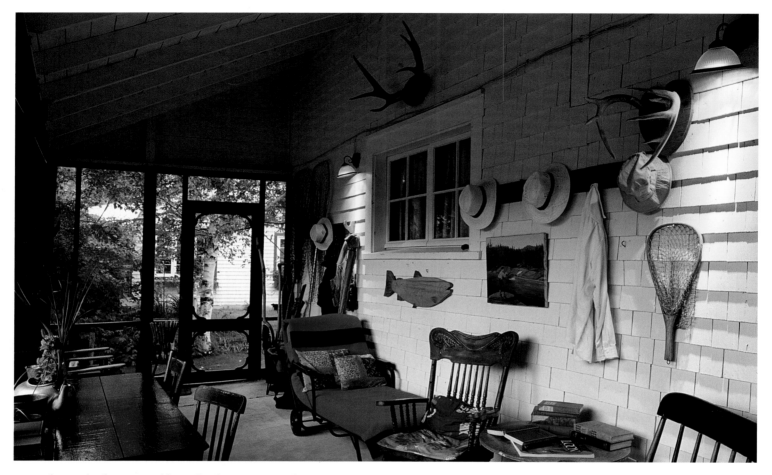

The porch of Camp Brulé. Until a few years ago, the screen bore numerous pellet holes from an incident in the 1950s when former owner Harry MacLean let off a shotgun blast over the then Minister of Air's drunken entourage in an effort to settle them down.

secrets in the fly-fishing community since William Logan, the celebrated geologist, conducted a survey of it in 1843. It is still famous for its huge salmon and the succession of illustrious people who have cast a fly to them.

The Petite Cascapédia has a very humble history by comparison. Unfortunately, this small, fast river attracted the wrong sort of people — loggers. What salmon stocks there were during the early 1800s had to contend with the inevitable silting of their redds by

runoff and regular scouring of their gravel beds by logs on their way downstream. Such was its plight that others used it as a warning of what might happen to other systems. In 1904 Edmund Davis, a prominent fly-fisherman, wrote that he was "scared that the [Grande] Cascapédia was going the way of the Little Cascapédia."

Despite the relatively few salmon and frequent logjams, the Petite was still seductive enough to entice ten businessmen from Montreal and the U.S. Together,

they formed the Little Cascapédia Fishing Club and leased most of the river in 1883. Perhaps they knew that this ugly duckling would flourish given time.

Initially, the club set up three main tent camps along the length of the river that served as bases for fishing forays. At the turn of the century these were replaced by permanent buildings. Camp Brulé was the first to be constructed and is the only one that stands today. In addition to these base camps, there were small campsites at each pool where members had the option of roughing it. One guide would be accountable for a particular stretch of river for the season and was expected to provide fishing services, food and shelter to sports. With guides, wardens and cooks, all told, the club employed forty-five people at its peak. Quite a few mouths to feed, especially when you consider that all provisions, including 30-gallon drums of kerosene, had to be poled upstream from New Richmond!

The McWhirters' association with the river probably predated that of the Little Cascapédia Club. Originally from Scotland, they settled in the region in the early 1800s and were, for the most part, woodsmen. In 1893 Ron's grandfather was hired as an assistant guardian by the club. Rait and Steve, James's sons, would follow in their father's footsteps, becoming respected river-men and future managers of the camp.

Probably the most eminent patrons of the original club were the Vanderbilts (U.S. railroad magnates). The granddaughters, May and Marjorie Field, accompanied by their mother, Lila, spent most of their

The Petite Cascapédia holds some of the largest sea-run trout on the East Coast.

childhood summers fishing the Petite Cascapédia. They were, by all accounts, exceptional fishermen who reveled in the woodsy environment and excellent sport. Two birchbark replicas of 30-plus-pound fish caught by Marjorie in 1932 still hang in the dining room of the camp.

In 1933 the Little Cascapédia Fishing Club disbanded, only to be replaced by another club that fizzled out during the Second World War. Ownership then passed to Henry Falkner Maclean, a huge, colorful gentleman who had made his name as an engineer during the war. Rait McWhirter was his second-hand man and camp manager, while Rait's wife, Ella, added the essential woman's touch.

Rait and Ella's work ethic and organization impressed Maclean so much that he sold them the camp and its riparian water for one dollar in 1957. For the next two decades they catered to individuals fortunate enough to be able to hire the camp and its staff for the entire summer. Tragically, a car accident claimed the lives of both Rait and Ella in 1974. Ron was working abroad and unavailable to carry on the family business, so Helen Campbell, Ron's older sister, took up the reins.

Having grown up on the river, Helen was no stranger to the business and quickly realized that the days of wealthy individuals hiring out fishing camps for the entire summer were numbered. Despite having no client list to speak of, she immediately set about converting Brulé to an outfitting lodge. Being the only female outfitter on the river was a challenge that she relished, and she soon stamped her own brand of

hospitality on Brulé, creating a charming, cozy enclave that was available to all. In addition, she set up a guide-training program that incorporated life-saving with the more traditional skills such as fly-tying and canoe skills. Her hard work paid off, and she rapidly developed a loyal following who used Brulé not only to fish its private waters, but also as a reliable base from which to try their luck on the neighboring Grande Cascapédia and Bonaventure Rivers.

After Ron retired from engineering in 1993, he assumed responsibility for Brulé and continued Helen's winning formula. His dry wit, intimate knowledge of the river and warm hospitality were a hit with the guests. He, too, oversaw improvements to facilities, but always took special care not to tarnish the genteel ambience. He readily acknowledges that the living history aspect of Brulé is something that all fishermen admire. The immaculate, white clapboard buildings, including an ice house, cook's cabin and guides' quarters, stand just as they did a century ago.

Kevin, Ron's youngest son, has recently taken on the dual responsibility of head guide and camp manager after relinquishing head guiding duties to Tommy MacWhirter, a distant relative. Kevin is passionate about fly-fishing Brulé and the Petite Cascapédia. A guide at the camp since the tender age of fourteen, he knows the river better than anyone apart from his father. He sees a bright future and is quick to point out that, unlike most Atlantic salmon rivers, the Petite is on the up thanks to prudent management, including a catch-and-release

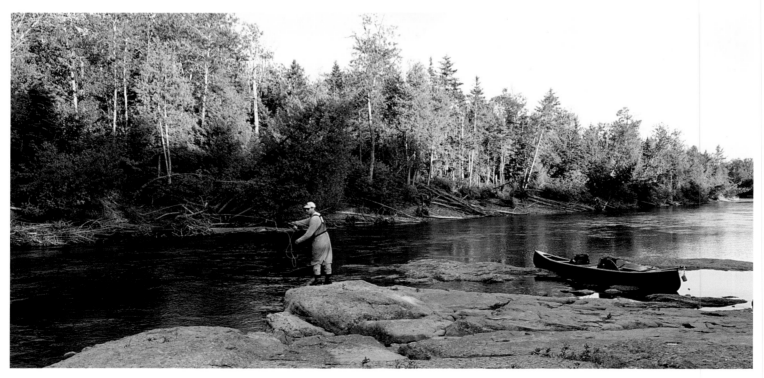

Due to prudent management, including a catch-and-release policy and various restoration projects,
the Petite's salmon run is up as much as sevenfold from late 1970s and '80s.

Chairs overlooking Camp Brulé's Home Pool, a view enjoyed since 1883 when ten businessmen and clergymen from Montreal and the United States formed the Little Cascapédia Fishing Club and leased most of the river.

policy and various restoration projects. In recent years the return of salmon has remained consistent, with run totals of up to 700–800 fish, as opposed to runs of 100–200 in the late '70s and '80s.

The fishing experience one can expect today differs very little from that of yesteryear. Sharpe canoes, originally designed for the Grande Cascapédia, play an integral role. At 26 feet long and 450 pounds wet, they are too bulky to be paddled efficiently by one person. The only practical way to control them in heavy water is with a pole. Basking in a reclined wooden chair while the guide digs his solid spruce pole into the gravel below with a satisfying crunch is a truly memorable experience. As you soak up the sights of the river, giddy with anticipation, the guide remains perched on the stern, constantly scanning the clear waters and more often than not giving a highly entertaining running commentary. We found that the number of expletives was inversely proportional to the amount of salmon holding in an expected spot!

Gaspésian anglers whose mothers happened to die while they were fishing have been known to direct siblings to keep their dear mamas on ice for a couple of weeks because the fish were "in." This intensity is a little extreme, but not too far off the mark when trying to describe the commitment of Kevin and Tom, the main guides at Brulé; they seemed to experience our trials and tribulations almost as keenly as we did.

As with all rivers in Quebec, the Petite's waters are mostly public and controlled by the local ZEC (zone d'exploitation contrôlée). Camp Brulé is the only establishment with riparian water and has exclusive rights to almost 4 miles. Jack Louis, Home Pool and Julian's Hole are some of the best pools on the river. I found Jack Louis and Home Pool so beautiful and tranquil that it was impossible to feel any animosity towards stubborn fish that refused to play by the rules. Because the camp is only 4 miles from the sea, the fish that are hooked are usually bright and fight like devils. The first run, consisting mainly of big salmon averaging 13 pounds, starts around mid-June, peaking in early July. After this there is a steady flow of grilse until the late run in mid-to-late August.

The record fish taken on the Petite Cascapédia is 45 pounds, but generally any fish over 20 pounds is considered very respectable. There is also a decent run of football-sized sea-run trout, which provide entertainment throughout the summer.

Most fish are caught on wet flies using a floating line. Dry-fly conditions are optimal during most of the season. According to the sages at Sexton and Sexton, the excellent little fly shop in Grande Cascapédia, any fly will do well as long as it's green. Kevin and Tommy go along with this, but in addition to your Green Highlanders, Stoneflies and Cossebooms, they will gently encourage other patterns such as Undertakers and Black Dose. If you take a break on the river, I would suggest you hand over the rod to your trusty guide and

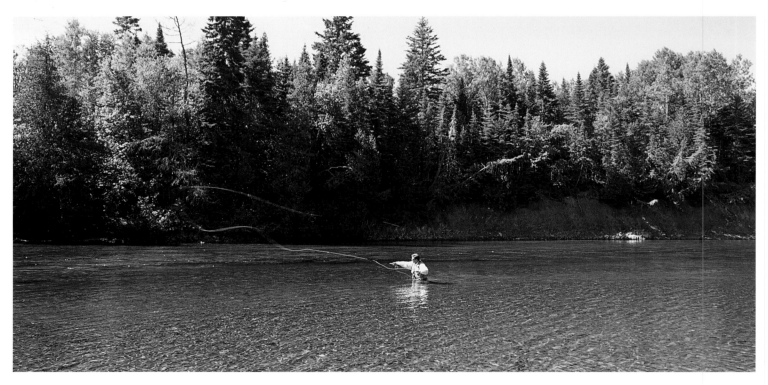

A fly-fisherman brushing off the cobwebs after a long winter. The clear aquamarine water of the Petite Cascapédia River allows anglers to sight-fish almost exclusively. Top-performing fly patterns include Green Highlanders, Cossebooms, Undertakers and Black Dose.

observe why fly-casting is generally considered to be an art form.

Ron and Kevin work closely with managers of the local ZEC, owners of riparian water on the Bonaventure and Grande Cascapédia rivers and the "society" that controls the latter's public water. The lodge sleeps thirteen people, and having room for only six rods per day on their own water means that it is in their interest to make other fishing opportunities available. With notice, fishing on a preferred stretch can be organized. Likewise, if people have made their own fishing arrangements, they are welcome to take advantage of the comfortable accommodation and excellent cuisine.

There can be few places more alluring than a seat on the screened porch of the main lodge in the twilight. Listening to the water bustle through Home Pool while sampling a cheeky beer or the divine smoked salmon and mustard brings a whole new meaning to pleasure. The dinners that follow are almost worth the visit alone. Ron's wife, Donna, has changed the meals to better reflect a healthier lifestyle, while maintaining the traditional Gaspesian menu. All meals are tailored to the needs of the angler and include several local delicacies such as lobster and fiddlehead soup.

To stay at Brulé is to experience the romantic heyday of salmon angling in North America. As Ed Belak, a regular at Brulé, said: "Why do guests come to Brulé? Fourth generation means a lot to people. Private water, history and lore. Tommy is

one of the best guides in the area, and Kevin is the best guide on the river by far." A visit to the "Jewel of the Petite Cascapédia," as Bill Taylor, president of the Atlantic Salmon Federation, described it, is not to be missed.

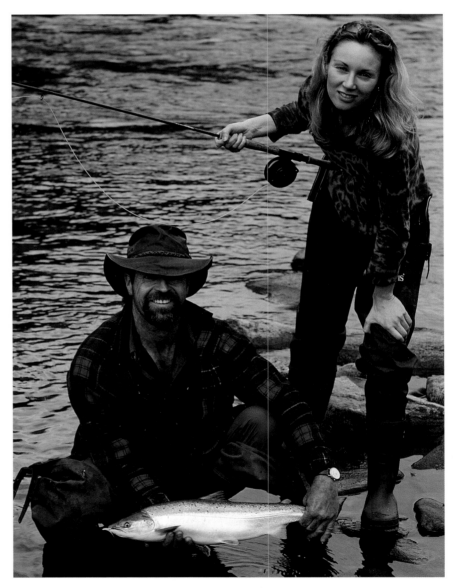

Guide Tommy McWhirter holds out a happy angler's first grilse, taken from Julian's Hole, just downstream from Camp Brulé.

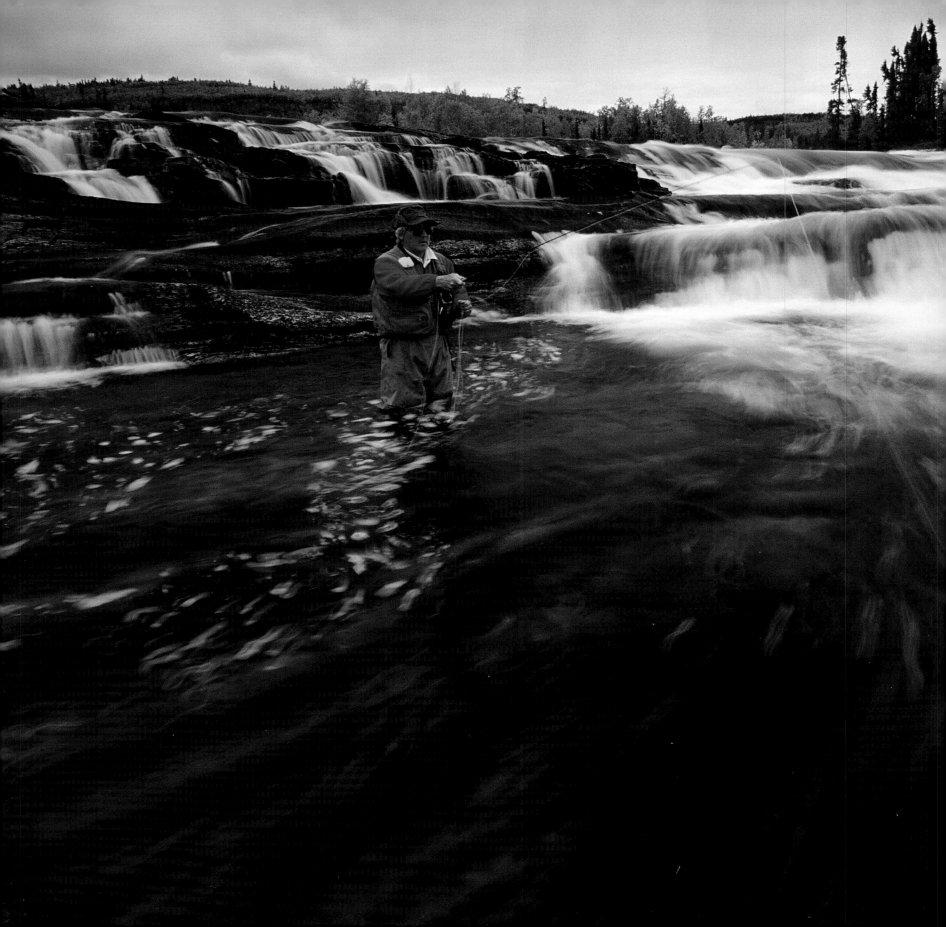

Scott Lake Lodge

hance spawns opportunities in many amazing ways. In the case of Scott Lake Lodge, a botched commercial fishing venture in the late 1950s led to the creation of one of Canada's premier lodges and fishing destinations.

Scott Lake's first and only commercial operators painstakingly and laboriously built six large fishing boats in anticipation of harvesting lake trout and whitefish. But they abandoned everything shortly after their first catch, as to their horror and their bank book's detriment the fishermen discovered that the whitefish of Scott Lake contained cysts, making them totally unmarketable. This was a blessing in disguise for the lake and its finned occupants, and curiously, is evidence of one of few documented cases of fish evolving natural defense mechanisms against commercial fishermen!

Inspired by testimonials attesting to magnificent numbers of fish, in the mid-'70s the Woloshyn family quickly snapped up all the boats and huts of the ex-commercial camp and set up an outpost there. A well-preserved example of the original commercial boats used by the lodge's first sports guests still lies by the water on the lodge's island, known as "Tundra Island." It is an enormous boat with a considerably deep belly and high gunnels. Due to the extreme weight of the boats, they were slow-moving, which forced guests to fish in close proximity to the lodge, leaving miles of shoreline and open water totally unfished and unexplored.

Far from the nearest television, Tom Klein fishes a Lefty Falls grayling pocket in Northern Saskatchewan on September 11, 2001, unaware of the horrors unfolding far to the south, in New York City. INSET The skull of a "water wolf" (northern pike) adorned with a collection of choice lures.

The morning rush hour. Boats race off through the maze of islands on Scott Lake towards the guides' "offices," their favorite pike bays and shoals harboring late fall lake trout.

There is definitely no confusing Scott Lake Lodge today with an outpost camp from the '60s. Tom Klein, the lodge's fishing-fever-inflicted owner, who purchased the lodge in 1996, has spared no expense in creating a first-class fishing playground. Despite accommodating only twenty-four guests maximum, the lodge complex is considerable, with over twenty buildings distributed around the 4-acre island. Impeccably maintained trails of fresh, fragrant spruce chips wind throughout the island, connecting the cottage-like cabins. Trails are lined with stones, sun-bleached caribou antlers and small spruce shoots, cut to measure. An

Inukshuk, a human-shaped stone structure and welcoming symbol of the North, stands proudly at the roundabout, where all island trails meet.

Modern guest cabins line the shore, peering through birch branches out at the lake. Above them, on the peak of the esker, the highest point on the island, stands the main lodge, like a church in a small town, towering over its flock below. In place of a steeple are two solar panels, tilted to face south, covering most of the roof like a giant satellite. These are the quiet, pollution-free generators that produce the majority of the lodge's power and don't impede the sounds of nature. The panels are symbolic

of management's desire to have the lodge run in a manner that ensures that it remains innocuous within its environment. Surrounding the lodge is a large wooden deck, a favorite evening spot for guests to sit and sip cocktails and look out over the fiery western sky. After dinner, guests gather around the firepit in front of the main lodge, seated on pine rounds, to smoke cigars, sip scotch, sing songs, laugh at the day's experiences and gaze skyward in the hopes of glimpsing the arrival of the aurora borealis.

Scott Lake is not the end of the world, but you can almost see it from here. It straddles the 60th Parallel, and guests fish in both Saskatchewan and the Northwest Territories during their stay. It's the farthest away from civilization that most of its guests will ever get, and is like another planet to many visitors, who rejoice in it in ways that don't always involve fishing. Non-fishing activities include kayaking, overnight canoe trips, tundra hiking, exploring the area by floatplane or observing the resident wolf pack on a neighboring island from the deck of the lodge's artists' studio. The lodge and its staff strive to provide opportunities for guests to interact with the land and sample its profundity.

This land has many spirits and sacred places, many of which are intertwined in the folklore of the area's Natives. The most famous spirit is that of a medicine

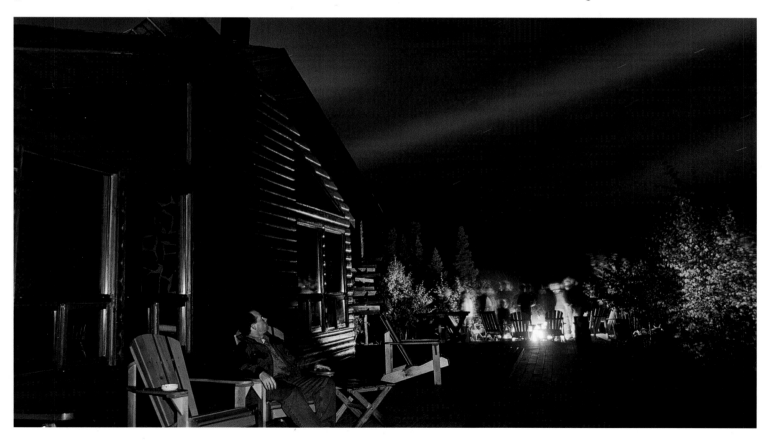

The northern lights make their ghostly appearance in early September. If the skies are clear, it is a nightly show.

man who lived for four centuries near Scott Lake. Special powers enabled the man to exist embodied in the form of a human for two centuries and as a wolf and pike for one hundred years each. In his final demonstration of magical healing, he sucked the illness out of a dying boy, sacrificing his life to save the child. Natives from Fond du Lac still make pilgrimages to his sandy grave, not far from the lodge, to gather bottles of medicinal soil, leaving canes, rosaries and smoking pipes as gifts. Perhaps descendants of his offspring still haunt the reefs and bays of Scott Lake.

Tom's mandate from the start was to create a Peter Pan-like fantasy island — a philosophical revolving door where men arrive but leave as boys. Perhaps Tom Klein prefers to surround himself with people who, like him, have lost track of time, succumbed to the enlightening power of the North, and who share his devil-may-care spirit. In 2002 he fished over eighty

days with guests and on his own. Tom is a man who leads his guests and his guides by example. He is like a cat, laid back and content, except when he's hunting or exploring, when his true prowess and intoxicating love of fishing are exposed. For Tom, every fish brought to boat is akin in pleasure to his first big trophy fish — he's ecstatic every time.

During our visit to Scott Lake, Tom guided us on the lodge's hiking trail, which circumnavigates a small lake on a neighboring island. It's called the Tundra Trail because of the openness of the terrain and the pillow-soft, turquoise-colored caribou moss that carpets the rolling eskers of the island. "Where trees meet tundra" is a good way to describe the forest environment of the area. Here, the taiga begins at the tail end of the giant boreal forest that stretches up from the northern United States. The forest is open and bright, permitting freedom of movement. The ground is a

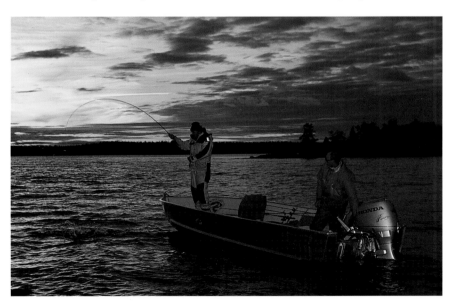

An evening drift over one of Scott Lake's countless shoals that in September offer outstanding fly-fishing for lake trout. These brightly colored fish are easily spotted in the clear, shallow water.

mosaic of colors and textures. Coarse sphagnum moss that looks like fine bleached coral grows in mounds and crunches satisfactorily underfoot. Small patches of bearberry, crowberry, bog cranberry and Labrador tea bush creep and weave around the moss. Lichens cling to almost every conceivable surface — rocks, the ground and the bark and limbs of twisted jack pines and ragged-looking spruce trees.

Tom's knowledge of the area is considerable, his talents and interests clearly not only piscatorial, as he filled our brains with fascinating details on the area's ornithological and biological wonders throughout the half-hour hike. It would appear the man also has a master's degree in scat, as he often bent

over and read off the previous night's dinner menu of the island's resident wolf pack with consummate ease. As we walked back to the beached boats, we followed in the tracks of wolves whose paw prints were larger than a man's hand.

We were fortunate to be visiting Scott Lake in the fall, the most colorful time of year. Skinny birch trees, anonymous throughout the summer against the green backdrop of spruce trees, scream out their new identities with bright yellow and orange leaves, which rattle together in the breeze over bouldered shorelines. Intensely blood-red blueberry bushes crouch low and tight against the shoreline's green and gray lichens. The air is cool and sharp, a prelude to the impending six-month ice age. When the northerly winds blow, the sky echoes with the bizarre and overwhelming sound of colossal flocks of geese, miles above, sometimes numbering in the hundreds.

Below the water's surface, too, new color and powerful forces are emerging. The normally olive-and-bronze lake trout are transforming into their warrior patterns of red, gold and white, rising up from the depths and storming the shoals in a spawning fury. All hail to the glory of the fishermen who are fortunate enough to be on the angling battlegrounds with these fish of the fall. The trout are almost unrecognizable in their coloring, and the summertime sport they provided to anglers is a fraction of the brutish strength they now possess, invigorated and recharged by both hormones and the oxygen-rich cooler waters of fall.

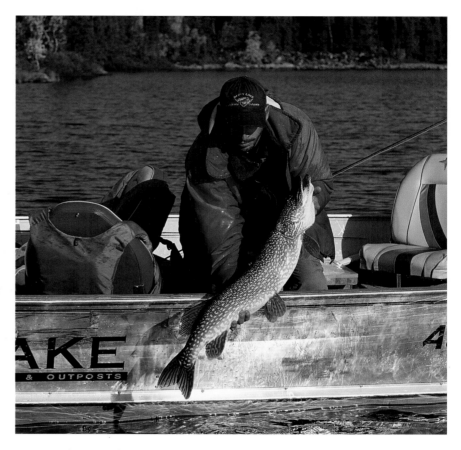

Pike are a phenomenal game fish on the fly. Some of the flies provided by Scott Lake Lodge guides are variations on flies used to catch sailfish, barracuda, and other saltwater species during the company's annual pre-season trip to a tropical destination, before the serious work begins.

The techniques required for catching these fish are not complex — there are simply too many fish to miss hooking up! Ideal conditions are clear skies and wind chop on the surface. In an initial approach on a shoal known to be a breeding spot, guides position the boat upwind from the shoal so that with motor cut a drift is made with the breeze over the 2-to-6-foot-deep shoals. Spinners, spoons, jigs and brightly colored Deceivers, Whistlers and Bucktail fly patterns are all hammered hard. Half a dozen 4-to-8-pound lakers can

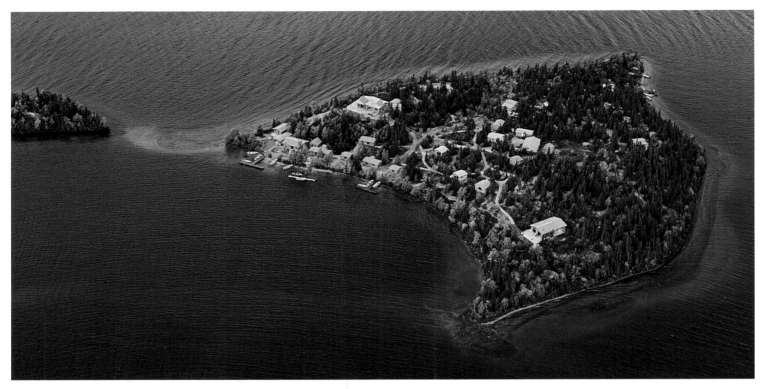

Tundra Island, home to Scott Lake Lodge. As is common with many northern lodges, all equipment and materials used to build the lodge and camp was flown in by floatplane and ski plane.

often be observed chasing each other and flies. Once hooked, even the smaller fish fight like salmon, with the power of a river at their disposal, taking out line and bending 9-weight rods straight over. Battles of five minutes for average-sized fish were not uncommon for us, despite intentionally trying to muscle in each fish so that we could enjoy the thrill of hooking another before the drift ended. The new colors of the fish are one of nature's finest works of art, and each specimen was admired by all before release. The experience is all-consuming, monopolizing the mind and body and exhilarating the soul in a flurry of activity. Many times we took pleasure in the chaos of a triple-header; lines crossing, fishermen barking out orders to each other.

Shakespeare believed that "the pleasantest angling is to see the fish, cut with her golden oars the silver stream, and greedily devour the treacherous bait." I don't believe that Shakespeare ever visited Northern Saskatchewan or the Northwest Territories, yet these verses so aptly portray pike fishing in the clear waters of Scott Lake. Sight-fishing for pike, or "jacks" as they're affectionately called, is one of many unique fishing offerings on Scott Lake, and certainly the most thrilling.

Scott Lake is vast, and its perimeter is a continuous, undulating wave of inland bays, which are ideal for pike. Big pike cruise the shorelines and shoals in late summer and fall, but lie like suspended logs in shallow

bays in the spring. It is during the early months of the season that anglers and guides hunt these shallow bays from boats, engaged in the act of fish spotting, or better, fish stalking. Pike just short of 50 inches are taken every year. Pike so heavy and menacing in appearance they make you weak in the knees just looking at them. And in the hungry two months after ice-out in early June, they'll hit anything, especially flies. Sometimes, the bigger flies attract the larger fish. With a stout rod, your guide will happily tie on a foot-long or bigger saltwater fly, used for targeting sailfish or marlin and procured in Costa Rica. This fly is slightly risky — hitting yourself with it could lead to a medical evacuation! But if you can cast it safely out in the general direction of a cruising behemoth, a hook-up is virtually guaranteed.

During the first couple of months of the season, these violent, angry animals will hit any gear or fly offered to them. They can be quite obliging, dear creatures. Each guide, though they might not freely admit it, has their coveted groves of "cabbage," or underwater forests of thick weeds and grasses that harbor duck-eating water wolves, a.k.a. pike. The more productive patches will guarantee an angler's participation in the after-dinner awards ceremony, where trophy pins are handed out to those who land a pike over 40 inches, lake trout over 35 inches or grayling over 15 inches. In 2002 there were 922 pins awarded for pike, 326 for trout and 171 for grayling.

The lodge does have rules, one of which stipulates that anglers must practice CPR on all trophies — that's catch, photograph and release. Every fish caught goes back from whence it came, except those sacrificed for shore lunch. Smaller pike kept for lunch go on to make the lodge's incredibly delicious KFP, or Kentucky Fried Pike, a nose-clearing, belly-warming concoction of pure happiness and spice, or else a healthier gourmet baked dish. Shore lunches at Scott Lake Lodge are extravagant, and indicative of the staff and management's constant goal to exceed the expectations of the guests and surprise them with non-traditional lodge activities.

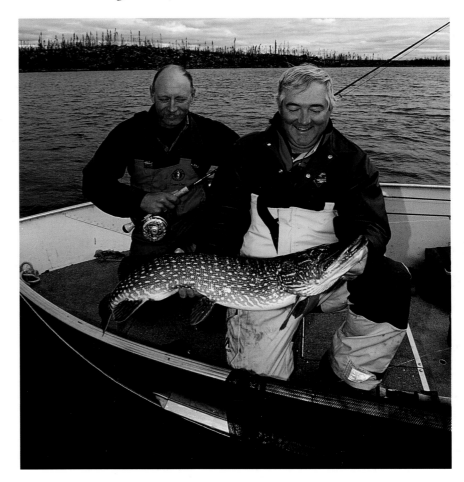

Lodge owner and author Tom Klein hoists a fat fly-caught pike.

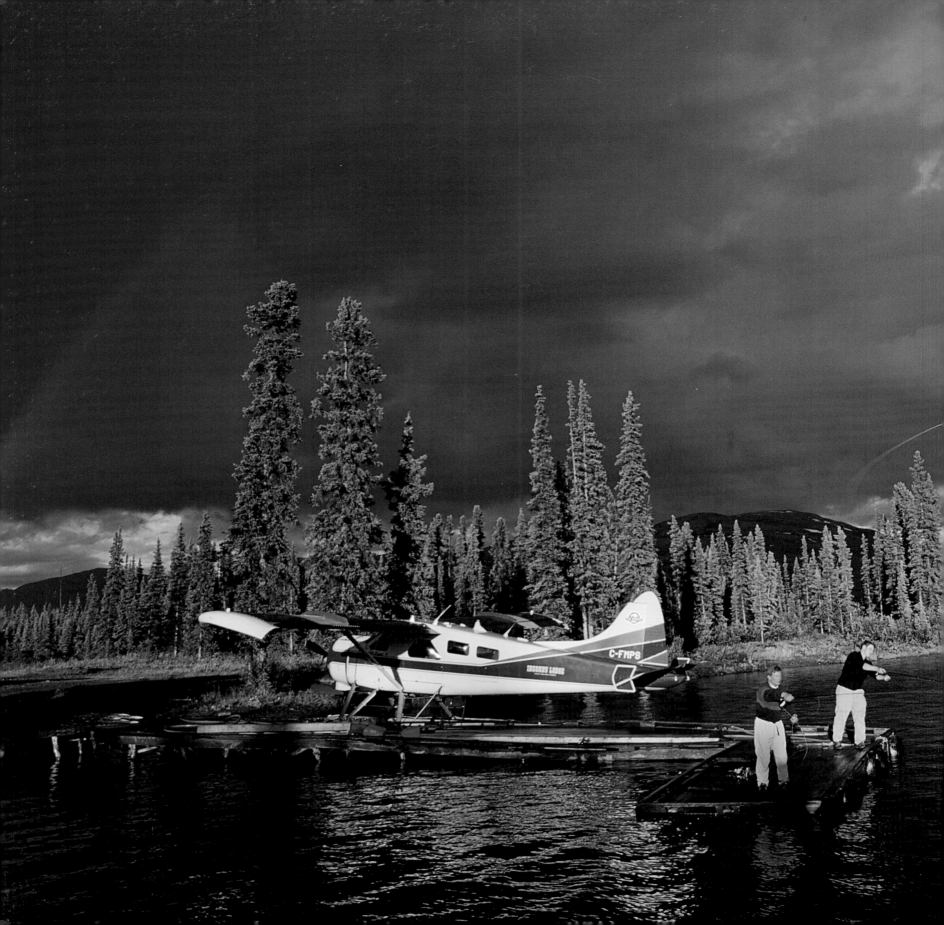

Inconnu Lodge

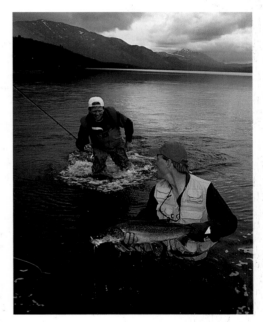

F riends joke and cajole as eager fishermen are hauled and helped up into the cold steel belly of the de Havilland Otter on the runway of the airport at Whitehorse. Greetings and smiles are liberally exchanged between strangers. Laughter and excitement prevail, and the anticipation of the paradise that awaits over the mountains, 185 miles to the east, has grown men giddy. As we leave the valley paved by the Yukon capital city of Whitehorse behind, the landscape below transforms into a mosaic of lichen and mosses tinged with pinks, olives, vibrant greens, yellow and red. Multicolored grasses border patches of tall, skinny black spruce trees, and there is water everywhere. Beaver ponds, bogs, lakes, creeks and rivers shimmer like pewter as they twist and carve the land.

The shadow of our plane grows and rises to greet us before disappearing as we weave our way through high mountain passes. All foreheads are pressed against the windows as we struggle to extend our view of scenery that is new to most of us. The land is stunted but consuming, and it commands attention. An hour and a half later, the huge "tundra tires" on our plane touch down and gently absorb the bumps on the 4,000-foot airstrip above the lodge. The latch on the door is snapped open and we clamber out into the crisp, fresh air and bright sun. Awaiting us on the fireweed-lined airstrip is the lodge school bus, which will take us down the winding road to the lodge complex at the base of the hill.

Inconnu's de Havilland Beaver, aerial workhorse of the North, rests between flights while anglers cast dry flies to rising grayling. INSET The elusive inconnu, or she-fish, is the largest member of the whitefish family and the only one known to be predatory.

The facilities, we discover, are luxurious and in stark contrast to the harsh, unforgiving environment of the Yukon landscape. We are reminded during the initial orientation session in the main lodge that despite attempts by our guides to protect us, we would still, during the coming week, be at the mercy of our surroundings and our own prudence, or lack thereof. Hypothermia, bear attacks, getting lost and helicopter prop injuries or death are all potential threats.

Five guest cabins and the main lodge sit side by side in a horseshoe overlooking a large, shimmering lake at the base of ancient Mount McEvoy, which looms large on the horizon. The cabins are constructed of imported red cedar and black spruce milled on-site and they glow with a golden hue in the midday sun. Each of the buildings is built low, hugging the earth, so as not to impede the view of surrounding scenery. The heart of the complex is the 6,500-square-foot main lodge, which houses the kitchen, dining room, lounge and games room, conference room and tackle shop. It is mind boggling to think that every single piece of material and equipment required to build the lodge complex was flown in by Beaver — over a million pounds and 1,000 flights — by owner Warren LaFave during the three-year construction, which began in 1987.

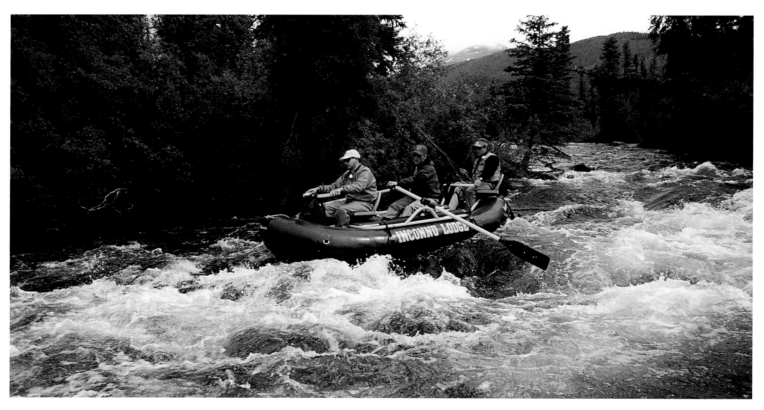

Pool-hopping on McEvoy Creek in pursuit of tight lines. Elk Hair Caddis and Green Humpy are especially productive fly patterns here. Some of the rivers and creeks around the lodge are clearer than aquariums, allowing guests to pick out a specific fish, whether it be a Dolly Varden, grayling or lake trout.

Stepping through the front door is like entering a natural history museum of the Yukon. The walls are decorated with the tools of the trade of early fur traders and gold prospectors. Gold pans, old snowshoes tied with sinew, and traps of all shapes and sizes hang on display under the gaze of mounted moose, grizzly bear, lynx, caribou and mountain-sheep busts. Historic photos of the Klondike Gold Rush create a theme for the dining room. Trophy-size replicas of burbot, grayling, inconnu, lake trout, char and pike hang from the walls or peer out from glass cases in every room as constant reminders of why we are all here, and to what we can aspire.

A bull moose shatters the glassy calm of a remote Yukon lake. Guests travel over the captivating landscape in Inconnu's Hughes 500 helicopter.

The walls of the hallway between the lounge and conference area are covered with plaques from the International Game Fish Association and framed tributes from successful climbing expeditions to the famed Cirque of the Unclimbables, thanking Warren and Inconnu for the outfitting services provided to climbers. The Cirque is one of the seven wonders of the climbing world, located an hour's flight from the lodge, and is best known for its imposing 2,200-foot vertical face called the Lotus Flower Tower. Virginia Falls on the South Nahanni River has twice the vertical drop of Niagara Falls.

Creating a virtual city like Inconnu Lodge in the middle of absolutely nowhere is not an easy task, and not something that many are likely to get right the first time. However, Warren LaFave is a descendant of fishing-lodge owners and outfitters, his family having operated in British Columbia since the early 1930s. And Warren has had a little practice of his own, having

previously built, owned and operated three different resorts in the Yukon. He was so successful and popular with his previous clients that when he was building Inconnu, past guests insisted on coming and camping in tents on the property, despite the fact that neither a cooking tent nor bathroom facilities existed. Their confidence in him was absolute.

For Warren and his wife, Anita, who runs the lodge with him, the Yukon's allure isn't a shiny metal. Their "Yukon gold" is the vast untouched wilderness and largely unfished rivers and lakes surrounding their lodge. Only time and the 192 lucky guests who visit each year, 12 at a time, will behold what these new waters contain. That is unless Jigging Jack, Warren's friend, omnipresent lodge character and chief fish scout, a.k.a. Jack Beeler, has first crack with his box of magical jigs.

Inconnu is named after a rare predatory member of the whitefish family. Inconnu means "unknown or strange" in French, and the name was given to the

101

species by Alexander Mackenzie's crew of French-Canadian voyageurs, who encountered the fish during early explorations around 1789. The name is not only appropriate for the isolated fish but also for the land it inhabits, which for the most part remains strange and unexplored.

Across the lake, in front of the lodge, the view is dominated by Mount McEvoy. Tall, skinny black spruce trees stretch sporadically from shore to the treeline, clearly visible at 4,000 feet, 700 feet above the lodge. The mountain face is quilted with meadows and exposed, smooth rock, which is often covered in fantastic, brilliantly colored lichens in shades of yellow, green, red and purple. There is a fair amount of snow above the treeline, protected in the gullies near the mountain's peak. A large telescope on the main lodge porch enables viewers to scan the slope for wildlife, and if fortunate, track a grizzly bear as it meanders over the tundra terrain rooting for grubs and berries. The same telescope is used by guests and guides to plot the peaks of preference for alpine picnics and hiking routes in the surrounding mountains.

The lodge buildings not only house guests, but also a large population of barn swallows. Every porch roof has at least one cup-shaped mud hollow full of young swallows vocally encouraging their parents, who are continuously hunting insects above the lodge's front lawn. The swallows are a welcome natural mosquito repellent.

On the morning of July 16, still full from the dinner extravagance of the night before, we flew out by Beaver towards the Upper Whitefish River, approximately a half hour away. We landed on the feeder lake, beached the plane and proceeded to overturn and load two Grumman canoes, our transport down to the river. When we started paddling there were three moose spotted on different marshy areas of the lake's shoreline, so we paddled, like voyageurs on a money run, in an attempt to get our photographer passenger a good shot. All three were spooked by our canoes before we could get into adequate range. Paddling full tilt towards these moose was exhausting, and probably the best exercise we'd had in weeks

The Upper Whitefish River forms at the narrows of the lake's outlet. We paddled down the slow, meandering headwaters of the river, at one point scaring a moose with twin calves and shortly thereafter giving ourselves a good shock as the sound of our paddles alerted and flushed an enormous bald eagle from a carcass in the tall grass beside the shore. I could have touched its wings with my paddle had I tried.

We arrived shortly at the junction of the Upper Whitefish and a larger tributary. Pulling the canoes onshore and wading into the shallow river, we caught many small lake trout and grayling. Each hook-up produced a powerful fish on our 5-weight fly rods. The lakers, averaging 2 pounds, were a spectacle of color, their red fins tipped with white, their underbellies milky orange. I think they must be a different species than their larger, grayer, uglier cousins in the lakes. The Arctic grayling are worthy adversaries and accommodating sport fish deserving of their nickname, "sailfish of the North," with their top-water acrobatics and disproportionately large dorsal fins, used to lever

INSET *Fed by snowpacks throughout the summer, a river meanders its way down a valley in the MacKenzie Mountain range, named for explorer Sir Alexander Mackenzie, who traveled these rivers in 1789. His French-Canadian voyageurs fed happily on the inconnu and are responsible for the fish's name. It means "unknown or strange" in French.*

themselves against the current and pull hard away from an angler's rod tip. The grayling's sides are lilac purple, and their tall, deep blue dorsal fins flash with tints of gold and silver. The fish take Mickey Fins and Egg-Sucking Leaches aggressively. Mark, our photographer, barked out instructions as he documented the prettier specimens and a few triple-headers.

We kept a grayling and a small lake trout for lunch. While our guide was cleaning them, he realized that the four fillets we had would not be enough for the five of us, so I promptly cast out and hooked a nice grayling, which was bonked and added to the frying pan. We had a great lunch of fresh-fried fish, rice and salad, washed down with a refreshing Chardonnay and completed with peanut-butter-and-chocolate brownies. A camp policy aimed at minimizing the impact of shore lunches on the environment dictates that all lunches are to be cooked using portable propane stoves. The only fish that leave the lakes and rivers are those headed straight for the lunch pan, and they are caught on barbless hooks, another lodge-initiated conservation measure. Since its inception, Inconnu Lodge has always been catch-and-release, thus maintaining the populations of pike, char, lake trout, inconnu and grayling that are found in the twelve major rivers and streams and seventeen lakes that the lodge fishes.

After lunch, we paddled farther downstream to a small, grassy, treeless island that splits the river. Here, we beached the canoes and fished. The sun came out and burnt off the chill and fog in the air. Grayling, visible to us in the clear water, immediately began to rise to feed on the surface, and we took many on dry flies. Grayling really are the least particular game fish and will rise to almost any fly, requiring little or no stealth on the part of a fly or gear fisherman. Especially popular were Elk Hair Caddis and Green Humpy patterns. We renamed the stretch of river "the aquarium," as fish were visible all around us, enabling us to target specific fish with our flies. Most exciting was observing huge Dolly Varden char in violent feeding frenzies, occasionally attacking hooked grayling and sulking on the bottom with them clasped tightly in their jaws. Dozens of fish were visible at all times. We later caught a Dolly and a large lake trout, both weighing about 7 pounds each.

The most exciting roller-coaster ride you've been on is a mere stroll in the park compared to the thrill of

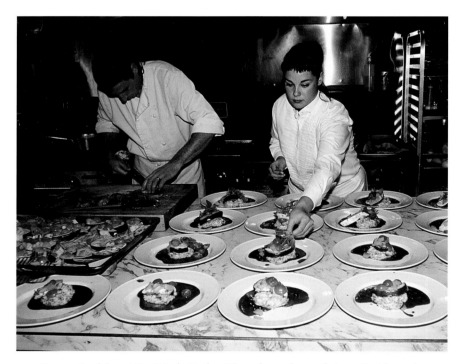

Gourmet cuisine at Scott Lake Lodge. Times have changed since Sir Alexander Mackenzie passed through McEvoy Lake over two hundred years ago.

flying in the lodge's Hughes 500 helicopter. You haven't lived until you've experienced the exhilaration and fright of flying in this Ferrari of helicopters, which can reach speeds of over 125 miles an hour. The day after our expedition up the Upper Whitefish River, Warren took us on an inconnu fish-hunting expedition. We really wanted a shot of this unusual-looking and elusive creature. After a wild ride up into the alpine, zipping between crests and peaks and hugging the smooth terrain at hair-raising speeds, the helicopter touched down gently at the mouth of Ptarmigan Creek where it flows into Pelly Lake. Warren has over 20,000 hours in his flight log — that's the equivalent of spending over two years in the air for 24 hours a day.

Mark hooked a mighty specimen on his first cast into the churning water. The fish had been holding right on the edge of the current, well out in the lake. Despite the initial success of the hook-up, the inconnu fought desperately to remain true to its reputation of obscurity, running deep into the lake and violently testing the line, rod and angler with heavy head shakes. At one point I had pinned the fish to win, but to my surprise, after a tremendous ten-minute battle, the inconnu was landed. Cheers of triumph echoed throughout the valley as we all crouched over the fish, examining its shining beauty and curious, prehistoric features. Afterwards, I spotted a huge set of grizzly prints in the soft clay shoreline not far from our helicopter. On the way home, we searched for caribou, scanning the colorful tundra meadows and flat mountain tops.

Well above the 60th Parallel, guests enjoy a campfire after dinner in the near 24 hours of mid-summer daylight.

We flew over the overgrown remnants of the Taylor and Drury Trading Company trading post at the end of Pelly Lake. Inconnu has an outpost cabin here for guests who want to get away from the luxuries of the main camp. The trading post was a bustling community of several families in the late 1800s and early 1900s.

We spent the evening catching grayling off the dock with other guests before eating an enormous meal of roasted herb-and-mustard-crusted rack of lamb with garlic mashed potatoes and a chicken-and-spinach roulade with ivory sauce. Dinner at Inconnu is always a relished event. Warren and Anita employ a talented executive chef, and the food is truly exquisite. After dinner, we toasted the day's generosity with other guests around the bar, while playing friendly games of pool and shuffleboard. Later that night, under the blue midnight sky, we relaxed in the hot tub beside McEvoy Lake.

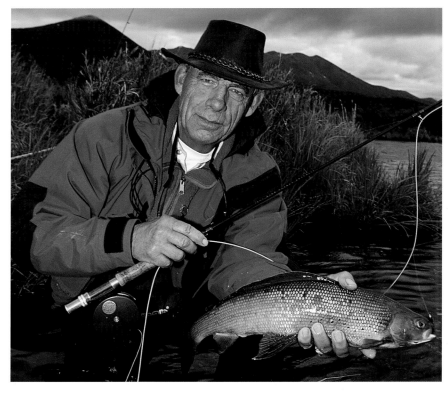

Inconnu fishing scout "Jigging" Jack Beeler displays a beautiful grayling taken on a dry fly. Arctic grayling are worthy adversaries, deserving of their nickname, "sailfish of the North."

The following day we had to cancel our alpine hike and lunch due to fog at higher elevations; however, this didn't impede the helicopter from flying, so our guide, Ken, quickly formulated an exciting alternative side trip. After loading the helicopter with fishing gear and lunch, we took off on the five-minute flight to the lake's outlet, McEvoy Creek. The helicopter touched down off a point of land in half a foot of water, and we slid out, crouching in commando fashion while Ken passed us the gear bags. The gusts from the blades threw clouds of mist in all directions, blowing off hats and soaking our faces. The chopper took off and quickly disappeared, and we were suddenly captured

by the exotic stillness of the place; silence has lease on the river valleys of the Yukon. A pair of trumpeter swans flew directly over us, the powerful beating of their wings clearly audible.

Awaiting us onshore near the mouth of the outlet was our river chariot, a Maravia inflatable raft. We loaded our gear and pushed off from shore, relaxing in swivel seats as our guide rowed us towards the hungry river mouth, where we were picked up by the current. We began to cast to fat graylings holding in small schools in the clear, shallow pools. A bald eagle fell forward off its perch in a tall spruce 300 feet away and landed on its outstretched wings, gliding effortlessly to intercept a struggling fish on the water's surface near our boat, snatching it in both sets of talons with precision. There was a tremendous rush as its massive wingspan thrust through the air and it triumphantly emitted a series of eerie, throaty shrieks as it landed back on its perch. We were spellbound.

Suddenly, the current picked up and we scrambled to break down our 5-weight Orvis fly rods and crouch low in the raft as we passed under a tree hanging out in the river. The river quickly narrowed, and we bounced and swayed as Ken thrust and maneuvered his oars in the water, guiding us between boulders and rushing whitewater that ended in a slow, even-flowing pool. The river continued patiently and smoothly as we spent the afternoon bringing to the boat dozens of brilliant grayling. Eventually, the intimate shoreline of thick forest dissipated and opened up into low-lying grasses and bushes near the estuary at our destination,

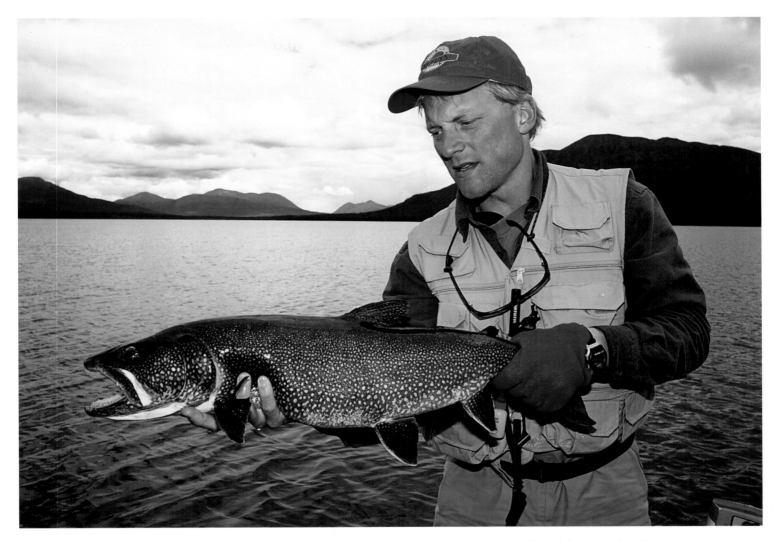

Guide and assistant manager Ken Richardson with a lake trout caught by a guest off the lodge dock after dinner.
Ken has guided from southern British Columbia to the Arctic Ocean for almost two decades.

Mud Lake. We pulled the raft onto a flood-plain island covered in thick, knee-high reeds, scouting the surroundings intently, as we had been forewarned that a grizzly had been spotted feeding on a moose kill on the island. Ken pulled out a portable satellite phone and called our air taxi. Twenty minutes later we were back at the lodge, steaming our perma-smiles off in the hot tub.

Inconnu and its campus of mountains, lakes and streams is a veritable playground for outdoor enthusiasts and fishermen alike. It is a place where people can experience things they've never seen or tried. For the fisherman, there is a chance to fish where nobody has ever cast a line before. The Yukon Gold Rush continues — only now it has fins.

Rifflin' Hitch Lodge

With tundra and rugged mountains in the north, and thick forest interspersed with lakes and rivers carpeting the south, Labrador is one of the most unspoiled regions of Canada. It is here that Gudie Hutchings has built a haven of rustic elegance on an isolated stretch of the Eagle River, a virgin watershed and salmon angler's paradise in the southern foothills of the Mealy Mountains. Guests come from all over the world to experience her unique brand of warm hospitality, enjoy true wilderness and catch salmon — the "king of fresh-water fish."

Labrador has a population of only 30,000 occupying a land mass more than twice the size of Newfoundland (113,000 square miles). For the most part, this is a pristine land where caribou herds running in the hundreds of thousands still roam, and rivers abound in salmon.

Gudie Hutchings, a jovial Newfoundlander with a twinkle in her eye, owns and runs Rifflin' Hitch. She has a zest for life and keeps close tabs on each guest, especially about how they fare on the river. "And how did you do today, my trout? Did you win or did the salmon win?" Her passion for salmon fishing comes from her father, a businessman from Corner Brook, Newfoundland, who loved to explore Labrador's lakes and rivers in his floatplane. Many summer holidays Gudie would accompany him, honing

Fishing Flummies Run from a Gander River Boat on the Eagle River. Labrador's 30,000 people occupy a land mass larger than that of the United Kingdom. It is a pristine land where caribou herds in the hundreds of thousands still roam and where rivers abound in salmon. INSET Rifflin' Hitch's irrepressible founder, owner and operator, Gudie Hutchings ("How are you, my little trout?").

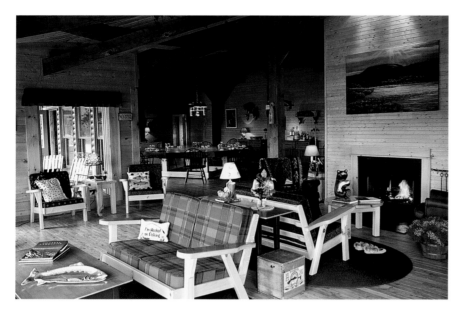

The lodge's comfortable sitting room boasts a wall of windows from which guests may survey the river and rolling hills to the south.

7,000-square-foot lodge made from native spruce, pine and juniper, with a commanding view of the river and the rolling hills to the south.

Gudie is immensely proud of her establishment and the incredible natural heritage in which it is immersed. A little snippet about the flora, fauna or geography of this country appears under the "Labrador for your information" section of the *Eagle River Daily*, a light newsletter that magically appears under everyone's door before breakfast. It provides information on the weather and the table fare to be expected, a fishing tip, cooking tips and "Gud's news," essentially an honors list in which she relates the triumphs of individual guests. David, Gudie's twelve-year-old son, edits this newsletter. This is one of his many responsibilities, as he also explains and processes licenses (no small feat given the baffling system Newfoundland and Labrador employ, such as the compulsory destruction of one of the tags), sells fishing gear and souvenirs, serves meals and humbles cribbage champions.

Good food is a must for Gudie, and she sees to it that all the meals are innovative and definitely not of the meat-and-two-veggie variety. Breakfasts and lunches are hearty but pleasingly light. Dinners are simply dynamite; we can't recall a single one that disappointed. Atlantic lobster, fresh cod and strip-loin steaks always get the thumbs up from us, but those paled in comparison to Labrador buffet night, a mixture of traditional Newfoundland and Labrador dishes. Everyone learned the names, historical context and ingredients of several previously unknown dishes, such as the ones that

her considerable skills as a fly-fisherwoman and sharing in the excitement of discovering new spots. The Eagle River was one of their favorite haunts.

Through university and careers in the hotel and airline business, she always fostered an ambition to build a world-class fishing lodge in Labrador. As luck would have it, the government put a commercial license on the Eagle River up for tender in 1996 after the Canadian Department of National Defence terminated its fishing camp. Gudie's proposal to construct a minimal-impact, aesthetically pleasing lodge won.

She picked the site wisely, opting to build her dream lodge on a treed terrace overlooking the rapids at the head of the second "steady" (large pool). It is accessible only by floatplane or helicopter, as intimidating rapids, both upriver and downriver, deter most sane people from traveling by boat. Among the densely bunched balsam firs, she has constructed a beautiful

comprise a "Jigg's dinner" and the delicious "fish and brewis." Cod cheeks with pork scrunchions, caribou stew, split-pea soup, caribou strips wrapped in bacon, and steamed molasses pudding were other treats. This immersion in the culture of Newfoundland and Labrador left a strong impression on our minds as well as our taste buds.

The Eagle River was a natural choice for Gudie, not only because of her intimate knowledge of its waters, but also because it remains one of the last great reserves for Atlantic salmon. Relatively healthy before the closure of the Labrador commercial salmon fishery in 1998, the average run is now estimated at 30,000–40,000 fish, definitely a contender for the largest run in North America. Grilse make up 80 percent of these fish. This is not a reflection of the natural balance, but of the destructive practices of the past when larger fish were selectively harvested. Given time, the salmon-to-grilse ratio will revert back to its natural equilibrium. Large hens start to enter in late June and are followed by cock fish (mature males) in August. Grilse run in large numbers throughout the summer.

Rifflin' Hitch opens during the last week in June, when the water is usually quite high and less suitable for wading, and it closes during the second weekend of September. Peak fishing is usually July through mid-August. Fishing is fly only, using only single barbless hooks at that. Gudie is very passionate about catch-and-release and has even been known to jump into the chilly Eagle River to revive a floundering fish. This policy is not absolute, as we were able

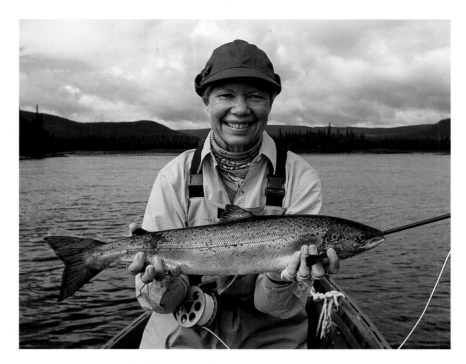

Mary Abel of Texas cradles a fine grilse before releasing it to continue its journey. The Eagle River enjoys an average run of 30,000 to 40,000 such fish, one of the largest in North America.

to have fresh salmon for dinner one night, and some guests were permitted to take one fish home with them. Great effort is also made on other fronts to minimize the impact of the lodge on the river. All boat engines are four-stroke, which are quieter and less polluting than older models; all fish are meticulously revived after being landed; and heaven help the smoker who flicks a cigarette butt into the river. All garbage is flown out, not buried or burned.

The guides are a mix of friendly characters from Newfoundland and Labrador. Each one is responsible for a particular stretch of the river; and the guests rotate throughout the week. All are wonderful conversationalists and accomplished fly-fishermen who will tell you where the fish should be holding. During the week, we

landed fish every single day and even managed to hook nine fish between us on two separate days. In salmon-fishing terms this was remarkably successful (especially for us), and quite unlike anywhere else we visited.

Our most productive flies were Green and Yellow Cossebooms, Silver Doctors, Collingwood Specials and Green Highlanders (usually pronounced "Islander" by the guides). By far the most effective presentation was with a rifflin' hitch, actually a pair of half hitches behind the head of the fly, causing it to skate across the surface. Renowned salmon angler and conservationist

Lee Wulff popularized this technique in the 1940s after he discovered a group of Newfoundlanders who swore by it. Its origins hark back to an era when snelled hooks were commonplace. Silkworm gut or snell was wrapped around the straight shank with thread and then varnished. Their main drawback was that after a few years the gut rotted or became brittle and weak.

Back when the Royal Navy covered the world, officers fished at every opportunity and gave away flies, which though beautiful were often obsolete due to their weakened gut eyes. Oaths directed towards His

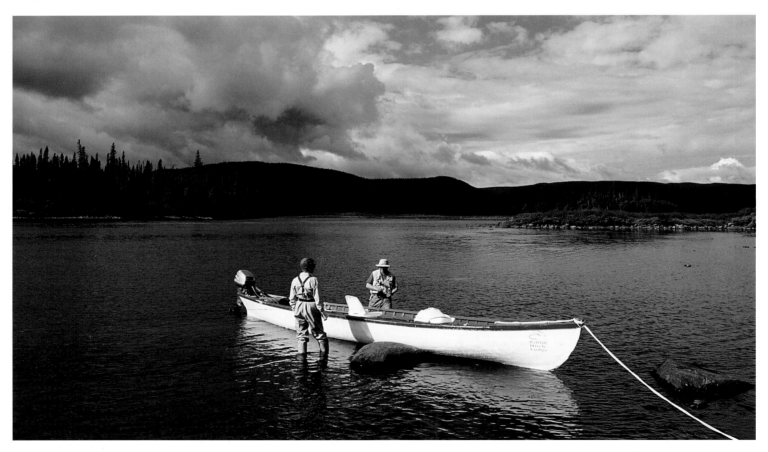

*One of the lodge's most productive stretches of water, Doc's Pool, where the favored technique is to employ a "rifflin' hitch,"
two half hitches looped behind the head of the fly. This causes wet flies fly to skate sideways across the surface,
which seems particularly infuriating to the salmon of Newfoundland and Labrador.*

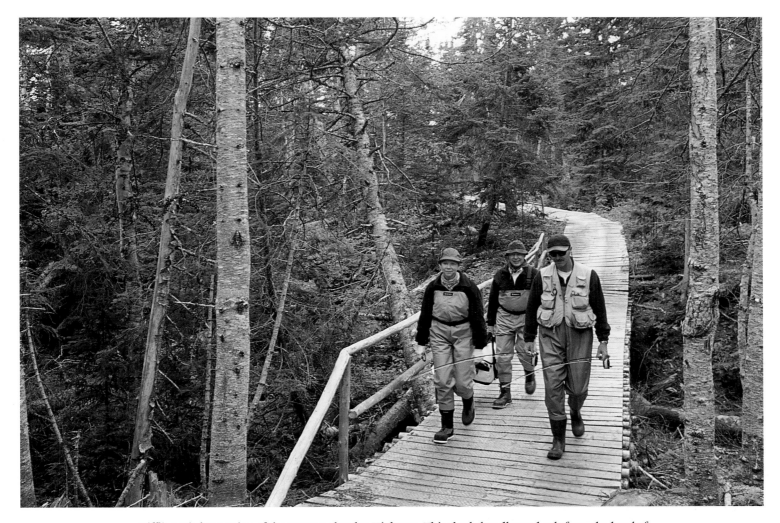

Rifflin' Hitch's version of the Trans-Labrador Highway. This shaded walkway leads from the head of the second "steady" (large pool) to the 7,000-square–foot lodge, custom built from native spruce, pine and juniper.

Majesty's Navy were commonplace after the loss of another good fish. However, on Portland Creek (a salmon river of northern Newfoundland) an angry but inventive individual not only tied his leader to the gut eye, but also took two half hitches behind the head of the fly. The skating of the fly created a wake, which aroused the fish of that river to such an extent that this technique was said to have been twenty times more effective than the conventional presentation. Although not quite such a phenomenally successful presentation in Labrador, it certainly works. Just ask Gudie, she named her lodge after it.

Both of our Champagne days occurred with Kevin, a comic thirty-three-year-old who took great pleasure in laying on a thick Newfie accent in an attempt to confuse us. After being reduced to hysterics on the first

113

This original painting of Rifflin' Hitch Lodge was done by Newfoundland artist Lloyd Pretty and hangs above the lodge's fireplace.

day, by the second we could just about say "Yer floi is roiding hoi on da wada" as well as he could. He is very much from the "if the fish show no interest on the first pass then try something different" school of thought. His territory was a pretty pool just above the camp, and each day he yo-yoed fore and aft of the wooden Gander River boat, changing our flies until something struck. At the beginning of August the ratio of grilse to salmon was roughly three to one, but even a 5-pound grilse was worthy of a 9-weight rod, given the strong

114

current. While I managed to almost exclusively hook grilse, my co-author enticed the lion's share of the salmon, including one of 18 pounds on his birthday. Grudgingly, even I admired the manic fights these fish

Chef Shannon Cosman with several reasons why Gudie's guests are rarely late for evening meals, which are taken as a group around a very large round table.

put up; cartwheels, aquaplaning and resolute hugging of the bottom were witnessed on several occasions. I suppose that after you have spent five years in a frigid river maturing into a smolt, then served two or more years in the ocean, you are going to be quite indignant that someone has the gall to hook you on your pilgrimage home. These bright, athletic fish had the lucky angler shaking his head in disbelief (for they were his first Atlantic salmon after many years of steel-heading) and proclaiming them to be the most aggressive fish he had ever encountered.

Twilight extends well past dinner, and the guides are only too happy to accompany guests on post-prandial expeditions. We hooked several good fish at this time of the day. Other activities in and around the lodge include sampling the multitude of single malts on offer, lounging in the hot tub and being humiliated in games of pool and darts. Due to the remoteness of the lodge and the dogged determination of most salmon anglers, trips last a week. We could have stayed much longer, but if guests are looking for something completely different, Gudie can organize a sightseeing helicopter to the coast, where giant icebergs and hump-back whales share the frigid waters of the Labrador Current.

Labrador is one of the last bastions of wild Atlantic salmon, yet many people remain genuinely unaware of the incredible fishing available there. Rugged it may be, but don't expect to rough it if you let Gudie and her staff take care of things.

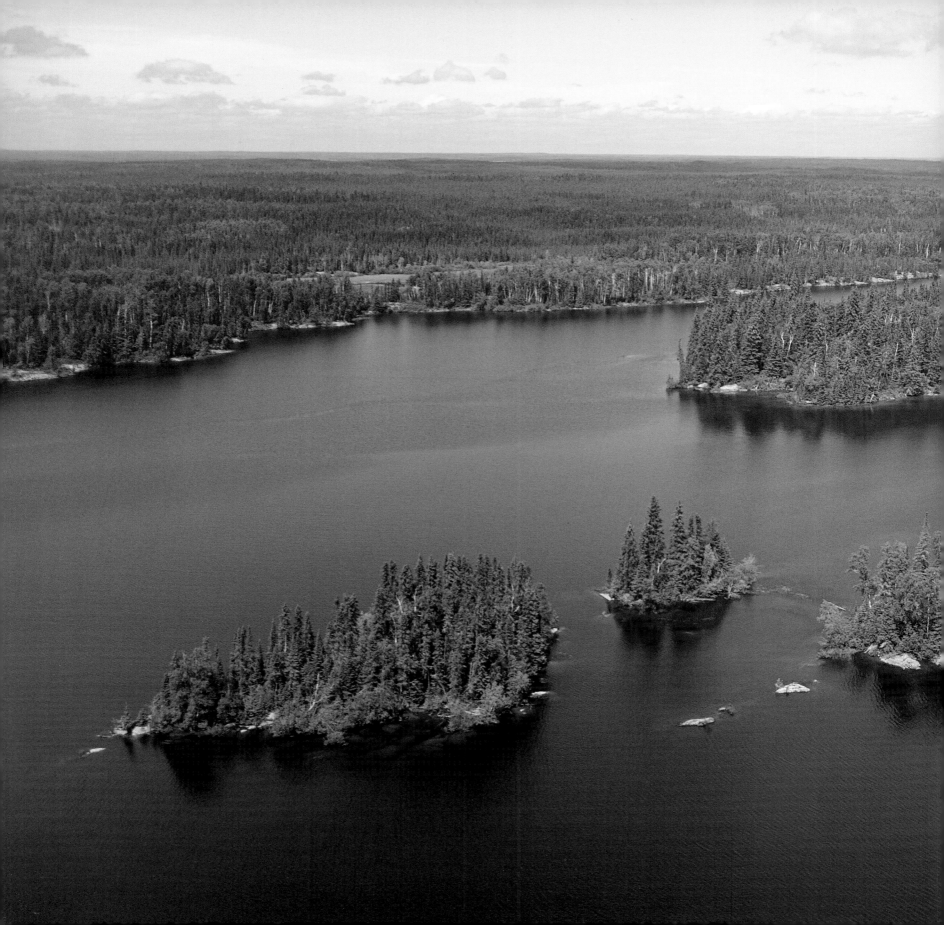

Knee Lake Resort

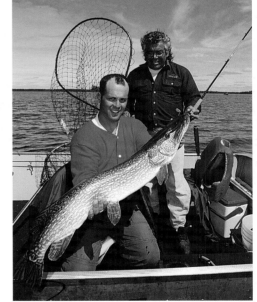

part from the pictographs near this lodge in Manitoba, one would never know that Knee Lake, one of the best pike fisheries in Canada, had ever seen a human face before fishing-lodge pioneer Al Reid chose it as the site for his latest and best establishment. Nothing could be farther from the truth. The lake is, in fact, a widening of the Hayes River, a historically important travel route from York Factory, on Hudson Bay (the northern fur-trade capital of the Hudson's Bay Company), to north-central North America.

Al Reid is a stocky, live wire of a man whom you could imagine having been a prize fighter. He was brought up in the business after his father, Frank, a "hunting and fishing nut," bought a fishing lodge in northwestern Ontario. Al struck off on p 117his own during the early '60s, acquiring Stork Lake Lodge, a very basic fly-in camp located brazenly close to his father's establishment. Al chuckles as he recounts his wife's immediate impression after stepping off the Norseman float-plane in her high heels, flowered dress and sun hat: "What the hell have you done? I'm taking the kids and leaving!" After managing to unruffle her feathers, transforming it into a reputable place was a relatively simple task.

In a business where turning a profit can be extremely tough, Al Reid thrived. From very early on in his career, he knew that the best money he could spend was that spent on the resort, and that his best advertisements were the people leaving the resort. He also knew the meaning of service

Manitoba's Knee Lake averages 9 feet deep along its 46 miles and receives a constant flow of warm, nutrient-filled water from the Hayes River. This translates into a rich ecosystem and provides the perfect habitat for large waterborne predators such as pike. INSET A typically large summer specimen from Knee Lake.

Staff enjoy a refreshing evening dip after a hard day's work. RIGHT *Last year, clients average over 1,000 trophy pike — no mean feat in a province that has the most stringent requirements for trophy fish (41 inches for pike).*

and was an ardent angler himself, always delighting in the successes of his clients. Today, a worn rotator cuff in his right shoulder bears testimony to decades of casting hefty lures to pike and muskie. Over the course of twenty years he turned around the fortunes of several other fishing lodges and established a couple of new ones, including a camp in the high Arctic.

In the mid-1980s, while he was acting as an outfitting consultant, the Provincial Government of Manitoba approached Al and enquired if he was interested in setting up a premier fishing lodge. He did not need a second invitation and immediately began the search for a suitable location. Armed with a map and statistics relating to fish reproduction, he identified five lakes that might be suitable. On closer inspection there emerged an undisputed champion — Knee Lake. Here was a large lake, free of settlements, full of pike and walleye, surrounded by other bodies of water of incredible fecundity, and part of the historic Hayes River system.

Knee Lake is within the territory controlled by Oxford House, a Cree community once intertwined with the Hudson's Bay Company. Through Indian Affairs, Al gained an introduction to the people of Oxford House and was soon extolling the virtues of a joint venture between the two parties. Al obtained the assistance of the local Oxford House counselor to personally interview 90 percent of the citizens, and when the issue went to the ballot box, their consent was almost unanimous. For a proud community where employment was woefully scarce, Al's proposal offered a double benefit, raising the profile of the area and providing vital jobs. Together, they set up a development corporation and raised the necessary capital. Members of this community must have been a very understanding bunch indeed, because it took Al a whole year to choose an appropriate site.

Al called upon all his business know-how to maximize the money to be spent directly on the lodge.

A winter road from Oxford House to the site was prepared and twenty-five transport-trailer loads of equipment were brought in. Nothing was rushed, as everything had to be perfect from the beginning. The job was completed in 1989, and the result is breathtaking. Located on a picturesque peninsula shrouded in birch, poplar and pine trees, the resort boasts fifteen luxurious lakeshore cabins and a 7,000-square-foot main lodge, all constructed from locally felled lumber and resembling an idyllic alpine village. The insides of these buildings are just as attractive and feature works by local artists as well as cozy wood-burning Franklin stoves. The dining room, almost a banquet hall, is the most impressive feature, with tables for sixty in a circle around a central fireplace, and two stories of headroom.

Al's intention had always been to build a lodge whose quality would keep it ahead of the pack for years to come, so that successive generations of Reids might be involved. In the early years he managed the lodge, but he soon managed to entice his preferred candidate for the job — his son Phil. Prior to partnering up with his father once again, Phil had owned several very successful lodges in northwestern Ontario and Manitoba, but the temptation to be involved in such an exciting establishment was too great.

Phil is an incredibly relaxed and healthy-looking fortyish-year-old. Perhaps this confidence comes from being third generation and knowing better than to treat the business as a hobby. His tradition of leaving his hair to grow all summer gives him the appearance of a mellowed rock star. But according to Gerald, the senior guide, this innocuous appearance is quite deceiving; he has a reputation for ruling with an iron fist in a velvet glove. "He runs a tight ship, but treats the staff very well. You know exactly where you stand with him and that's the way we like it."

Senior Knee Lake guide Gerald Hart prepares to release a fine pike. Hart has worked with the Reid family for 33 years and knows Knee Lake perhaps better than anyone.

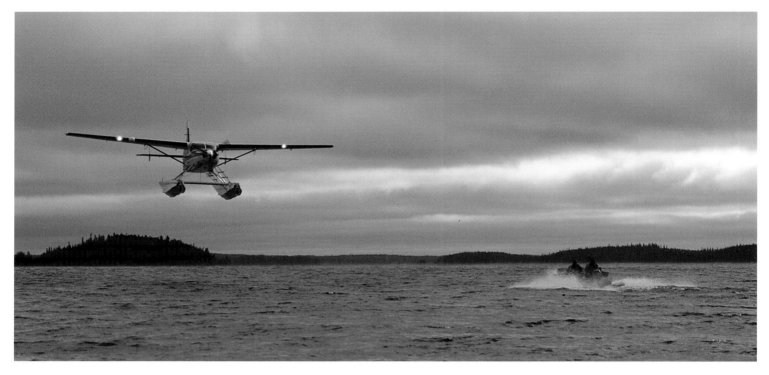

An approaching storm fails to deter guests, as the trophy pike of Knee Lake and its neighboring fly-out lakes prove too enticing.

The pike fishing in Knee Lake is generally acknowledged to be the best in Manitoba, if not Canada. Just ask regulars such as Bob Izumi or one of the thousand-plus guests that were lucky enough to get the opportunity last year. Dennis Maksymetz of Resource Manitoba was very helpful in explaining why it's so good. Since it's at a widening of the Hayes River, there is a constant flow of warmer, nutrient-rich water from its mostly southern catchment area. Knee Lake is also relatively shallow, averaging 9 feet deep along its 46 miles. This means that there is a tremendous amount of structure and therefore suitable habitat for smaller baitfish. The result is an extremely diverse ecosystem with many, many large predators — pike. A key to the maintenance of this fishery is the zero-tolerance catch-and-release policy. Last year, clients of Knee Lake released over 1,000 trophy pike. This is no mean feat in a province that has the most stringent requirements for trophy fish (41 inches for pike). However, not all the credit can go to the water itself. The skill of the guides is also an important factor in everyone's success. Eighty percent are from Oxford House, and every one of them has graduated from the resort's guide-training program. On average, they must serve a two-year apprenticeship around the camp and on the water before they are let loose with their own clients. Most have at least ten years of experience.

We had the pleasure of sharing a boat with Gerald, the senior guide. He has worked with the Reid family for thirty-one years, and, as one would expect, knows the lake intimately. His favorite area is the north end, with its vast weed beds. This meant an

120

hour boat ride either way, but it was worth it. We caught two dozen fish exceeding 35 inches and even managed a couple of trophies. Mind you, we would not have accepted anything less from someone who recorded 432 trophies in his boat alone in a single season!

The first I knew about my biggest fish, a 43-inch beast, was when the large black Suick I was absent-mindedly retrieving came to a shuddering halt. A couple of powerful head shakes confirmed it was a decent size, but it seemed to bow surprisingly easily to the pressure

I was applying. As soon as we caught a glimpse of each other I gasped, and it went berserk. For a full minute I needed all my strength just to prevent my stout rod from snapping over the gunwale as it dived directly under the boat. What a rush. It's great to see a beautiful fish such as that, but a privilege to catch one. Ruby Eyes, Daredevils and Silver Minnows worked well, but our biggest fish were taken on large Suicks.

Pike may be the most sought-after game fish at Knee Lake, but there are several other exciting fishing

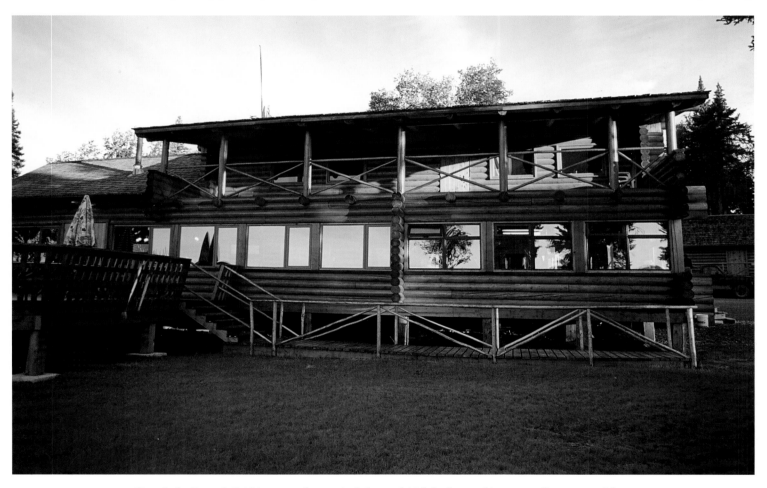

Knee Lake Resort's 7,000-square-foot main lodge and 15 lakeshore cabins were all constructed from locally felled trees that were milled on site. Together, they resemble an idyllic alpine village.

Even the most unlucky of anglers will not go hungry at Knee Lake Resort.

Die-hard walleye fishermen who visit Knee Lake cannot believe how little respect this fishery gets, as almost anyone who targets them for an entire day will catch over a hundred. For those who relish a challenge, whitefish and brook trout are also potential targets. While whitefish are found virtually everywhere, guests must take a floatplane to a section of the Hayes River proper for brookies. By all accounts it is worth it, as many are hefty sea-run fish exceeding 5 pounds and readily take the fly. For those who want another very good excuse to experience a floatplane trip, there are a number of satellite lakes that provide the most consistent trophy pike fishing because of the little pressure they receive.

Early travelers on the Hayes River soon found that the traditional canoe was too fragile and incapable of transporting adequate supplies to inland posts. The need for a more robust vessel with a larger carrying capacity led to the evolution of the York boat (so called because its most common destination was York Factory), which could withstand the stresses of running rapids, repeated beachings and rough lake crossings. These were long, broad and shallow, capable of carrying 40 hundredweight and nine men, besides three passengers. The men who rowed these boats were a mixture of Natives and tough, skinny voyageurs who lived on pemmican — animal fat mixed with dried meat and berries.

opportunities. Almost everyone will have the chance to catch walleye, a respected foe and highlight of the delicious shore lunches that are served up there.

Guides today enjoy a more balanced diet, but still need to transport their guests around the vast, shoal-

These centuries-old pictographs are located a stone's throw from the main lodge. Knee Lake is essentially a widening of the Hayes River, a historically important fur-trading route of the Hudson's Bay Company.

strewn expanse of Knee Lake in comfort and safety. To make this job easier, Phil Reid and Bill Page, head of maintenance, collaborated with Lund boat manu-facturers to make some alterations to their standard recreational fishing boat. For the past three years every one of the thirty-five boats at the resort has been of the customized "Knee Lake Edition" variety. With reinforced side panels and front platforms, they are sturdier and more stable on the water. In addition, deluxe spring-loaded seats with extra padding ensure that when the wind whips up whitecaps, guests' lower backs do not suffer.

After a day on the water it is absolutely necessary to put your feet up and contemplate the ones that got away, the beautiful environment and the impending dinner. We made full use of our veranda to soak up the magic of Knee Lake, swap stories with our excited neighbors and take in the northern lights.

Langara Island Lodge

Balanced on the tip of the Queen Charlotte Islands off the coast of British Columbia, Langara Island is the center of the Pacific salmon-fishing universe. It is also a holy land for nature lovers. Sea lions, seals, pods of humpback and killer whales, dolphins and birds of countless species surround and captivate anglers.

When surrounded by these distractions and the beauty of the windswept prehistoric rainforest, it's easy to forget the real reason that most people visit — to do battle with the greatest game-fish adversary in the country, the ocean-run chinook salmon. Langara Island Lodge is a 10,000-square-foot mansion perched high atop a cliff and protected by towering Sitka spruce — one of the most enviable locations for a lodge in Canada.

The island's first residents, the Haida, discovered a supply of fish and shellfish so plentiful that Native families colonized the entirety of this small island's shoreline. Eventually, the island became so overpopulated that many abandoned their villages for the Alaskan coast, which is visible from Langara.

Beginning in the early twentieth century, the seas around Langara Island became a haven for the British Columbia coast's commercial fishing armada. In the 1980s, with the arrival of Langara Fishing Adventures, sport-fishermen discovered the island's exceptional proximity to amazing fishing. The fishing isn't superb just by chance — there are specific environmental reasons why Langara forms a natural

A boat brings anglers home across Parry Passage. Langara Island is the smallest of the three main islands that comprise the Queen Charlotte Islands, located off the coast of British Columbia. INSET The Chief Edenshaw triple mortuary poles at Kiusta Village, a centuries-old Haida community. The poles are visible from Langara Island Lodge's deck.

125

Langara Island Lodge was constructed in the post-and-beam style from west coast cedar.
RIGHT The walkway down to the lodge's cottage.

bottleneck in the migratory route of millions of salmon each year. The following explanation appeared in the Langara Fishing Adventures 2001 newsletter: "Langara is unique in that the continental shelf drops off to a depth of 1,200 feet within one mile of the north end of the island. Strong tidal currents produce upwellings of nutrients from these cold depths. Enormous amounts of phytoplankton provide food for massive shoals of shrimp, krill, needlefish and herring. Close to the protected shore of Langara Island, the herring and needlefish find shelter from the currents. Schools of chinook salmon hold around the island to take advantage of the richest feeding opportunity they have on their journey back to their home rivers to spawn. They gorge themselves on the huge abundance of baitfish in the waters surrounding the island. Wave after wave of salmon migrate around the island all year long. The Langara area also feeds the Pacific Coast's richest population of halibut, ling cod and rockfish."

The bait of choice at Langara Island Lodge is cut plug herring, cut at an angle and gutted so that it trolls in a tight roll, with a circular 4-to-6-ounce weight to keep the bait down. Single-action mooching reels are the area's traditional weapon of choice, mounted on long, medium-action mooching rods. The reels resemble large fly reels and can hold upwards of 300 yards of 25-pound test. When a big spring (chinook) is running, the two knobs on the reel spin at a blurring speed, clipping clumsy fingers that get in the way, hence the reel's nickname, "knuckle buster."

Most hooked salmon put everything they've got into the fight. Despite the power of "smileys," or "tyee" as they are affectionately known, the initial strike of

a chinook is often very subtle; close attention must be paid to rod tips at all times. The first indication of a fish is usually a slight tapping of the rod tip, as if the salmon is almost mouthing the moving bait. To hook the curious fish, the rod is removed immediately from the holder and two long strips of line are pulled out of the reel, dropping the bait back into the salmon's mouth. Nine times out of ten the fish will take the bait, leaving the angler to reel up any slack before heaving the rod back towards him to ensure a good hook set.

The satisfying, rod-bouncing head shakes that follow a hook-up signal a successful set.

Never content to come to the boat voluntarily, these silver beasts employ a complicated series of tactics that can make any angler weary. They run several times during a battle, sometimes sounding and hugging the bottom before suddenly rushing straight for the surface and launching into the air. Watching a 30-pound chinook crash into the water and reappear 50 feet from where it landed a split second later is as

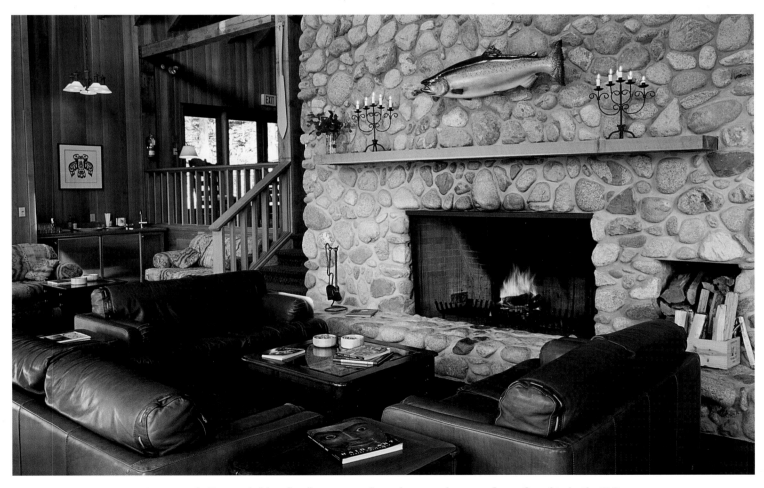

A mounted 65-pound chinook salmon, or spring salmon as they are often referred to in the U.S., decorates the lodge's incredible 40-foot-high, double-sided, river-rock chimney in the lower lounge.

127

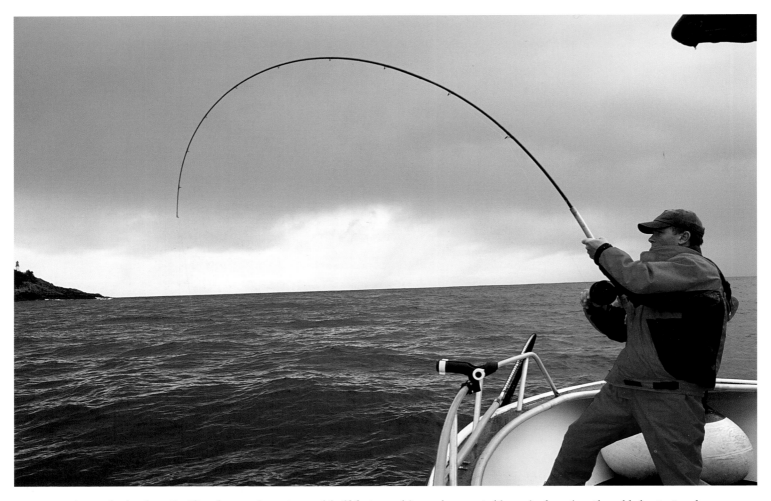

An angler battles a Pacific salmon using a ten-and-half-foot mooching rod supported by a single-action "knuckle buster" reel. Gargantuan sea lions have been known to seize hooked fish, swim off and practically burn the bearings out of these reels.

exciting as it gets. Biceps bulge and burn in pain after every tussle with fish 15 pounds or greater. Anglers are looking at an even ratio of minutes to pounds to fight an ocean-run chinook. That means that many of the salmon caught at Langara every year take over an hour to land. Try bringing in twenty or more springs a day and you will soon realize that fishing takes on an entirely new physical dimension in the Queen Charlottes. If you tire on the water from catching too

many fish, fear not, the lodge's zodiac patrol boat is never far and always laden with rejuvenating thermoses of hot coffee, hot chocolate and fresh soup, as well as homemade baked goods.

With salmon and huge halibut luring anglers to the Charlottes, it is easy to overlook some of the smaller game fish in the area. One of the busiest and most enjoyable fishing experiences I sampled was fly-fishing for black sea bass in the kelp beds near shore. Every cast

drew a hammering hit from one of dozens of fish in the 2-to-4-pound range. The action was constant, and lengthy casts were not necessary. Occasionally, a menacing-looking ling cod, mouth open, baring hundreds of fierce teeth, would appear out of nowhere, startling the angler and nearly snatching our fish. Interestingly, within 50 feet of where we were fishing was a sea lion colony of perhaps sixty, who showed no interest in our fish and only barked with amusement while we were there.

If you stand on the deck of the lodge and peer across Parry Passage, you can make out the mortuary pole or triple totem beside the abandoned village of Kiusta, on the north tip of Graham Island. With permission from the local Aboriginal people, guests can visit this fascinating ancient spiritual place. Abandoned around 1868, Kiusta was once a busy coastal community of nine to fifteen houses and home to one of the most famous of all Haida chiefs, Edenshaw of Kung. Today, only the depressions remain where homes once stood. Some building outlines are visible; however, much of the wood used for shelters and totems is rotting under a rug of moss, slowly returning to the earth, as the Haida believe it should be left to do. This only adds to the mystery of the place, and the imagination runs wild with visions of what life must have once been like in this idyllic little cove hundreds of years ago. The serene beauty of the place is a positive force, and to experience this is one of the highlights of walking through the old village. By far the most astounding site is at the northern edge of the bay, where the elaborate Edenshaw mortuary poles still stand. It is

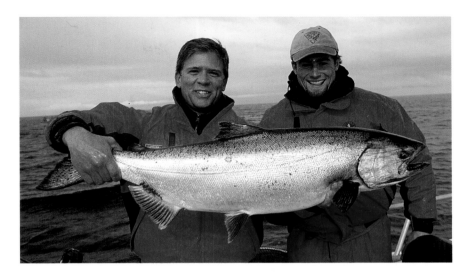

Long-time guide Geoff Thorburn and one of the authors pose with a 25-pound chinook caught on a cut-plug herring. The waters off Langara Island are an important feeding ground for migratory salmon.

believed that these poles were ceremoniously erected sometime between 1830 and 1850. At one point their flush tops would have supported the remains of a chief, raised high to ensure his spiritual liberation. Behind Kiusta is a forest of giant trees, emerald green ferns and a floor of foot-thick moss. A worn trail that weaves between truck-sized tree trunks is just visible in the dusky light filtered by millions of spruce, hemlock and cedar needles over 100 feet above. One wonders if this is perhaps nature's greatest tribute to the color green. The air is heavy with moisture that is trapped from the sunlight by the forest's thick canopy.

At the end of the trail, bright sunlight reflects off the fine sand beach of Lepas Bay. The contrast between the two environments is tremendous; suddenly there is energy and wind and sound all around. Huge, rolling waves crash onto the sandy shore with a rumbling roar, signaling the end of their journey from somewhere miles out in the churning

129

Pacific Ocean. For the avid beachcomber, the sand is stuffed with commercial fishing artifacts, from pieces of nets to floats and colorful glass buoys. The beach is seemingly at the edge of the earth, and there isn't a soul in sight, even though it's only twenty minutes from the lodge.

Langara Island Lodge is the jewel in the corporate crown of Langara Fishing Adventures, a private company that owns four fishing lodges in British Columbia. Built in 1995 of post-and-beam cedar, the lodge rests within an old-growth Sitka spruce forest high on a cliff overlooking the churning currents of Parry Passage and

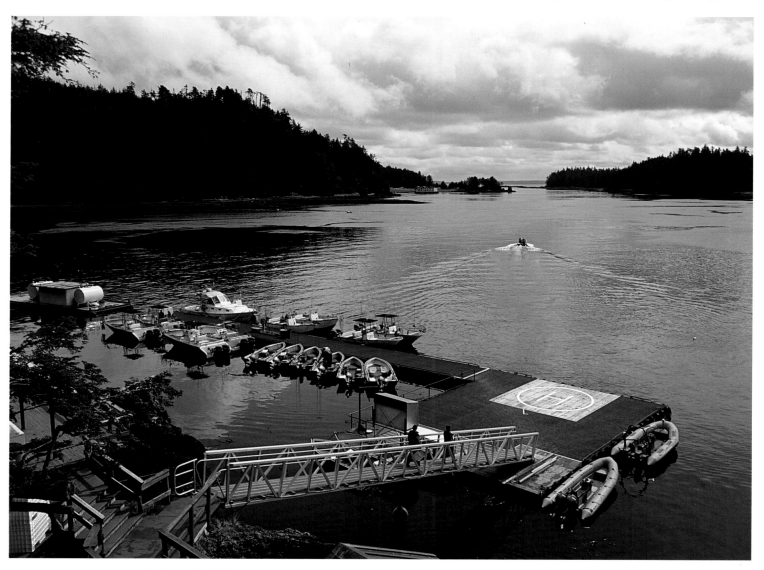

A view from the hillside of the docks below the lodge. In the foreground aluminum boats, custom-built for use at Langara, await guests, while in the distance one eager party gets off to a head start.

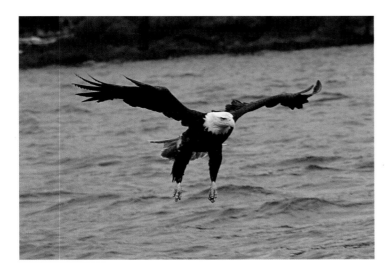
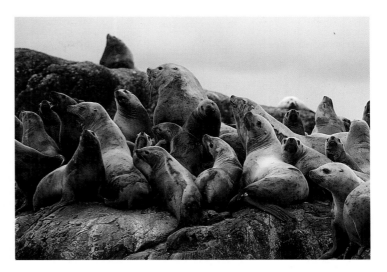

The British Columbia coast is home to tens of thousands of bald eagles. RIGHT *The stellar sea lion rookery at Langara Rocks, off the west coast of the island. This area provides great fly-fishing for black sea bass and ling cod.*

the busy activity of Henslung Cove. Henslung Cove is the summer home to several floating fishing lodges, one of which belongs to Langara Fishing Adventures and was the first lodge at the island. In the busy summer months, Henslung Cove is a floating city of sport-fishermen. Company president Richard Bourne and his partners have created an enterprise that can focus on fishing as well as on accessing the surreal natural surroundings. In addition to hiking through rainforests and visiting Haida cultural sites, the lodge offers whale-watching, ocean kayaking and helicopter tours of the area.

Life for a guest at Langara Island Lodge is nothing short of luxurious. From the lodge's full-time masseuse, to the heated lockers where all-weather survival suits are stored, to fine West Coast cuisine and wines, being spoiled is an integral part of the guest experience. From the ocean, the only access up to the lodge is via a tram gondola, which creeps slowly up the cliff's steep face. Guests are met in the main lodge with a sumptuous buffet of seafood delicacies and an open bar before the lodge manager provides an orientation on fishing regulations and tactics and the week's activity options. A two-sided stone fireplace stretches over 50 feet high to the angled cedar ceiling. The main lodge is large and spacious and divided into two levels. The lower level provides the best scenic view and acts as the lounge area, while the dining level above centers around a single long table where guests dine together over exquisite five-course meals each evening. Guest rooms stretch out in two wings behind the main lodge, each with a view of the water. The rooms are lightly scented by the smell of cedar dressers and furniture. On the large deck surrounding the entire lodge front, two hot tubs peer over the cliff below. Perched on tree limbs above steaming guests, bald eagles glare down like gargoyles guarding the lodge.

Langara Island Lodge is a grand cathedral to the religion of fishermen.

131

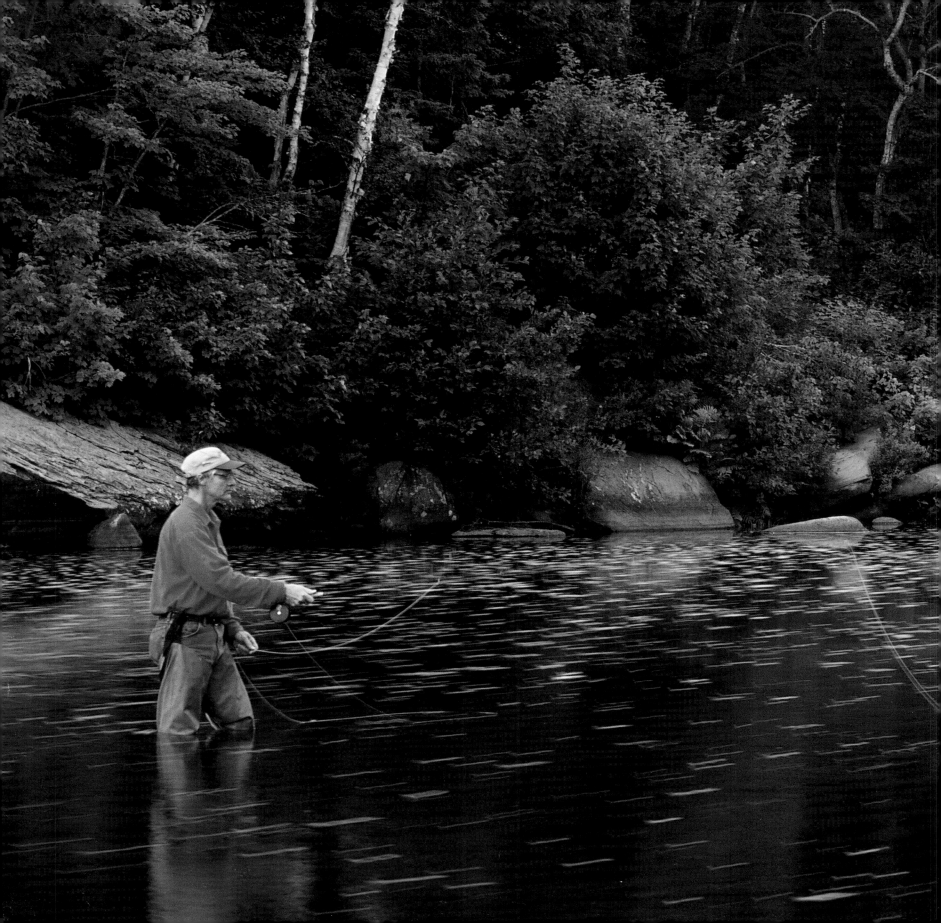

Wilson's Sporting Camps

Wilson's Sporting Camps Ltd. is one of the oldest fishing lodges and outfitters in Canada. The Wilson family has been in business at its unique location in McNamee, New Brunswick, since 1928, when Willard Weston Wilson and his wife, Sarah, began outfitting and accommodating anglers lured by the famed Atlantic salmon runs of the Miramichi River. An outfitting and guide service was a natural fit for Willard, as his ancestors had been fishing and guiding on the Miramichi River since the mid-1800s. Willard's great-grandfather John Wilson settled on the same property in 1803, just a few hundred yards from the banks of the tempting Miramichi.

In the early nineteenth century, salmon from the Miramichi provided an important source of food for the isolated early pioneers of the area, in addition to providing great sport. Perhaps John Wilson was the source of his family's affinity with the river. He was an "inspector of fishing" on the river between 1810 and 1814, and subsequent generations of Wilsons have embraced the family's traditional reliance on the Miramichi River and the woods surrounding it, including its current proprietors, Keith Wilson and his wife, Bonnie.

Before the arrival of the first guest in 1928, Willard and Sarah ran a country store from their house. Possessed of an entrepreneurial spirit, Willard also provided amateur veterinary and undertaking services for other citizens of the isolated community. It is uncertain if Willard

Guide Lloyd Lyons tempts the salmon in Wilson's Home Pool on the Miramichi River in New Brunswick. Wilson's Sporting Camps is one of the oldest fishing lodges and outfitters in Canada. The family's special connection with the river began in 1810 when John Wilson was made "inspector of fishing." INSET Vintage camp brochures and some salmon-fooling flies.

133

The Wilson family's whitewashed homestead since 1803. In the early nineteenth century, salmon from the Miramichi were an important source of food for the isolated pioneers who settled the area.

simply fell into the fishing business or if it was a calculated move; however, it is known that the first guests of Wilson's Sporting Camps came as a result of hearing tales of the opulent salmon fishing from Willard's daughter, Marie Grace. Perhaps it was Marie Grace's enthusiasm that drove her father into harnessing the bounty of the river.

As a registered nurse, Marie worked at Dick's House, the infirmary at Dartmouth College in Hanover, New Hampshire. It was here that she met many doctors and professors, some of whom were avid

anglers. The first "sports" (as fishing clients are affectionately called in the eastern provinces) to make the trip at Marie's suggestion were Dr. and Mrs. John Gile. Other early guests were Harry Wellman, professor of marketing at Dartmouth's famous Tuck School; Halsey Edgerton, treasurer of the college; and Nat Burleigh — all of whom became frequent and loyal guests. They each paid a fee of $8 a day, which included legendary home-cooked meals, accommodations and guide services provided by the Wilsons' sons, Murray and Thomas.

Here, Thomas Wilson describes hooking a fish with early guest Harry Wellman:

Harry went around the ledge and got into the boat and we started fishin'. It was a pretty deep pool and we fished maybe an hour and by and by he hooked this fish. That would be about eleven o'clock. Well, we played it for quite a while and he says 'By God, Tom, that's an awful salmon.' And I said, 'Yes, it just put you in mind of a pig jumpin'. And it did — you know, when he came down in the water with a big splash. I says 'I don't know if we'll ever land that or not.' But there was a rock down below us about 60 feet and what did that salmon do but went right around that rock and the line went around it, and he come up on the other side. And Harry says 'I'm caught.' I said 'Don't do a thing. I'll wade out there and see if I can trip him.' And I did. And boys that salmon went. He was jumpin' then and we played him there for four hours and fifteen minutes. Harry hung right on to her. He was so played out the next day he couldn't fish. Finally I waded out by this rock — the water was over it. So when he could get the fish dropped down by the rock I had a pretty good chance to put the gaff in him. When he did come down, I put the gaff in him and he started and took me right off me feet. I went right down in the water on my knees but I held it to him, and then I got him around and got him in on shore. We were both played out. I think that fish weighted 38 pounds and some ounces. We won the Rod & Reel prize that year.

Tales of the phenomenal fishing quickly spread throughout Dartmouth College campus, and Dartmouth staff and faculty came in ever-increasing numbers. For the first decade as an Atlantic salmon camp, Wilson's was essentially the college's private fishing club. Strong friendships emerged between early Dartmouth clients and the Wilson family. In 1934, at Professor Wellman's suggestion, Willard Wilson Jr. returned to Hanover with him and enrolled in high school, as there were no secondary schools in the Upper Miramichi area at the time. James Wilson followed three years later with Halsey and Mrs. Edgerton. Both boys went on to graduate from Dartmouth College. While at Dartmouth, the Wilson boys followed in their sister Marie Grace's footsteps in the role of campus direct-marketing agents for Wilson's Sporting Camps.

For thousands of years prior to the arrival of Europeans, New Brunswick's Miramichi River sustained and nourished communities of Mi'Kmaq Aboriginal people who called the river *Lustagoocheehk*, meaning "little goodly river." Today, the name Miramichi, meaning literally "Mi'Kmaq Land," is believed to be a Montagnais word and the oldest Native place name in eastern Canada still in use today.

While the Miramichi has certainly lived up to its reputation as the generous "little goodly river," this sadly hasn't been reciprocated by the beneficiaries of the watershed's bounty. Destructive clear-cutting of timber in the watershed and massive commercial over-fishing of Atlantic salmon in the ocean near the river's mouth have taken a serious toll on salmon stocks and their habitat. In 1785 Benjamin Marsten, the first sheriff of Miramichi County, prophesized in a letter to the government that "unless the salmon

fishery is attended to [by the government], it will be ruined by the ignorance and avarice of those concerned in it." It took one year less than two centuries to heed this advice, and while the commercial netting of salmon in the Maritimes has been banned since 1984, returns of salmon today are still a shadow of their historical levels.

Today, the majestic, serene beauty of the southwest Miramichi disguises the impact of man. There are 26 primary tributaries fed by the over 7,700 streams that comprise the 13,600 acres of salmon and trout spawning habitat that is the Miramichi River watershed.

Despite the fact that historic returns estimated to have been as large as a half a million fish have been reduced to 30,000–50,000 salmon, it is believed that more salmon make their annual pilgrimage up the Miramichi than in all the rivers in Quebec combined. It is a tribute to the resilience of the river and its hardy fish that the Miramichi remains one of the greatest salmon rivers in the world.

In July 2001 we had the pleasure of sojourning at Wilson's Sporting Camps. Time stands still on the Miramichi, and this is reflected in the relaxed and patient disposition of all local residents that I

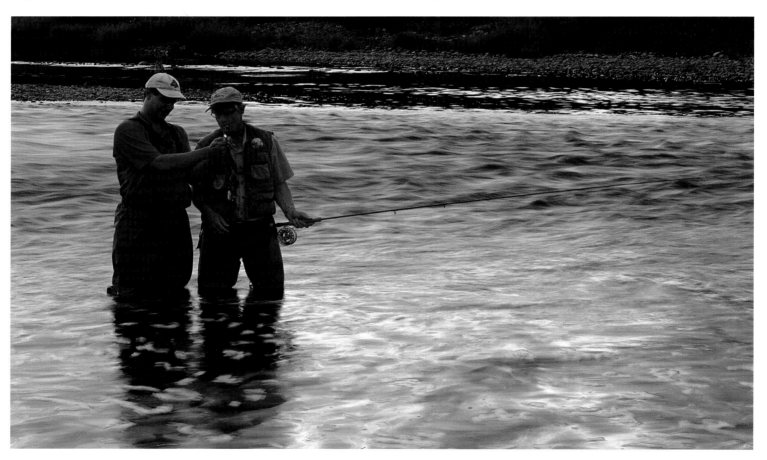

When the action slows, a good cigar can often strengthen one's resolve.

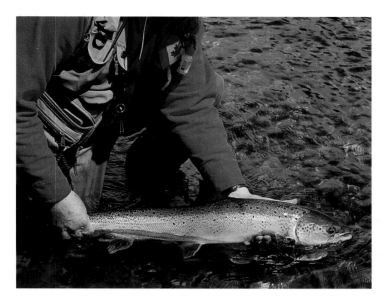

Despite estimates that returns once as large as 500,000 fish have been reduced to 30,000 to 50,000, it is believed that more salmon make their annual pilgrimage up the Miramichi than in all the rivers in Quebec combined. RIGHT Jerry Doak and John Lyons behind the counter of W.W. Doak Ltd, a Canadian Atlantic salmon fishing institution. The store was started by Jerry's father, Wallace Ward Doak, in 1946.

encountered, especially the fishing guides. Tranquility prevails in McNamee, on the banks of the Miramichi, and it is contagious. Worries or stresses that arrive with anglers quickly vanish in the calm of this sleepy rural town. The main building of the camp is the original Wilson family homestead, built by Keith Wilson's great-great grandfather, John Turnbull Wilson, in the late 1800s. Running through the house between the den and kitchen there still exists the sawdust-insulated structure once used as a refrigerator and built over a trough through which ran a constant flow of cold spring water.

The main house has been immaculately preserved and stands proudly yet inconspicuously as the heart of this commercial camp on the sleepy stretch of road in this small town of only fifty houses. A tractor trail winds between two old barns behind the house, down a small hill next to a farmer's field, towards the river a short

distance away. Directly across the small road, in front of the main house, are five cottage cabins that house the majority of guests. These unpretentious cabins are built in a semicircle formation next to a covered storage area where many gleaming 20-foot Chestnut-brand green canvas canoes are hung to dry. While these canoes have been essentially retired in favor of the lighter and more durable Kevlar canoes of today, Keith Wilson obligingly takes one or two of the Chestnut canoes off their hooks each summer so that an old customer may enjoy the same ride as they did years ago.

Tradition is entrenched in the psyche of many of the guests who have been coming to Wilson's for years. For numerous guests, the journey to the camp and time spent on the river is an important annual ritual. Approximately 80 percent of Wilson's guests are repeat customers, several of whom are second generation. Fishing the Miramichi and staying at Wilson's is a family

tradition for many. The possibility of fishing a week without catching a salmon is understood by all visitors and is testimony to the fact that the intrinsic value of salmon fishing on the Miramichi is of a broader scope than simply catching a salmon. This unique place allows devotees to convene with Mother Nature in solitude, or to share it with close friends. The surging spring freshets change the course of the river slightly each year. How the water moves differently over and around rocks compared to the year before, or curves at a bend, are all of interest to a *Salmo salar* fly-fisherman. Keith Wilson embodies this philosophy and believes that Wilson's "isn't about selling salmon. It's selling the sport, the beauty of the water, the camp life and the joy of having a salmon on your line."

This is such an important part of some people's lives that it is not unusual for Wilson's to host the families and friends of guests who pass away. They come to retrace the deceased's steps, to see the place and water so precious to them when they were alive, and to leave ashes on the river, where the soul is left to fish a favorite stretch of river for eternity.

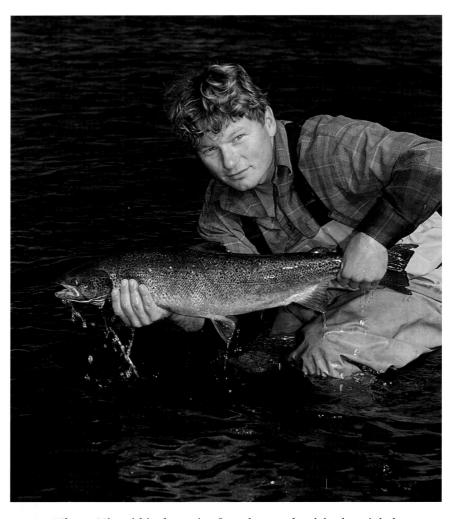

When a Miramichi salmon rises from the tea-colored depths to inhale a bomber, the world stops for a split second and all is well.

Each cabin has its own porch, where anglers spend lazy afternoons resting, smoking, telling tales or sipping whiskey between fishing shifts. Three of the cabins, Church, Arenson and Lukehart, are named after loyal guests who over the decades have made annual pilgrimages to the lodge. The only sounds are those of the wings of birds, crickets, bees and dragonflies.

During our stay, each morning after a hot shower we strolled across to the old dining room on the ground floor of the main house for a hearty breakfast of farm-fresh eggs, bacon and sausages, and home-made bread. The room catches the early morning sun.

Robert Barnwell Roosevelt, uncle of American president Theodore Roosevelt, ate in this same room in 1862, during a trip to Wilson's that he later wrote about

in his book entitled *The Game Fish of the Northern States of America and British Provinces*. Roosevelt started his trip in New York, traveling by ship to Saint John, New Brunswick, then on to Wilson's by stagecoach. It cost him $306.69 for himself and a friend, including meals and lodging, guide service and transportation. He included a cost of $10 for "delicacies," which perhaps came from the country store that the Wilsons used to operate in the same building.

After breakfast, Keith Wilson enthusiastically gives the guests a routine briefing on the stretch of river each will be fishing that day, as did Keith's father, Kurt, every morning when he ran the lodge, and his grandfather, Murray, before him. Keith Wilson endeavors to limit the impact on his stretch of river by allowing only six rods a day. This ensures that each angler can fish three new pools per day.

Lloyd Lyons, our guide, arrived shortly thereafter in his pickup, and in his thick, Miramichi Valley drawl shared the virtues of the day's fishing pools with us. Lloyd has been guiding on the Miramichi for 37 years, an indication of the dedication that is not unusual for a guide at Wilson's. Ernest Long, the head guide at Wilson's, has over 50 years of guiding under his belt — a virtual Ph.D. in fishing and river experience. A photo of Ernest hangs in the Atlantic Salmon Museum in nearby Doaktown, commemorating his induction into the Atlantic Salmon Hall of Fame. The five primary guides at Wilson's have, combined, over 145 years of guiding experience on the southwest Miramichi. If there were a university faculty of fly-

fishing for Atlantic salmon, these guides would be the professors.

My spirits were buoyed by the knowledge that more Atlantics are caught by fishermen on the Miramichi River every year than on any other river in eastern Canada. But past experience has taught me that Atlantic salmon glory is never a given, so I looked to Ted Williams, of baseball fame, for inspiration. Ted was a diabolical fly-fisherman and fished the Miramichi extensively, mostly at his private camp. In 1978 he earned the prestigious Triple Crown of angling by catching his 1,000th Atlantic salmon on a fly, having previously caught and released 1,000 bonefish and 1,000 tarpon on the fly. If 1,000 salmon could be caught by a single man, surely I was good for at least one.

Over four days we fished many of the best of sixteen pools that Wilson's owns, over 5 miles of private water.

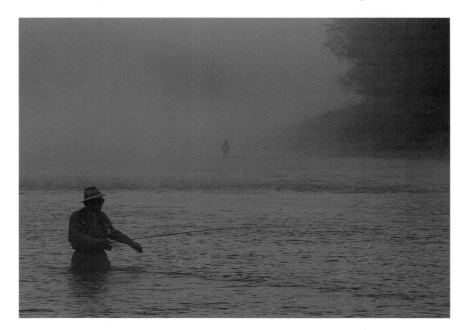

Wilson's guests have access to 16 pools that stretch over five miles of water. These include traditional staging pools and runs such as Hovey's Front, Dudley Pool, Harvey's Front, Little Murphy, Buttermilk and O'Donnell's Landing.

Lloyd, determined not to let the fish win, drove us over miles of back-country gravel roads and poled us fearlessly, from the stern of a river canoe, through several traditional staging pools and runs such as Hovey's Front, Dudley Pool, Harvey's Front, Little Murphy, Buttermilk and O'Donnell's Landing. The sun blazed mercilessly on the river, reflecting off the millions of bright-colored pebbles that make up the riverbed and turning the water an electric lime-green color.

Guests can elect to fish from the canoe or from shore. With the water so low, casting and wading were a breeze, so we always elected to fish from shore. And cast we did, our Orvis 9-weights punching out thousands of feet of line each day. Every fly in our fly vests had its turn. Bombers and Wulff patterns, Copper Killers, Green Machines, Silver and Rusty Rats, and Cossebooms in all sizes and colors. Even an emergency visit to celebrated fly-tackle outfitter W. W. Doak in Doaktown, where we purchased additional flies, didn't change our luck. Seeing the fish porpoising and thrashing the surface at times made it all the more frustrating for us.

As it did on the fish, so too did the sun take its toll on us, necessitating frequent trips to the shade of riverside trees or an occasional dip in the river below where the fish were holding. Sweat-soaked from casting and wading in the hot sun, we'd sit down heavily on riverbank logs for an evening "lunch" of fresh sandwiches, cake, brownies and drinks. "Dinner" at Wilson's is served at 12:30 P.M. and is always a delicious, hot, home-cooked meal using decades-proven recipes created by the Wilson women, such as Ethel Wilson's renowned cream-of-fiddlehead soup. With my muscles conditioned to making constant micro-adjustments while wading, I could still feel the river's current flowing around me and pushing me off balance as we sat on shore watching the heat rise, creating a mirage that turned the gravel bars upside down over the river below us. We absorbed the serenity of the ancient river and basked in the luxury of our own solitude. This is one of the true gifts of flowing water running over its native rock bed. Lloyd entertained us with stories of finned monsters that past clients had the glory of catching. After dinner, the schedule at Wilson's requires all anglers to willingly retire to their cabin porch for a well-deserved siesta before heading back to a new stretch of river in the late afternoon.

Due to the timing of our visit, we missed out on the famous shore-lunch experience enjoyed by Wilson's guests who come to fish the unique black or "spring" salmon fishery of early spring. Just after ice-out in mid-April, the Miramichi River salmon fishing season commences, with anglers fly-fishing for hungry salmon that spawned the previous fall and wintered-over below the ice. After months with little or nothing to eat, the salmon feed ravenously, aggressively attacking flies as they slowly make their way back to the ocean. The weather is cool and the river high and often raging at this time of the year. Shore lunches then center around a blazing wood fire where guides prepare hot coffee, fried potatoes and vegetables and grilled salmon.

The dust behind Lloyd's pickup settled quickly with the weight of the morning dew as we drove down a gravel road to our favorite, and one of Wilson's most famous pools, Coldwater, a popular holding pool for salmon, especially during warmer water temperatures. The pool lies just below the confluence of the southwest Miramichi and the cooler waters of Stewarts Brook, and in addition is shaded for much of the morning. These two forces combine to keep the water

Gil Rousell, Lloyd Lyons, Keith Wilson, Ernest Long, Joe Stewart and Cleve O'Donnell.
Together, these river gentlemen represent over 150 years of experience on the Miramichi River.

temperature a precious few degrees cooler than in most other sections of the river. Immediately above Coldwater the river runs wide, swift and shallow, allowing oxygenation and posing a hurdle during low-water conditions. Up to three anglers can easily fly-fish this water, and there are many fish in the pool, mostly at the head of the run feeding it. Fish rose and jumped often to laugh at us. Overhead, an osprey flew, gripping a large fish tightly in its talons. We saw the same osprey several times during our stay, mostly flying over Coldwater Pool, and it always had a fish. But it was not to be for us. Despite the many libations of golden single-malt poured into rivers and lakes across the country, our homage to the river gods went unheeded. The relentless blaze of the sun and the low water conditions had put what salmon were in the river into a state of narcolepsy. No wonder Wilson's has such a long history of repeat visitors. Revenge.

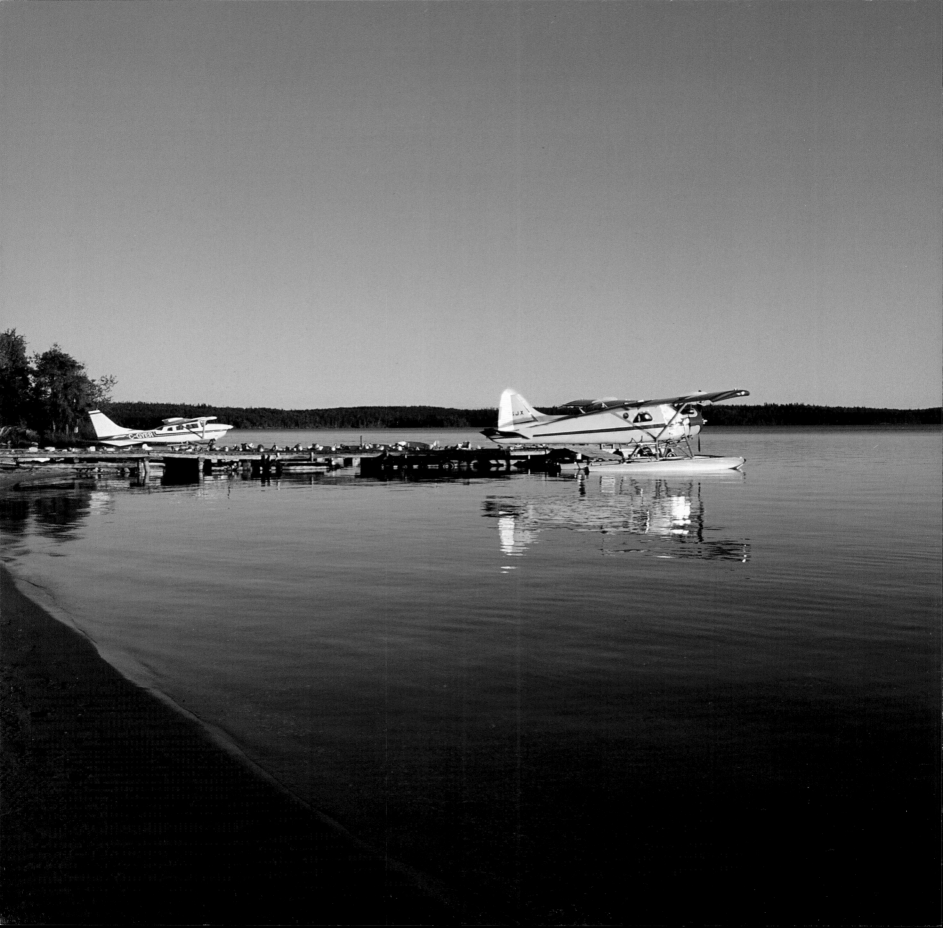

Sabourin Lake Lodge

In 1957 the Webb family, with the support of the Canadian government, purchased a plot of land and began construction of Sabourin Lake Lodge, located in the northern sector of Ontario's Woodland Caribou Provincial Park. The family had previously owned a fishing camp on Oneman Lake, on the English River system, which had been flooded under 35 feet of water by Ontario Hydro. In response, they had to search for a new location and, after exploring the Gammon, Pigeon and Berens Rivers, decided upon the Bloodvein River system. The Ontario government agreed to set aside the forest preserve and, as compensation for the flooding, to allow a lodge to be built on Sabourin Lake.

In early fall of 1957, Ralph Webb; Berger Olson, a building contractor out of Kenora; and Jerry Dusang, one of the original guides, began construction of the lodge. They flew in a crawler tractor, portable sawmill and generator, and milled some of the area's plentiful jack pine for lumber. Construction continued through the summer of 1958, during which time Ralph began to worry about costs and the construction delays. To speed things up, he ordered his crew to leave out one course, or layer, of logs on the main floor of the lodge. Today, only tall guests will notice this minor alteration. By the end of construction in 1958, the project's Norseman floatplane had flown over half a million pounds of construction materials from Oneman Lake, Laclu and Kenora

A beautiful start to the day on Sabourin Lake, Woodland Caribou Provincial Park, Ontario. "Acrobatics, including spins, not approved" reads a factory sticker on the lodge's de Havilland Beaver floatplane. Fortunately, all the aerial shows involve the lake's piscine residents. INSET A bald eagle leaves her fledglings in search of their next meal.

to Sabourin Lake. This amazing feat is believed to be the largest airlift in the North by a single aircraft at that time. Construction continued off and on for ten years until the completion of the lodge's store, the Hook Shop, in 1968.

Perhaps Sabourin Lake Club would be a more appropriate name for this timeless camp located in the northern sector of Ontario's sixth largest provincial park. For many of Sabourin's loyal guests, the annual summer pilgrimage to the lodge is simply not enough, and several visits a season is the norm. One guest has returned 120 times in the past thirty years — the equivalent to three full summers!

Wildlife is abundant and highly visible within Woodland Caribou Provincial Park. The park's official motto, "Where nature still rules," rings true. The vast, untainted prairie-boreal forest wilderness that surrounds Sabourin is busy with bear, wolf, fox, wolverine and a huge moose population. A small population of the elusive woodland caribou, estimated to number no more than 120, inhabits the park and feeds on the plentiful turquoise-colored lichen that has wrapped

During the lodge's construction in 1958, owner Ralph Webb ordered his crew to leave out one layer of logs on the main floor in order to speed things up. Today, only tall guests will notice this minor architectural shortcut.

The 30 windows on the front wall of the main lodge help illuminate the lounge and provide an impressive vista of Sabourin Lake. RIGHT These inconspicuous Ojibwa pictographs, found nearby on weathered, lichen-covered rock walls, depict images of various shamans, animals and hunting scenes.

itself over the smooth granite face of the ancient Canadian Shield. As its name suggests, the Bloodvein River is a rich life source for pine marten, otter, mink, muskrat, beaver, bald and golden eagle, osprey, waterfowl and songbirds. These furred and feathered wild inhabitants obligingly entertain fin-focused guests throughout each day.

While today's visitors are there to enjoy these animals from behind a lens in the comfort of a trolling boat, the Bloodvein watershed was once a highly productive fur-trapper's paradise. The river was also an ideal transportation route for traders and trappers, with its 190 miles of navigable waterway flowing west into Lake Winnipeg, from which furs could be taken north to York Factory on Hudson Bay. This adventurous history charges the imaginations of visitors to the area and stimulates them further with the Native and early European relics left behind. The area is dotted with

the remains of Hudson's Bay trading posts, trapper's cabins and numerous, daunting pictographs, images of shamans, hunting scenes and animals created by the Ojibwa inhabitants of centuries past. These pictographs lie inconspicuously on flat, weathered, lichen-covered rock walls. They are the ancient maps and mysterious stories of the land's spirits, and passing visitors may find small bundles of burnt sage in the cracks of walls stained with pictograph art. These have been left by respectful viewers.

"Acrobatics, including spins, not approved," reads a factory sticker on the control panel of the lodge's de Havilland Beaver floatplane. Fortunately, all aerial histrionics are piscatorial, especially those of the northern pike (*Esox lucius*, translated "water wolf"), a notoriously aggressive and violent fish. When this fish is hooked, anglers are often treated to lightning-quick surface strikes and powerful splashy lunges straight into the

145

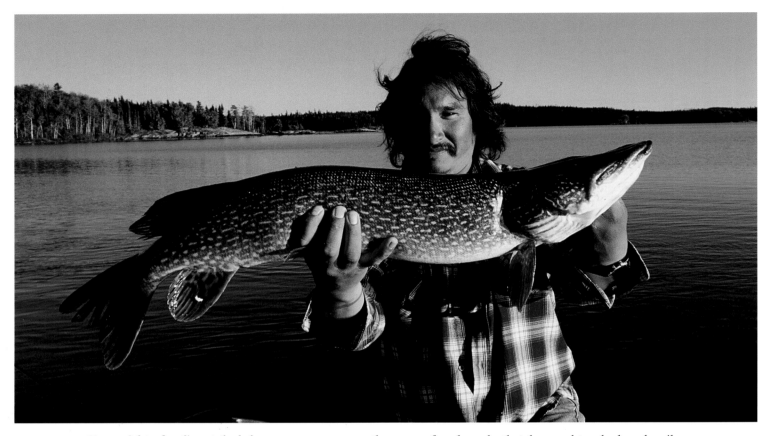

Every night, after dinner, the lodge manager announces the names of anglers who that day caught and released a pike,
walleye, bass or lake trout over specific trophy dimensions. In the summer of 2002, over a thousand trophy pins were awarded.

air. If handled improperly at the boat before release, pike usually leave the angler bleeding. Pike are plentiful in the tea-colored water of Sabourin Lake and complement the great action from walleye, whitefish, chunky smallmouth bass and lake trout caught in nearby lakes. Sabourin offers over 250 miles of shoreline fishing, both lake and river.

All species are native to the lake, with the exception of the bass. One of the lodge's original guides, Jerry Dusang, a Second World War veteran and commercial fisherman, was instructed by lodge founder Ralph Webb to catch eight smallmouth bass on a fly-out lake near the English River in the early 1960s. He brought the fish back in a 5-gallon bucket and released them in front of the lodge. This was done to prevent Ralph from being accused of false advertising, as he was still using his old brochure from Oneman Lake and it promised smallmouth. To this day, a healthy population of smallmouth bass swims the waters of Sabourin. As guardians of this resource, the lodge enforces a strict catch-and-release policy on all lake trout and bass caught. Suicks, Little Joes, Johnson Silver Minnows, weedless Daredevle spoons, jigs, spinners and worms are the traditional gear of choice at Sabourin.

However, it is the glassy-eyed walleye that swims its way into the hearts, minds and bellies of most anglers at Sabourin. Some fish it exclusively for its fight, but all anglers pursue it for its performance as the prima donna of the shore lunch. And perform it does, coated in Sabourin's decades-proven secret batter, it is the deep-fried sustenance for guides and guests alike. Shore lunches at Sabourin are akin to religious rituals (though far more pleasant and as keen for the spirit), and the guides are its high priests, for the guides hold the key to the primary reason why most people are really there at all. The sights, smells and sounds of shore lunch are a temporary yet emancipating voyage into a life that people wish they could live, but realistically can't — that of the hunter-gatherer in symbiosis with nature. And the guides administer this fantasy in happy doses, along with deep-fried or buttered fish, fresh fried potatoes, grilled onions, canned beans and corn. Shore lunches are mandatory at Sabourin Lake Lodge.

At Sabourin Lake Lodge there is fame and glory for those who practice catch-and-release fishing. Beginning in 1976, as a conservation initiative, the lodge launched its "Trophy Pins" program. Every night during dinner, the lodge manager announces the names of those anglers who during that day caught and released a pike or walleye over specific "trophy" dimensions, or any bass or lake trout. Each victorious angler is greeted with cheers and applause and receives a commemorative lapel pin as an award.

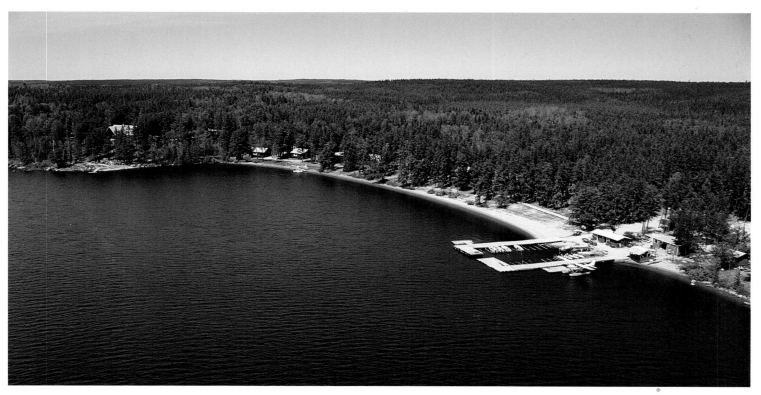

Lodge and guest cabins shelter in the shade of pine trees along the sandy shoreline of Sabourin Lake.

147

Guides hover, engines idling, waiting to pick up guests from the beach in front of their cabins. Many aspects of life at Sabourin Lake have never been altered. Each cabin's wood stove is stoked and hot coffee left for guests every morning before sun-up.

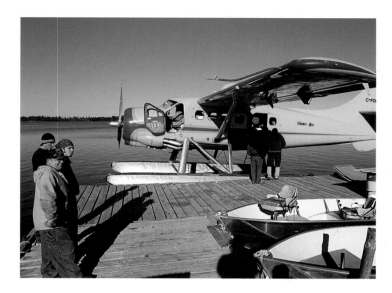
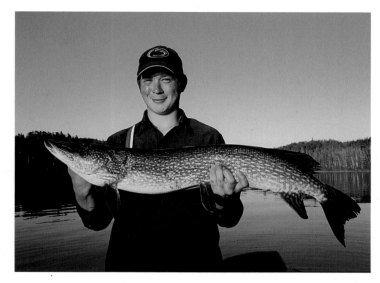

New guests and old friends are always warmly welcomed by lodge manager Fred Penner and his wife, Susan, as they disembark from the lodge's floatplane. RIGHT *Matt's mission: big pike for Sabourin's guests.*

This has been an immensely successful program for the lodge. In the summer of 2002, over 1,086 trophy pins were issued. Prior to 1976, many of those fish would have been filleted and frozen for transport home. Another initiative aimed at promoting sustainable management is the annual draw for a free trip the following summer. Only those guests who purchase provincial conservation licenses are eligible.

If you can imagine yourself at a summer camp in a remote spot back in the 1950s, you've pretty much described the atmosphere at Sabourin. Despite changes in fishing practices, many aspects of life at the lodge will never be altered. Wise Native guides from Winnipeg, Kenora and Red Lake return summer after summer to expertly ply their trade. One of the guides, Stanford, has become an institution by humbling cocksure guests at the gigantic chessboard in the main lodge. Each cabin's wood stove is stoked, with hot coffee left for guests every morning before sun-up. Tuesday night

is still chicken night, as it was forty years ago. New guests and old alike are always warmly welcomed by lodge manager Fred Penner and his wife, Susan, as they disembark from the lodge plane.

Guests like things just the way they are. This is one of the reasons that Sabourin has never really advertised since the early 1980s, when owners Ron and Shirley Williams, who purchased the camp in 1968, promoted the lodge at a couple of sport shows in the United States. Much of their current guest base, overwhelmingly from the midwest United States, was established at this time. Not having to advertise for close to twenty years is a testament to the quality of experience and service that guests enjoy at Sabourin.

You could not build a camp as large as Sabourin Lake Lodge without the help of interesting people, each with their own stories. Many have passed on to the Great Beyond, and it is with great respect that Sabourin shares these stories.

Gander River Outfitters

During peak season, from mid-July to mid-August, up to 175 Atlantic salmon per hour can be seen jumping in the home pool of Gander River Lodge, the name of Gander River Outfitter's main lodge. Located only 4 miles from the salt chuck, every one of the over 20,000 salmon that arrive home to the Gander each year pass just 30 yards from the doorsteps of the lodge. Once reduced to a dwindling run due to commercial overfishing, the Gander has become a tremendous success story in terms of recovery and now hosts one of the largest returns of wild salmon in Newfoundland. The river has been a sportsman's paradise since the first commercial camp was built in the 1930s. Prior to this, the Gander was a valued thoroughfare for the transport of goods inland from the sea. This was a physically demanding job carried out by adventurous rivermen who challenged the river's whitewater in their famed wooden Gander River boats.

Gander River Outfitters was started in 1986 by Terry Cusack, a former transatlantic air traffic controller at Gander airport. Today, he and his partner, Lanita Carter, both of whom are avid fly anglers and hunters, run the camp side by side with the help of a chef and guides, many of whom come from families who have guided sports on the river for generations. For Terry and Lanita, fishing is a passion, and both enjoy the thrill of sharing it with others, especially those new to Atlantic salmon fishing.

Twenty-foot Gander River boats are beached in front of the lodge and its home pool, where during peak season up to 175 Atlantic salmon an hour can be seen jumping. Over 20,000 salmon are said to pass through this stretch of water every year.
INSET The lodge's talented chef displays some of his delicacies.

151

Even when absent from the river, they introduce fly-fishing neophytes to the sport through their Newfoundland Fly Fishing School. For the last fifteen years, Gander River Outfitters has served anglers and moose hunters from around the world, with many guests coming from as far away as Australia, South Africa and Spain. When it comes to dividing up the various responsibilities related to the business, Lanita seems to get the rough end of the draw. Not only is she the camp manager, but she also looks after most of the administrative and marketing sides of the business. Terry modestly proclaims that he just likes to "fix things," and believes that somewhere between Alan Jackson's "Don't Rock the Juke Box" and "Braveheart" is the theme song for the Gander River Outfitter's lodge.

Standing on stilts above the river's flood plain, the lodge is quaint and unpretentious. Windows surround

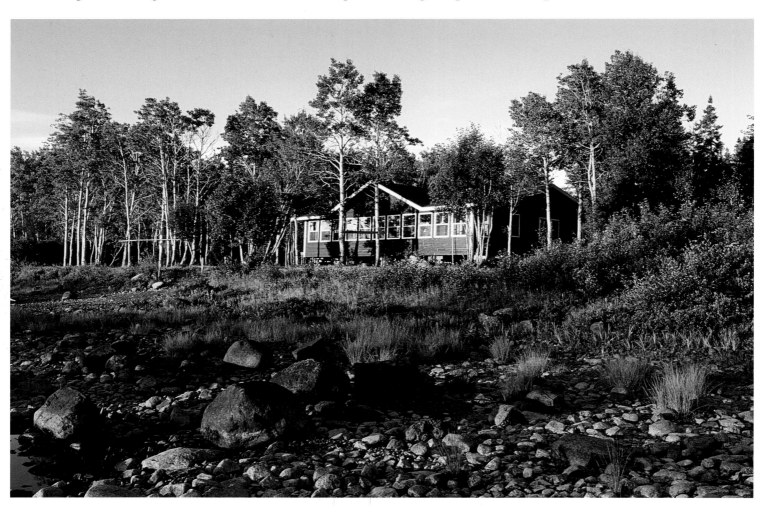

The lodge is located above the first "rattle" (the local term for rapids), only four miles from the ocean, and the river rises and falls a couple of feet with each change of tide.

the entire front of the main cabin, providing a panoramic view of the river and angling activity at all times. A comfortable library in the main cabin is an ideal spot to put your feet up and watch the salmon jump or play against an angler's line. The soothing rush of the rapids known as "First Rattle," just upstream from the lodge, washes in through the cabin's screened windows. On the wall above well-stocked shelves a beautiful moose head and rack, a memento of Lanita's first hunt with Terry, gazes down steadfastly.

A walkway leads from the lodge across a small, stony beach in front to the docks, where several bright white Gander River boats lie moored, their sterns swaying in the eddy's current, awaiting the lodge's angling guests. Behind the main cabin, a long, elevated board-walk leads to the guest cabin. A giant caribou head-and-rack mount dominates the guest lounge, which is heated by wood stove on cool evenings. The remainder of the wall space is decorated with posters of famous Newfoundland salmon flies and metal plac-ards outlining the various sizes of bullets made by Remington and Winchester. All the rooms are named after well-known fly-rod and rifle manufacturers, with the exception of Western Star, the lodge's self-catering cabin, which is located on a neighboring property.

Dinners at Gander River are a harmonious blend of good wine, home-cooked meals with a local flare, and great tales from Terry. If you time your visit right, you'll enjoy one of the house specialties, fresh, deep-fried, succulent Atlantic cod caught by the lodge's talented chef, Lloyd, and served on the camp's own Portmeirion Complete Angler china. Lanita, who is from

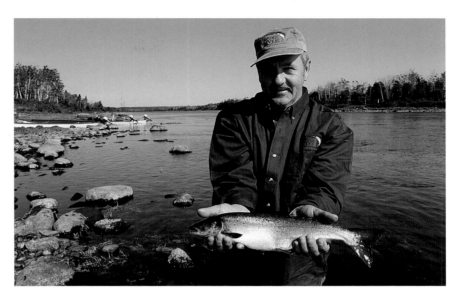

Guide Ike Gillingham — who bears the scars of a near fatal bullet wound acquired when his brother-in-law mistook him for a moose — holds a modest grilse taken a few feet from the lodge.

Alabama, complements Lloyd's creations by adding her own southern touch to the menu with dishes like orange-and-maple baked beans and southern fried onions. Over meals, Terry brings the area's colorful rivermen to life, entertaining all with stories of hard-ship, humor and adventure on the Gander River. Some of the anecdotes involve legendary guide Brett Saunders, whose life stories are recounted in a book by his son entitled *Rattles and Steadies — Memoirs of a Gander River Man*. Brett lived life to its fullest and spent most of it in the Gander-area woods, trapping, hunting and guiding. He guided fishing celebrity Lee Wulff in the '50s and established Saunders' Camps, one of the first fishing lodges on the Gander River, which he built and ran with his brother Don.

Often the salmon are so thick in the lodge's home pool that guests need not go anywhere else to fish. It is even possible to fish from shore successfully at times.

But to do this exclusively would be to miss out on one of the unique experiences at Gander — fishing from your own guided Gander River boat. The lodge boats themselves are handcrafted by Gander's chief guides, Harry Bauld and Isaac "Ike" Gillingham, based on construction plans handed down over generations. Although the boats originated in Gander Bay, their practical design and superior performance in handling fast-flowing rivers has led the design to be adopted by fishermen and rivermen across the Maritime provinces. Extremely stable and able to cut through waves like a hot knife through butter, these boats make an ideal casting platform. At over 20 feet long, powered by 20-to-25-horsepower engines and capable of carrying up to 1,500 pounds of freight, they continue to be the workhorses of the Gander River and were responsible for carrying all the equipment and materials used to build the Gander River Lodge. Lumber for the handcrafted boats comes from the banks of the river itself — spruce for the keel and gunwales, tamarack or juniper for the ribs, and balsam fir for planks.

Many years ago, two Gander boats strapped together were used to take the cockpit of a Hurricane fighter plane downriver from a crash site. It is a real thrill to recline on the boat's deck chair at water level as your guide motors upstream and the bow slices

The reluctant release of a dazzlingly beautiful specimen.
OPPOSITE PAGE *Gander River boats are durable and handle fast-flowing water so well that they are now ubiquitous in Newfoundland. All of the Gander River Outfitter boats are hand-built by their guides.*

through calm "steadies" and turbulent whitewater "rattles" without feeling the least bit in danger. During low-water conditions, when navigating between rocks becomes more difficult, don't be surprised to hear your guide bark out "Lard Jasus" more than a few times as you pass up through or down a swift rattle.

In the past, men in their Gander River boats looked upstream to the thick spruce forests and fur traplines for a living; now they peer down under their boats for the finned shadows of summer and fall. While approximately 80 percent of the Gander River salmon run are grilse, the river does receive large fish every year. The record salmon on a fly rod is reported to have weighed in at 42 pounds. While the precise date is unclear, the story tells us that the famous fish was hooked at 6:00 P.M. and fought tirelessly until 11:00 P.M., when the weary angler got fed up, dragged the fish into shallower water, and jumped on it before killing it with a hunting knife. The angler was Jim John, a legendary Mi'Kmaq guide and trapper on the river.

What Gander River salmon lack in size, they more than make up for in fight and spunk. They are a beautiful, acrobatic strain of fish, and each one does its best to entertain when hooked. Maneuvering the boats into prime casting spots takes considerable skill, requiring a combination of engine power and good

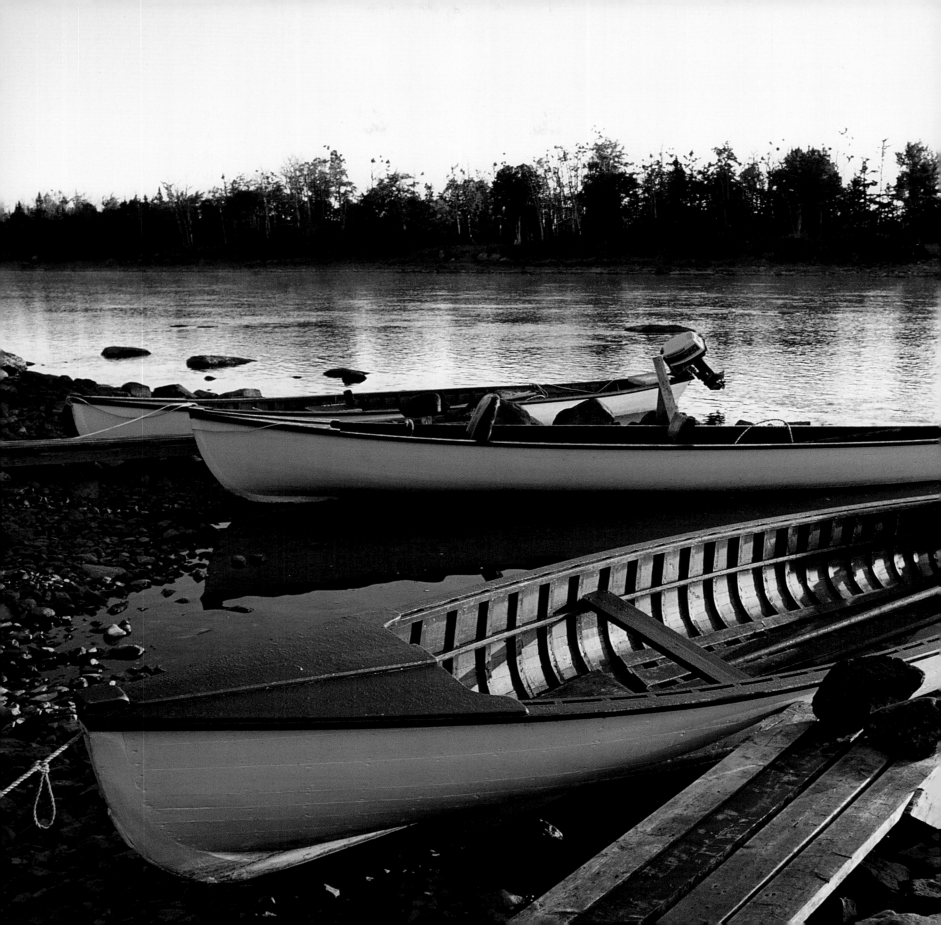

old-fashioned poling before a 40-pound lead anchor is tossed over to secure the boat. Surprisingly, the large splash doesn't scare the salmon, and a hook-up on the first cast is not unusual. If a big fish is hooked and takes off downriver, the anchor is raised and the guide must put his long spruce pole to use once more as he avoids the many giant boulders that are strewn across the river. Popular flies on the river include Black Doctors, Blue Charms, Silver Grays, Green Bugs, Thunder and Lightning, and Silver Tips. In addition to salmon, there are resident and sea-run brook trout that reach very respectable sizes. These curious yet cautious fish are partial to large Mickey Finns and are regularly spotted chasing hooked parr on the end of your line. Despite early attempts by Lee Wulff to persuade locals otherwise, rifflin' hitches and dry flies are not established techniques on the river.

Traditionally, the Gander was open from mid-June to mid-September; however, a persistent Terry Cusack was convinced that the river received a strong run of fish

Fishing a "rattle" near the lodge from a Gander River boat. Flies of choice include Black Doctors, Silver Charms, Silver Grays, Thunder & Lightning and Silver Tips.

The lodge's complimentary all-weather suits have saved many an angler who underestimated Newfoundland's unpredictable climate.

well into the fall and invited a fisheries officer to test fish the pools around the lodge at the beginning of September and October of 1994. The results were astounding. Between the two of them, they hooked 107 fish in one week in September and 94 salmon in a week in October. Terry had proven his case, and Gander River Outfitters was issued the first ever "experimental fishing license" for fall fishing on the Gander. Today, thanks to Terry, anyone can catch fresh salmon right up until October 7.

At Gander River Outfitters there is a serenity that pervades the day's activities, and a contentment that is manifest on the faces of guides and of guests that pass you on the river. Guides and river residents, who all seem to know each other, never miss a chance to greet and exchange friendly insults — barely decipherable in their thick accents to outsiders — but always leading to hearty laughter. The river is as intimate as the people that live on its shores and fish its pools. For some, this is as alluring as the fishing, and undoubtedly one of the great pleasures of visiting Newfoundland. If salmon is what you're after, perhaps Terry Cusack's rhetorical question will help you with a decision: "Why fish where the salmon used to be when you can fish where they are now?

157

Bibliography

Campbell, Kenneth, C. "By Canoe to York Factory Summer, 1911." *The Beaver*, Aug.–Sept. 1992.

Cohen, Saul B. ed. *Columbia Gazetteer of the World*. New York: Columbia University Press, 1998.

Combs, Trey. *Tackle and Techniques, the Great Rivers, the Anglers and their Fly Patterns*. Lyons & Burford, 1991.

Cook, Leon. Personal communication, 2001.

Csanda, Dave. "New Wave Pike — Riding the Crest of Trophy Pike Opportunity." Fisherman, 1993.

Curtis, Wayne. *River Guides of the Upper Miramichi*. Fredericton, N.B.: Goose Lane Editions, 1997.

Curtis, Wayne. *Currents in the Stream — Miramachi People and Places*. Fredericton, N.B.: Goose Lane Editions Ltd., 1997.

Dalzell, Kathleen E. *Queen Charlotte Islands, Vol. 2, Places and Names*. Madeira Park, B.C.: Harbour Publishing, 1973.

Dean, William G., Heidenreich, Conrad E., McIlwraith, Thomas F., and John Warkentin, eds. *Concise Historical Atlas of Canada*. Toronto: University of Toronto Press, 1998.

Department of Geography. *Atlas of Newfoundland and Labrador*. Memorial University of Newfoundland, 1991.

Dregger, Wayne. Personal communication, 2001.

Engle, Bob. Personal communication, 2001.

Fisheries and Oceans Canada. "The Labrador Salmon Fishery." April 1997.

Genge, Barb. Personal communication, 2001.

Government of Newfoundland and Labrador. "Eagle River Proposal." News release, July 19, 1996.

Gruenefeld, George. *Atlantic Salmon River Log — Gaspé Region*. Montreal: self published, 1988.

Hanmer, S., S. Bowring, O. van Breeman, and R. Parrish. "Great Slave Lake Shear Zone, NW Canada: mylonitic record of early Proterozoic continental convergence, collision and indentation." *Journal of Structural Geology*, 14 (1992):757–773.

Hart, Gerald. Personal communication, 2001.

Hearne, S. *Arctic Dawn —The Journeys of S. Hearne*, out of print.

Howe, Geoff. "Their Names Live On." *Northern Visitor*, Nov. 1, 2000.

Hutchings, David. Personal communication, 2001.

Hutchings, Gudie. Personal communication, 2001.

Kretz, Diane. Personal communication, 2001.

Lewis, Adam. "A Report to Stakeholders." Steelhead Society of British Columbia, Bulkley Valley Branch, 2000.

Low, George. Personal communication, 2001.

Mackinnon, William R., Jr. *Over the Portage — Early History of the Upper Miramachi*. Fredericton, N.B.: Centennial Print and Litho Ltd., 1984.

Manitoba Department of Natural Resources Parks Branch. "The Middle Track & Hayes River Route, 1963.

Maksymetz, Dennis. Personal communication, 2001.

McLane, A.J., ed. *McClane's New Standard Fishing Encyclopedia and International Angling Guide*. Holt, Rinehart and Winston, Inc, 1965.

Microsoft Encarta Online Encyclopedia. "Great Slave Lake." 2001

Moore, David, research technician, Science Branch, Department of Fisheries and Oceans Canada: personal communication, 2001.

Murray, Craig. Personal communication, 2001.

Myers, Stephen. Personal communication, 2001.

O'Hare, Mike. Personal communication, 2001.

Robinson, J. Lewis. *Concepts and Themes in the Regional Geography of Canada*, rev.. Vancouver: Talonbooks, 7th printing 1990.

Peterson, Eric. Personal communication, 2001.

Plummer, Chummy. Personal communication, 2001.

Plummer, C. C. Diaries kept in 1944 and 1946.

Pollack, Lori. "The Good Life." Canadian Resorts North Management Inc. & Training Centre Inc.

Reid, Al. Personal communication, 2001.

Reid, Phil. Personal communication, 2001.

Reynolds, Ken. "A Stage I Archaeological Assessment of an Outfitter's Lodge on the Eagle River, Labrador." Written on behalf of the Government of Newfoundland and Labrador

Richards, J. H. and K. I. Gung. Atlas of Saskatchewan. Saskatoon: Morgan Press, 1969.

Ritchie, James. "Voices of Hudson Bay Brings York Factory History to Life." *Nickel Belt News*, Monday, March 3, 1997.

Ross, Rachel. Museum Note No. 5, "Early Sports Fishing 1890–1940." Campbell River Museum, 1982.

Silkens, Thelma. "Campbell River, a Modern History of a Coastal Community." Campbell River Museum, no date.

Stewart, Clayton Stanley. *Life on the Miramachi*. Fredericton, N.B.: Unipress Ltd., 1960.

Stewart, Hilary. *Indian Fishing — Early Methods on the Northwest Coast*. Vancouver: Douglas & McIntyre, 1982.

Stewart, Hilary. Personal communication, 2001.

Taylor, Bill. Article in Atlantic Salmon Journal, Spring 1995.

Tyson, Dave. Personal communication, 2001.

Wallace, Gord. Personal communication, 2001.

Waller, Lani. Personal communication, 2001.

websites:

www.wwanglers.com/shlodge.htm

www.bigsandlakelodge.com

www.campbrule.com

www.ganderriver.com

www.inconnulodge.com

www.kneelake.mb.ca

www.langara.com

www.minipicamps.com

www.nimmobay.bc.ca

www.painterslodge.com

www.plummerslodges.com

www.rifflinhitchlodge.nf.ca

www.scottlakelodge.com

www.selwynlakelodge.com

www.voyageur.ca/~sabourin

www.wilsonscamps.nb.ca

www.mibc.nb.ca/history/discover.htm

www.intellis.net/miramachi/history.html

Index